Wicked
PITTSBURGH

Wicked PITTSBURGH

Richard Gazarik

THE
History
PRESS

Published by The History Press
Charleston, SC
www.historypress.com

First published 2018

Manufactured in the United States

ISBN 9781467138567

Library of Congress Control Number: 2018945672

For Toni and Bill McLeod

CONTENTS

Acknowledgements 9
Introduction: Metropolis of Corruption 11

1. Captain "Smiling Johnny" Klein 23
2. Little Canada 33
3. Booth & Flinn: The Company that Built Early Pittsburgh 43
4. Pittsburgh by the Numbers 53
5. A Blind Eye 63
6. City Hall Scoundrels 71
7. Vote Early, Vote Often 82
8. Pittsburgh's Clown Prince of Politics 90
9. Boss Lawrence 100
10. Crime Never Paid for Roxie Long 108
11. Pittsburgh's Gilded Palaces of Sin 115
12. Pittsburgh's Iron Curtain 126
13. The Harder They Fall 135

Bibliography 145
Index 157
About the Author 160

ACKNOWLEDGEMENTS

The Archives Service Center is a great starting place for any research on the history of Pittsburgh. Its collections contain a wealth of information about the city and people who governed Pittsburgh. Its friendly staff members went out of their way to provide information that I needed to complete this book. Historic Pittsburgh is a digital library connecting libraries, museums and universities in Pittsburgh to provide access to their respective historic books, maps and photographs. The staff at the Pennsylvania Room at the Carnegie Library maintains extensive clipping files on people and events on the city's history. The H. John Heinz History Center maintains the papers of Pulitzer Prize–winning journalist Ray Sprigle, who spent decades investigating crime and political corruption in the city for the *Pittsburgh Post-Gazette*. Sprigle won the Pulitzer Prize in 1938 for stories exposing Supreme Court justice Hugo Black's membership in the Ku Klux Klan. The evidence that Sprigle uncovered included a copy of a resignation letter from Black written on the stationery of the Alabama Klan. Sprigle's work uncovering the connection between racketeers and elected officials was invaluable in writing this book. J. Banks Smithers of The History Press provided encouragement and guidance in formulating the outline for this work, and editor Abigail Fleming caught my mistakes. Finally, my wife, Lucy, was a sounding board and editor for this work as well as my first two books.

Introduction

METROPOLIS OF CORRUPTION

All a nice man ever gets is a big wedding and a quiet funeral.
—Senator James Coyne

ittsburgh, over its history, has been a wicked city. At times it has been evil, sinful, immoral and corrupt. It accepted corruption as a way of life. Mayors, councilmen and police chiefs have plundered the city for their personal benefit. Reform movements came and went, but corruption continued. The Municipal League, the Voters' Civic League, the Citizens Committee, the Law and Order Society and the Police Research Commission railed against election fraud and police corruption and conducted investigations into gambling, prostitution and liquor rackets.

Politicians, stung by public criticism, ordered police to clean up the city, but operations quickly went back to normal after the dust had settled. Pittsburgh suffered through its share of political bosses, voter fraud and election scandals, corrupt mayors and councilmen and dishonest cops and weathered its share of reform movements that had short-lived effects on governing.

Pittsburgh earned the title "Metropolis of Corruption" from muckraking journalist Walter Liggett, who came to Pittsburgh in the early 1930s to expose the links between politicians, police and bootleggers. Liggett, who was murdered by racketeers, published similar exposés in Boston, Washington, D.C., and Minneapolis in *Plain Talk* magazine. His investigation in Pittsburgh

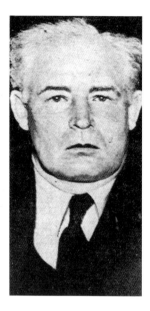

Walter Liggett, crusading editor of *Plain Talk* magazine, who chronicled corruption in Pittsburgh during Prohibition. He was murdered by gangsters in Minneapolis. *From the* Pittsburgh Post-Gazette *Archives.*

ranked the city on the same level as Detroit, Cleveland and New York City for corruption and violence—although he said Pittsburgh had more vice per square block than any of these other cities. Big business worked together with gamblers, brothel operators, speakeasy owners, bootleggers and politicians, allowing vice and crime to embed itself in the fabric of the city.

Liggett wrote:

It is very doubtful whether anywhere else in America there exists such debauched, dishonest or utterly incompetent public officials as these comprise the political machine which mismanages the affairs and systematically loots the treasuries of Pittsburgh and Allegheny County.…Brazen political alliances of businessmen on the one hand and blind-piggers, gamblers, brothel proprietors and grafters on the other has no parallel in the United States today.…There isn't a form of depravity that hasn't been put on a dividend basis in Pittsburgh, and even perversion is made to pay a profit.

Liggett exposed how ward chairmen sold concessions to criminals that allowed them to operate brothels and speakeasies and how the police department served as a collection agency for payoffs and bribes. He detailed how the courts allowed individuals charged with first-degree murder to remain free on bail and how policemen drank free at speakeasies while on duty. Liggett exposed the ineptness of the police, who were only able to solve one out of eighty gang killings during Prohibition. His story bought howls of denials from elected officials, but the *Pittsburgh Press* reminded its readers that sometimes, the truth hurts:

His story is not one to arouse pride among Pittsburghers. It is not a nice story to have emblazoned before the country and there will be ostrich-minded persons to say that such things should not be presented because they will give Pittsburgh a black eye. But the black eye is not caused by Liggett's wallop.

There is truth in the Liggett story, much truth and it has been presented in the past without arousing a sense of civic indignation sufficient to wipe out the controlling political forces which permit and foster the evil conditions which Mr. Liggett so flamingly presents. That's where the black eye comes. Even Liggett's mistakes cannot controvert the fact there is more truth in the Liggett story than is good for Pittsburgh.

Pittsburgh during Prohibition was a "boozocracy," said the *Pittsburgh Post*. Everyone was corrupt, from the beat cop to his bosses to city councilmen and the mayor. Even Prohibition agents could not be trusted. While Pittsburgh police officers often protected illegal distilleries from raids, federal agents accepted bribes and were arrested and convicted.

In 1923, the Internal Revenue Service sent undercover agent Saul Grill to Pittsburgh, posing as a corrupt agent willing to be bought. Grill had earned a reputation for his undercover work that led to the seizure of $2 million in pre-Prohibition liquors, including ten thousand cases of champagne, and the dismantling of a bootlegging operation in New York. While working in New Jersey, Grill accepted $85,000 in bribes as evidence against officials. Some of his cases were thrown out of court or overturned because his investigations were considered entrapment.

Grill was sent to Pittsburgh and met with bootleggers who promised to pay him $20,000 a month to overlook their operations. Grill took $33,000 in bribes, and his investigation led to the indictments of a former city councilman, two Prohibition agents and a deputy commissioner of the IRS.

When the time came for their trial, Grill wasn't on the witness list for the prosecution because he had been fired, ostensibly for taking a month off in Miami without informing his superiors, reported the *Gazette Times* in 1925. Whether that was true or not, Prohibition administrators in Pittsburgh were subjected to intense political pressure to ease up on bootleggers. Several administrators quit in frustration. John Pennington, an aggressive agent who conducted thousands of raids in Pittsburgh and western Pennsylvania, found himself transferred to Philadelphia.

Pittsburgh was saturated by so much alcohol that the city was "wet enough for rubber boots," according to congressional testimony. There were so many stills operating that one could smell the aroma of mash in the air. In one raid, agents found five two-thousand-gallon vats, boilers and compression pumps to make booze in an abandoned warehouse, according to the *Pittsburgh Post*.

Competition was so intense that bootleggers tried unsuccessfully to form a "bootleggers' union" to set prices for alcohol sales. The bootleggers even

created badges identifying them as union members so they wouldn't waste time soliciting one another for business, said the *Pittsburgh Press*.

Every vacant building or warehouse was involved in bootlegging. Raids routinely turned up large, sophisticated distilling and brewing operations that eventually led to the indictments of 167 individuals, including Pittsburgh police superintendent Peter Walsh, several inspectors and politicians. Eventually, according to the *Pittsburgh Press*, the charges were dismissed after the government said it was unable to prove the allegations. Federal agents raided a mansion in a city neighborhood where bank presidents and oil company executives lived and found a distillery operating "full blast," reported the *New York Times* in 1923.

Inside the first floor of the building, agents found lavishly decorated rooms with expensive carpeting, furniture and draperies and a second floor containing two one-hundred-gallon stills, fifty gallons of mash and a large quantity of liquor and wine.

In 1903, muckraker Lincoln Steffens penned a classic article about corruption for *McClure's*: "Pittsburg: A City Shamed." He wrote:

> *The city has been described physically as "Hell with the lid off"; politically it is that same with the lid on. I am not going to lift the lid. The exposition of what the people know and stand for is the purpose of these articles, not the exposure of corruption, and the exposure of Pittsburg is not necessary. There are earnest men in the town who declare it must blow up of itself soon. I doubt that; but even if it does burst, the people of Pittsburg will learn little more than they know now. It is not ignorance that keeps American citizens subservient; neither is it indifference. The Pittsburgers know, and a strong minority of them care; they have risen against their ring and beaten it, only to look about and find another ring around them. Angry and ashamed, Pittsburg is a type of the city that has tried to be free and failed....Superior as it is in some respects, however, Scotch-Irish Pittsburg, politically, is no better than Irish New York or Scandinavian Minneapolis, and little better than German St. Louis. These people, like any other strain of the free American, have despoiled the government—despoiled it, let it be despoiled, and bowed to the despoiling boss. There is nothing in the un-American excuse that this or that foreign nationality has prostituted "our great and glorious institutions." We all do it, all breeds alike. And there is nothing in the complaint, that the lower elements of our city populations are the source of our disgrace. In St. Louis corruption comes from the top, in Minneapolis from the bottom. In Pittsburg it comes from both extremities, but it began above.*

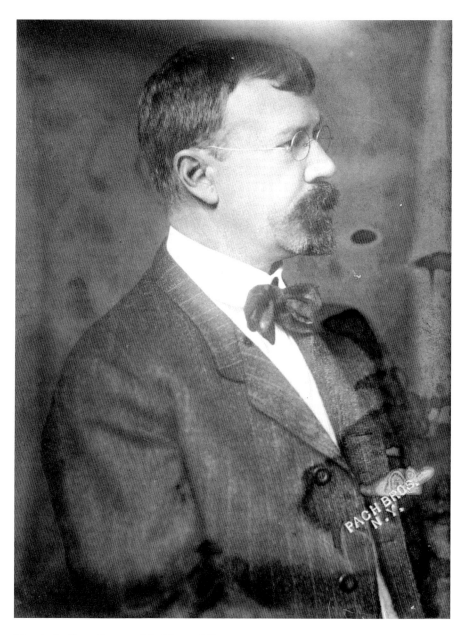

Lincoln Steffens. *Courtesy of the Library of Congress.*

Lincoln Steffens's biographer, Justin Kaplan, wrote that Steffens found "self-government there was dead, reform broken in spirit, a controlling oligarchy so firmly established in power that 'nothing but a revolution' could recapture the city for the citizens."

Sex also was a major business in the city. Prostitutes paraded openly on the street under the guise of protective policemen, who instead of scaring away customers, assured them their presence was welcomed. There were hundreds of brothels employing one thousand prostitutes.

Pittsburgh was a rough-and-tumble place filled with mystery and murder. When workers were demolishing a building in 1906, they found two skeletons buried two feet beneath the ground where a notorious downtown saloon, Oyster Paddy's, once stood. Oyster Paddy's catered to thieves and river men and was the scene of killings, stabbings and brawls. The skeletons had been buried there for at least three decades and had been covered with quicklime to speed decomposition.

Police had several theories as to how the remains ended up beneath the floor of Oyster Paddy's. One theory was they were the bones of two Allegheny City detectives who joined a gang of criminals and were murdered sometime between 1870 and 1880. Former police officers couldn't recall any detectives ever going missing in that era. Allegheny City was located across the Allegheny River from Pittsburgh and was a city in its own right until it merged with Pittsburgh in 1907. The area now is known as the Northside.

Another idea was that they were members of a gang operating in Pittsburgh in the late 1870s and early 1880s who robbed two banks and then were killed after having a falling out with other gang members over their share of the loot. Detectives tracked down the former owner, Hugh O'Donnell, who was living in Wheeling, West Virginia, but he was unable to shed any light on how the bodies ended up beneath his saloon, which closed in 1888.

Detectives told the *Pittsburgh Post* that they suspected the bodies were buried quickly since they were only dumped in graves two feet deep and covered with lime. "It was evidently a quick job that had to be done," Detective Thomas McQuade told the *Pittsburgh Press*.

Municipal elections were tainted by fraud for decades. Battles for political control were fought in the streets with fists and guns. People were shot, killed and beaten, according to accounts from Pittsburgh's primary newspapers, the *Pittsburgh Press* and *Pittsburgh Post-Gazette*. The numbers racket, introduced to the city in 1926, spread throughout Pittsburgh and the adjacent mill towns, creating a multimillion-dollar operation that employed as many as five thousand people writing numbers.

Mayors Charles Kline and David Lawrence, the future governor of Pennsylvania, were tainted by corruption. Lawrence was indicted several times during his political career but escaped conviction. Charles Kline turned graft into a well-oiled business until he was convicted of forty-nine counts of malfeasance in office and forced to resign. State Senator James Coyne, the city's Republican boss, was charged with vote fraud for rigging a congressional election but was acquitted. Nevertheless, Coyne's tenure as boss was a "dark era of Pittsburgh politics," railed the *Pittsburgh Press* in an editorial.

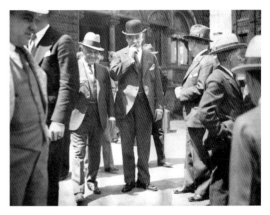

Right: Mayor Charles Kline during a break in his trial for malfeasance in office. Kline was the most corrupt official in the history of Pittsburgh. *From the* Pittsburgh Post-Gazette *Archives.*

Below: Pittsburgh mayor David Lawrence with Branch Rickey (*right*) and Pirate co-owners Tom Johnson and John Galbreath for the home opener at Forbes Field in 1951. *From the* Pittsburgh Post-Gazette *Archives.*

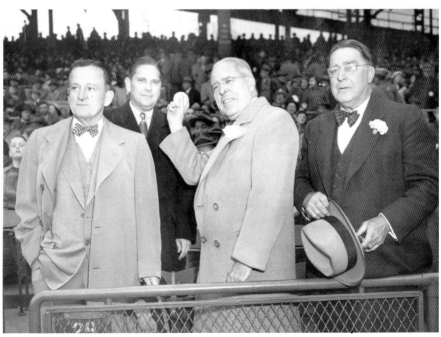

Members of election boards were routinely convicted of tampering with election results over the decades. Between 1931 and 1932, 150 city residents and officials were convicted of election fraud, according to Paul Beers's history of Pennsylvania politics.

In a city election in 1909, ballot boxes were dumped into one of Pittsburgh's three rivers. The same year, the Voters' Civic League, a reform group aimed at ferreting out corruption in city hall, learned of bribes paid to councilmen. A grand jury investigation resulted in 180 indictments that snared forty councilmen. Two years later, the league lobbied the state legislature to transform Pittsburgh's unwieldy one-hundred-member bicameral council to a more manageable nine members.

The police department, instead of enforcing laws against vice, served as a collection agency for crooked politicians. Superintendent Peter Walsh was blind when it came to finding gambling dens and speakeasies during the 1920s and 1930s. Inspector Charles Faulkner protected brothels and gambling joints and beat and arrested journalists who had the temerity to question his integrity. Lawrence J. Maloney, who rose from being a church janitor to assistant superintendent of police, earned a reputation as a crusading cop leading a unit known as "Maloney's Marauders" that raided vice dens while taking bribes to protect other operations during the 1950s.

Democrats blamed Republicans for the corruption after decades in power, accusing the GOP of growing rich through the graft and vice generated by the city's prostitution rings, gambling dens and speakeasies.

"Only a fool would believe that a house of ill fame, a gambling den, a slot machine operator or a numbers salesman can do business without paying someone for protection and that someone is necessarily a Republican political boss," read a full-page ad in the *Pittsburgh Press* on the eve of the general election in 1933, which saw the Democrats assume political control over the city. Pittsburgh was the bedrock of GOP power until Roosevelt carried Pittsburgh and Allegheny County, putting the Republican Party in the minority for the first time since the Civil War.

Corruption is as old as Pittsburgh. It existed long before journalists like Liggett and Lincoln Steffens ripped the scabs off the city's political wounds and allowed them to heal in the sunlight. Industrialists H.C. Frick and Andrew Carnegie were not above paying bribes to get what they wanted.

When Carnegie and Frick wanted to expand their steel plant in Homestead, they were stymied because the additional land they needed was the site of Pittsburgh's 144-acre poor farm. Councilmen were bribed to put the property up for sale and move the farm elsewhere, according to

David Nasaw's biography *Andrew Carnegie*. Carnegie and Frick dispatched intermediaries to Christopher Magee, half of the notorious Magee-Flinn political machine, to negotiate a price for the coveted property, according to Nasaw.

Frick's attorney Philander Knox met with Magee, who asked Knox how much Frick and Carnegie were willing to pay him to push the deal through. "Magee now agrees to put the matter through but wants to know our price and just what we'll agree to pay him," wrote Nasaw. Carnegie and Frick balked at bribery.

Magee suggested that he put up a dummy bidder who would submit a price of $2,775 so it wouldn't appear that Frick and Carnegie were the only ones interested in the property and suggested they submit a bid of $2,805 an acre. When the bids were opened, the steel magnates were shocked to discover a third party had submitted the highest bid of $2,903 an acre. Frick and Magee were forced to pay Magee his bribe plus additional funds to purchase the farm from the higher bidder. "It looks as if the Boss has taken us in" said Frick.

The history of city government has been tarnished by backroom deals, bribes, kickbacks and political intrigue ever since the days of Magee-Flinn. The construction of a new city hall during the first decade of the twenty-first century was shrouded in so much mystery that details of the transaction were kept secret for eighteen years until they inadvertently surfaced.

In 1908, Pittsburgh's city hall was a dirty and dingy building located on Smithfield Street. Mayor George Guthrie was in office when the discussions of construction began, but it wasn't until Mayor William Magee, nephew of boss Christopher Magee, became mayor that the project began to move forward.

While several sites were considered, Magee pushed for a property on Grant Street that was the site of Maloney's Saloon, owned by his close friend, Michael Maloney. Maloney's Saloon was a popular hangout for judges, lawyers, ward bosses and public officials who would meet at the end of the day to hoist a few schooners of beer to discuss the law and politics in the politically driven city.

Maloney, with the help of Mayor Magee, had tried to sell his property to Allegheny County, but county commissioners weren't interested because Maloney's asking price was too high. The city floated a $3 million bond issue to construct the building, and the project moved ahead—but the details of the financing were kept from the public until 1931.

Pittsburgh condemned Maloney's property in 1913 and valued the land at $600,000, but instead of taking the money, Maloney opted

to take a twenty-year mortgage at 4 percent interest. When the deal expired, Maloney exercised an option to extend the mortgage another five years at 3.5 percent interest. Over the years, Maloney and his family received $531,000, plus another $100,000 in interest. The deal became public after city council voted to pay the last installment of $500,000 to Maloney's eighty-year-old daughter and his grandson, according to the *Pittsburgh Post-Gazette*.

By the late nineteenth century, Pittsburgh was becoming an industrial power. By 1890, the city's mills were producing two-thirds of the nation's steel and half of all the glass. As the city's population grew, new neighborhoods sprouted up throughout Pittsburgh, creating the need for better streets, water and sewer lines, public utilities, new bridges and streetcars to carry people from outlying areas to the downtown.

The political vacuum was filled by Christopher Magee and William Flinn, who together built a political machine by enlisting saloon owners, liquor dealers and grocers who became power brokers in the city's wards. Magee went to New York City and studied Tammany Hall. The Magee-Flinn hold on Pittsburgh politics stretched from the late nineteenth century into the early twentieth, enriching them at the public's expense, according to "The Machine Age—History of Modern Municipal Politics," published by the *Pittsburgh Post-Gazette*. They were big-city bosses at a time when other urban areas were controlled by men like Boss Tweed in New York City, Martin Lomasney of Boston, George Cox of Cincinnati, Israel Durham of Philadelphia and Abraham Ruef of San Francisco.

The machine's growth was aided by immigrants in need of social and economic help and businessmen who needed to curry favor with the Magee-Flinn political machine if they wanted to do business in the city, according to Bruce Stave's *The New Deal and the Last Hurrah: Pittsburgh Machine Politics*. The immigrants expressed their appreciation by their votes and businessmen by fattening the war chests of office holders with campaign contributions and bribes. Industrialists ordered their employees to vote for machine-backed candidates or face firing. This combination allowed Magee-Flinn to remain in power. "The machine was simply the political expression of inner city life," wrote Stave, and "reform was a movement of the periphery against the center."

Corruption continued throughout the 1920s and into the '60s as reformers seemed unable to stop gambling, murders, prostitution, voter fraud and persistent political exploitation despite the best efforts of honest men to stop it. Mayor Lawrence looked at vice as the cost of doing business

in a big city and tolerated corruption as long as it didn't detract from his political agenda.

Howard Williams, executive secretary of the League for Independent Political Action, told a gathering of city business leaders that Pittsburgh rife with corruption. "I put Pittsburgh down as one of the most corrupt cities in the United States," reported the *Pittsburgh Press* in 1932.

1

CAPTAIN "SMILING JOHNNY" KLEIN

*P*ittsburgh councilman Captain "Smiling Johnny" Klein's first mistake was waving six crisp $5,000 bills in front of Ernest Lee Frey, whose eyes bulged at the sight of so much cash. Klein's second mistake was boasting about how easy it was to get rich in politics. "It comes easy in council," Klein said. "Oh, we councilmen don't have any trouble making money," according to a 1910 account in the *New York Times*.

An angry Frey told city auditor Frank Kimball, who told Mayor George W. Guthrie, who told A. Leo Weil, head of the Voters' Civic League, who told President Theodore Roosevelt, who dispatched a banking regulator to the city to investigate the link between Pittsburgh City Council and the selection of several banks as the depositories for city funds. The banks bribed Klein and other councilmen to handle the city's accounts.

The Voters' Civic League was formed in 1902 to investigate the backgrounds of candidates for city and Allegheny County political offices after the demise of the Magee-Flinn political machine. No one knew where the league got the money to fund its work, but speculation centered on Andrew Carnegie and the Rothschild banking family, which had business interests in Pittsburgh, according to the *New York Times*.

Klein was known as "Captain'" because he owned several excursion boats operating on the Monongahela, Ohio and Allegheny Rivers. He was a "wharf rat" who got into politics at a time when Pittsburgh was ruled by Christopher Magee and William Flinn during the last two decades of the nineteenth Century. By 1900, Klein was a councilman whose irrepressible smile became his trademark.

Pittsburgh was becoming an industrial power by the end of the nineteenth and early twentieth centuries according to the Pittsburgh Chamber of Commerce, which published "Pittsburgh the Powerful" in 1907. Six million tons of iron ore and three million tons of coal were produced each year. The city was home to major corporations: the Pittsburgh Reduction Company, which later became ALCOA, U.S. Steel, Westinghouse Electric and H.J. Heinz. There were thirty thousand coke ovens stretching for miles and more than nine hundred mines producing coal that fueled the furnaces of the region's steel mills.

The city was becoming a modern metropolis. Electricity paved the way for the creation of an electric trolley system that connected distant neighborhoods with the downtown business district. Telephones were installed in homes, and electric light bulbs brightened the darkened city. The city was populated by Slavs, blacks, Jews and Italians, but it was the controlled economically, politically and socially by Scotch-Irish Presbyterians.

A few days before Klein waved the money in Frey's face, city council voted to designate six Pittsburgh banks—the German National Bank, the Columbia National Bank, Workingman's Savings and Trust, the Fruend-Hoffstot, the Farmers Deposit National Bank and the Second National Banks—as depositories for $4 million of taxpayers' money. The votes didn't come cheap. The banks ponied up $102,500 in bribes for councilmen to ensure the measure passed. Klein met two officials of one bank in their offices. When one of the men returned from a vault carrying a shoebox containing $17,500, the two left Klein alone in the room. When they returned, the money and Klein were gone.

That was too much for Mayor Guthrie, who campaigned in 1906 on the promise to rid Pittsburgh of graft and corruption. Guthrie, who would later become U.S. ambassador to Japan, refused to tolerate even the hint of wrongdoing. After Deputy Public Safety Director Samuel J. Grenet was acquitted of vote fraud in 1907, Guthrie demanded his resignation. Grenet had been charged along with several others with distributing tax receipts to unqualified voters. In those days, to vote, an individual needed to produce a tax receipt. Grenet was accused of acquiring hundreds of bogus tax receipts, passing them out to individuals who could not vote and driving them around town to vote in different precincts for candidates Grenet was supporting. Even though Grenet was acquitted, he resigned—but was hired the next day as a mercantile appraiser by city council.

When police refused to crack down on speakeasies, saloons, gambling houses and brothels, Mayor Guthrie called police officials on the carpet and

demanded an explanation. Assistant Police Superintendent John Glenn was personally questioned by the mayor about a hideout that was home to a group of "yeggs," an old reference to safecrackers, and why police never made any efforts to arrest them.

"Did you know about the 'yegg' resort at 105 Grantham Street?" Guthrie asked. "Yes, sir," Glenn answered. "How long did you know it was there?"

"About eight years," Glenn replied.

"Wasn't a certain amount of money paid every week by the yeggs to allow this place to run?"

"I knew nothing about it," answered Glenn.

City council blocked Guthrie's reform measures by overriding his vetoes to keep the financial spigot flowing. City council was a bicameral body and, until 1911, an unruly bunch of one hundred members. There were sixty common councilmen who were elected based on the amount of taxable property in a district and forty select councilmen who represented each ward in the city. Each councilman expected a piece of the action when it came to awarding contracts or adopting ordinances.

"You see," Klein testified, "we in councils discussed earnestly every ordinance that had a dollar mark on it. If a councilman thought there was something doing, he would come to me and say: 'Am I in? If not I'm going to squawk.' One of them told me he was going to tell Guthrie."

Weil, representing the Voters' Civic League, went to Washington, D.C., to ask President Roosevelt for help. Roosevelt dispatched federal bank examiner Harrison Nesbitt to Pittsburgh to investigate the banks. Nesbitt immediately began examining bank records. Meanwhile, Weil, a crusading reform-minded lawyer, arranged for private detective Robert Wilson of Scranton to come to Pittsburgh to lead an investigation into graft in Pittsburgh. Wilson helped clean up graft in Scranton for the Scranton Municipal League by posing as E.S. Dolph, the owner of a lumber company, who wanted to sell Pittsburgh wooden street-paving blocks. Wilson approached Klein, who said council would be glad to award Wilson a contract, but it would cost him some money.

Wilson was an itinerant preacher who arrived in Scranton from Elmira, New York, preaching on the back of a "gospel wagon." He was a machinist by trade but also worked as a stoker and roustabout on riverboats. He opened a rescue mission and began railing against the hundreds of saloons and prostitutes working in the city. He associated with the Scranton Municipal League, became a private detective and began gathering evidence against corrupt councilmen, brothel owners and gamblers.

"He is never angry; he is utterly without fear. He is a man of superb physical proportions, quick and agile as a panther but cool as ice," wrote the *Outlook*, a religious magazine published in 1900 in New York City. Wilson said he prayed before starting every investigation.

"I take my Bible and concordance, go up in a garret and say my prayers," he told the *American Magazine* in 1919, "and look up every reference on the subject of graft. I read them over and over till my mind is full of them, and then, I go down to city hall and hunt a grafter." Wilson once single-handedly raided a gambling den in Scranton when the group rushed him until someone recognized Wilson and warned, "Look out, boys, it's Wilson." The men quickly retreated, and he ushered them to jail.

Wilson rented adjacent rooms at the Duquesne Hotel in preparation to meet with Klein, drilled holes into the door and placed paper cones in the holes so stenographers could listen and record every word of the conversation he had with Klein. "When I get the money, I go out among the boys and distribute it," Klein told Wilson.

Klein was the conduit for payoffs to his colleagues. Sixty councilmen met in secret at a hotel to discuss the passage of bills and determine the cost of selling their votes. They put the bribes into a common pot, and each member drew his share. After Klein promised Wilson's company would be awarded the paving contract, he told Wilson there were eighty-eight councilmen who would have to be taken care of. Klein received between $40,000 to $45,000 in payoffs to be distributed to his colleagues, according to the *Pittsburgh Post*.

That conversation led to indictments of Klein and two bankers. Wilson agreed to pay Klein $3,000 to win the contract, but the two also discussed future payoffs in which bribes would be mailed to fictitious recipients outside Pennsylvania. Klein boasted to Wilson that graft "isn't an art. It's a science," according to accounts of his trial.

Pittsburgh was rife with corruption and filled with gambling dens, speakeasies and houses of prostitution even before Smiling Johnny Klein became embroiled in scandal. In 1886, city council investigated allegations that a businessman had bribed Councilmen David W. Llewellyn and General C.L Fitzhugh to pass an ordinance that would allow the installation of a railroad switch at a business so the politically connected owner, T.C. Jenkins, would have an easier time shipping his product.

Jenkins allegedly promised to pay $6,500 cash and stock in his company if the ordinance was adopted. Reporters hounded Jenkins, who denied any wrongdoing. "I will not be drawn into a discussion of this matter through the newspaper. Good day," he told the journalists.

Later, Jenkins said the only money he offered to pay was $100 in legal costs for drawing up the proposed legislation. "Have you any reason to believe the money was paid for passage of the ordinance?" Jenkins was asked. "I have not. No one has told of any. I never said that any money had been paid for the passage of the ordinance," said Jenkins.

Council subpoenaed the business managers of the *Pittsburgh Post*, *Commercial Gazette*, the *Penny Press*, the *Pittsburgh Leader*, the *Pittsburgh Dispatch*, the *Pittsburgh Times*, the *Chronicle-Telegraph* and the German-language *Freiheits Freund* to ask if they had been paid money to influence the vote through news stories. One reporter said he was offered $500 for writing a supportive article but declined the money, according to the *Pittsburgh Daily Post*.

When A.M. Beyer & Company wanted the city to vacate a street so the company could expand, an employee delivered a shoebox containing $10,000 to Dr. W.H. Weber, who was president of council. According to a grand jury report, Klein took $6,000 to distribute to his colleagues. Council approved vacating another street to help the Pennsylvania & Lake Erie Railroad. When news of the investigation leaked, investigators were offered $250,000 to drop the graft probe, per the *Pittsburgh Press* and *Pittsburgh Daily Post*.

Klein was arrested but said the evidence against him was circumstantial. The *Pittsburgh Press* reported on his interrogation: "How about your confession?" asked a detective. "Oh, there is nothing against me except circumstantial evidence," he said. "I'm not guilty. This has been a grave mistake."

He said the charges would have no effect on his reelection campaign for city council. "This will not affect my candidacy in the least. I will be out hustling in the morning as usual." His colleagues were indignant. "It's simply a mean political trick," councilman W.H. Melany said. "I have never been approached by any persons or person on any subject or for any cause. Nor have I ever been promised or received compensation."

Mayor Guthrie was surprised by Melany's arrest. "I have always thought you to be an honest man and if you haven't been, you fooled me." Melany responded to the mayor: "I have lived a clean, honest life and have not been influenced in my business or political dealings by any promises of reward, either financial or otherwise."

"My skirts are clean. I don't know why I'm arrested with this bunch," said Jacob Soffel Jr. "I don't know why they put me in this crowd." Councilman Hugh Ferguson said he was "all at sea." T.O. Atkinson said, "I am not guilty. I am willing to abide by the outcome." Councilman William Brand had no comment.

Weil, of the Voters' Civic League, was pleased with the results of the investigation and indictments: "We won't need 'squealers' to win our case against accused councilmen. We have plenty of evidence, enough to justify more arrests and prove every charge we will bring against those arrested. We feel comfortable with the outcome," he told the *Pittsburgh Press* in 1908.

Smiling Johnny went on trial in 1909. During the testimony, county detectives arrested five men lurking in the courthouse hallways trying to bribe jurors, according to a dramatic account in the *Pittsburgh Press*. "You will see enough jury fixers to start an army," said a detective. Ernest Frey was the first witness to testify and told the jury his brother-in-law Albert Brahm witnessed Klein display the $30,000. Another witness testified he saw Klein flash another $1,700 in bribe money, all in tens and twenties.

The banking scandal involved Klein; W.W. Ramsey, a bank president; and August Vilsack, a bank cashier. Klein told Ramsey he was a friend of Vilsack and wanted to do Ramsey a favor in return for $102,500. During Klein's trial, defense attorneys argued it was Vilsack who approached Klein, not the other way around.

Council approved a contract to Wilson's bogus firm to pave streets with wooden blocks in return for a $17,500 bribe. When another councilman went on trial, defense attorney John Marron argued in his closing that "the testimony that Klein had six $5,000 bills is a downright fabrication" and called Klein "a miserable little weasel."

He continued:

> *Place no credence in Klein's words....If he is not out of his mind, he is surely on the road. This man cannot distinguish between right and wrong so far as the consequences are concerned. He appreciates no difference between truth and falsehood. Are you going to accept the testimony of this little pervert? He knows nothing but to tell lies. This little rat—to add insult to injury—tried here yesterday to ruin the reputation of the cleanest, noblest man in Allegheny County.*

District Attorney William Blakeley told the jury in his closing argument, detailed in the *Pittsburgh Sunday Post*, that Klein was at the center of the scandal ferrying cash to his colleagues for their votes:

> *The man who gives a bribe is culpable but he is not more culpable than is the man who takes a bribe. When the man who takes a bribe is a man elected by the people because they trust his honesty. When a man elected to*

public office sells his trust he becomes as dirty as a criminal as the man who offers him money. And we got a man who took the bribe—nay—more—a man who combined in himself the elements of the bribe giver and the bribe taker. This smiling innocent man know all about the payments made by other banks. I have no doubt that if he would open up he could tell all about it, the amount paid, who got it and how much his share was. Is it any wonder he was going about with big rolls of money in his pocket? He was the collector. Klein is the worst element in our civic life.

It took jurors only thirty minutes to convict Klein, who maintained his perpetual smile. "The war has just begun," he said. He was sentenced to three and a half years in the notorious Western Penitentiary on Pittsburgh's Northside overlooking the Allegheny River. Blakeley was amused by Klein's veiled threat that if he went to prison, he would take other councilmen with him. "Klein's irrepressible, a man we can't help but like," Blakeley said.

Klein stayed in a hotel the night before he was to surrender and begin serving his sentence. He walked across a bridge over the Allegheny River to Western Penitentiary accompanied by two detectives. When he arrived, the

Sketch of Western Penitentiary on Pittsburgh's Northside where "Smiling Johnny" Klein served his prison sentence. *Courtesy of Wikimedia Commons.*

prison refused to accept him because officials had not received a commitment order, so Klein called Blakeley. He also penned a note to the *Pittsburgh Press*, writing that even though he was going to be incarcerated, he "still wears the same old smile."

He wrote friends asking them to visit him. "I will be down by the river and if you're down that way, drop in." Whenever one of his boats passed the prison, the captains blew their whistles to let their boss know how business was doing. One toot meant business was good; two, moderate; and three, bad.

Blakeley wasn't done with Klein. He subpoenaed the diminutive Klein to testify before a grand jury that continued to investigate corruption in city hall. Klein refused to appear. "Klein will testify," Blakeley said. "Klein will not testify," said his attorney, John Robb Jr.

The *New York Times* said Klein's colleagues promised to take care of Klein's wife and twin sons while he was in prison, but they reneged on their promise. Smiling Johnny decided it was time to make a deal. "Why don't you give me a chance instead of sending me to the stone pile?" he asked the district attorney.

Klein faced a rough time behind the sprawling prison because he was a "squealer" and desperately wanted parole. He mailed postcards to his political friends, lobbying for help in obtaining parole. "Won't you someday assist in having me paroled after you think I have been sufficiently punished?" Klein wrote, according to the *Pittsburgh Daily Post*.

He decided to implicate his former colleagues. His change of heart triggered a rush by the others to clear their consciences by admitting their roles in the bribery scandal. "City Lawmakers March to the Bar of Justice and Confess their sins," read a headline in the *Gazette Times*. Klein gave prosecutors a detailed statement that Weil called "one of the most remarkable documents that I had ever seen." His memory was just as remarkable, said Weil. Klein's confession led to forty-one indictments of councilmen and several bankers. Councilman Wasson was the next to confess, and another thirty-one targets followed suit. Wasson appeared in court, tears streaming down his face, and had to take back his claims of innocence and admit he accepted money from Klein.

Klein's former colleagues stood in line to confess, hoping for leniency if they did. Councilmen recounted how they collected money on liquor sold at brothels and payoffs from gamblers and a share of the money spent a speakeasies and saloons. Prosecutors also investigated ties between one councilman and a white slavery ring that shipped prostitutes to Pittsburgh.

Klein's critics speculated that he aided the prosecution because they had more to offer than his former colleagues.

One rumor making the rounds at city hall was that the defendants had pooled together $100,000 to buy Klein's silence. Another was that Weil and Blakeley had offered $25,000 and a pardon if he cooperated, according to a headline in the *Pittsburgh Press*, "Was 'Johnny Klein' Bribed to Confess?" Klein was pardoned after serving half of his sentence.

Some of his fellow city councilmen were so greedy that Klein said one member received $25,000 in bribes but only turned over $15,000 to the kitty to which all councilmen were expected to contribute. Another, Klein said, received $60,000 and kept every penny. Blakeley said Klein's confession showed "a condition of corruption that was truly startling," according to an account in the *Press*.

Disgraced politicians began lining up to enter pleas of "no contest," which carried the same weight as a guilty plea after Pennsylvania attorney general M. Hampton Todd said there would be no pardons for grafters. A.V. Simon got four months in prison and a $200 fine. Vilsack, the bank cashier, was sentenced to eight months in prison and fined $5,000. Charles Stewart also received eight months and a $500 fine. Dr. W.H. Weber got six months and a $500 fine.

Hugh Ferguson was sentenced to four months and a $250 fine by a reluctant Judge Thomas Frazer, who said he had known Ferguson "for a long time…still he was a shareholder for the bank pool and kept the money in a safe deposit box, rented by him." Ferguson's attorney, John Marron, said his client was the "loneliest man in the city. His wife died some time ago and he is a one-man business. Any sentence will ruin his business."

Frazer sentenced Morris Einstein to six months in jail and fined him $2,500. "I have known him for a number of years," added Frazer, "but I realize I must do my duty." P.B. Kearn received a four-month sentence and a $250 fine. Councilmen William Melany and Jacob Soffel Jr. were found not guilty. Testimony revealed Soffel was offered $5,000 for his vote but rejected the offer.

Weil continued his probe into graft and corruption. After Klein had spent 550 days in jail, Governor John Tenner pardoned the informer, who swore off politics. "I helped give old Pittsburg a black eye," he said. "Now, I am out to boost the town," he told the *Pittsburgh Press* after his release.

A smiling Klein walked out of the penitentiary and was met by reporters and photographers. He told them he was going to focus on his riverboat business, which his wife had been managing while he was away. "I'm going

to forget the past and start anew," he told a *Pittsburgh Press* reporter. A photographer asked Klein to pose for a photograph. "No use in a fellow trying to get away from the newspaper men," he said.

Weil continued to rail against corruption and campaign for good government for the rest of his life. He once spoke to a group of New York reformers about the story of graft and corruption in Pittsburgh, leaving them with one thought: "When they shall hear the voice of the city calling aloud to its people, 'deliver us from evil, thine is the glory,' then the problems of city government will have solved itself."

Klein's riverboat excursion business continued to prosper, as he purchased more boats hauling passengers and cargo from Pittsburgh to New Orleans. After working on the river for fifty years, Klein died of a heart attack at his home in 1945. He was seventy-five. The *Pittsburgh Press* recounted his exploits but never mentioned the scandal that rocked Pittsburgh and city council during the first decade of the twentieth century.

LITTLE CANADA

*A*cross the Allegheny River from downtown Pittsburgh, where PNC Park, Heinz Field, the Andy Warhol Museum and the Carnegie Science Center are now located, lived some of the most famous criminals in the nation, who found a safe haven in the lower wards of the Northside known as "Little Canada."

Hobnail Riley, English Bill, Dutch Alonzo, Dice Box Miller—not to be confused with Shoebox Miller—Chicago May, Sheeny Mike, Fainting Bertha, Windy City Walsh, Baltimore Harry, Sleepy City Jake, Praying Mary, the Albany Kid and Dick the Waltzer found sanctuary in Little Canada while on the lam.

Little Canada was a neighborhood within Allegheny City before Allegheny City was annexed by Pittsburgh in 1907 and renamed the Northside. It was created in 1787 and became a borough in 1828. When Pennsylvania expanded the canal system linking Philadelphia with Pittsburgh and Erie, the state created the Pittsburgh channel linking Allegheny City by way of the Kiski and Conemaugh Rivers, according to a 2007 account in the *Pittsburgh Post-Gazette.*

The neighborhood was a rough-and-tumble place filled with brothels, speakeasies and saloons and served as home to safecrackers, thieves, pickpockets, prostitutes and con men who lived unmolested by police provided they followed the unwritten rule "leave Allegheny alone" and committed their crimes elsewhere.

Allegheny City Post Office, longtime landmark that was built in Allegheny City before the area became part of Pittsburgh's Northside. *Courtesy of Wikimedia Commons.*

If you broke the rule, you likely ended up in a dungeon-like cellblock in the basement of the Allegheny City Police Station. The cellblock, built during the Civil War, was found when workmen began razing the structure in 1937. A heavy door at one end of the corridor cut off all light and made breathing difficult. A story in the *Pittsburgh Press* said it "rivaled the black hole of Calcutta."

The neighborhood got its moniker because a crook was as safe in Little Canada as if he were in its namesake to the north. "The law of the state and nation stopped on the north banks of the Allegheny and Ohio," read one story. Little Canada was "notorious as the playground of the criminal element and leaders of the vice and booze syndicates" reported a Pittsburgh newspaper. This motley assortment of criminals, madams and prostitutes worked in 150 brothels, which newspapers referred to as "resorts."

Little Canada and Allegheny City existed a century before Pittsburgh absorbed them. Among the residents who lived in Allegheny City were Andrew Carnegie; H.J. Heinz; novelists Gertrude Stein, Willa Cather and Mary Roberts Rinehart; dancer and choreographer Martha Graham; poet Robinson Jeffers; and actor William Powell, who was known for playing the "Thin Man" in a series of detective films. George Ferris, inventor of the

Ferris wheel, and Charles Taze Russell, founder of Jehovah's Witnesses, also lived there at one time. Art Rooney Sr., who founded the Pittsburgh Steelers, was raised in Allegheny City, where his father owned a saloon.

The city encompassed eight square miles and had a population of 125,000, making it Pennsylvania's third-largest city at the time. Today, the Northside includes the neighborhoods of Allegheny Center, Brighton Heights, Fineview, Manchester, Perry North, Perry South, Troy Hill, Spring Garden, Marshall-Shadeland and Northview Heights.

Its reputation for lawlessness and corruption continued into the 1920s, as politicians and police turned a blind eye to vice in exchange for cash. Pittsburghers looked down on their neighbors across the Allegheny River—especially the residents of Little Canada, said William Rimmel, a longtime reporter for the *Pittsburgh Post-Gazette* who was born in Allegheny City and wrote frequently about his hometown. "To them [Pittsburghers] it meant the underworld—the home of 'Little Canada'—a haven for thieves and the tenderloin of the district."

Josiah Flynt Willard, an author and sociologist, was hired by the *Pittsburgh Gazette* to study the underworld of Allegheny City. He spent a week visiting brothels, speakeasies and gambling dens rubbing elbows with pimps and thieves such as Farmer John, Nosey Steel, Kid Taylor and Skinny Ellsworth and concluded criminals resided in Allegheny City thanks to police protection.

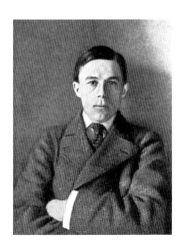

Sociologist Joshia Flynt Willard, who came to Pittsburgh to study vice. *Courtesy of Wikimedia Commons.*

"In Allegheny, it is permitted thieves to take up habitat and they live there unmolested," he wrote in 1901. "I know of no other community of the size of Allegheny which is so littered up with thieves and people of low class."

In an editorial, the *Pittsburgh Gazette* lamented the unsavory reputation of Allegheny City in general and Little Canada in particular: "Allegheny had been dragged into the mire of vice and graft until its good citizens are sick at heart."

Allegheny was heavily populated by people of German descent who drank beer at taverns and listened to music from German bands. Street preachers urged pedestrians walking along Federal or East Ohio Streets to start thinking about salvation, recalled Rimmel.

The *Gazette Times* reported about a spate of suicides in Allegheny City that prompted a poem: "What's this? Another dangling rope? Another brother bowed with toil and grief has shuffled off to Allegheny." There were so many suicides by hanging that one councilman unsuccessfully introduced a bill banning the sale of rope on dark and rainy days, Rimmel said.

At the center of Little Canada was a saloon operated by Jimmy McKay on the corners of Federal and Robinson Streets near where Allegheny Landing and the statute of Roberto Clemente are located. McKay's saloon was known as the "capital of crookdom" because criminals planned their crimes or hid their stashes in McKay's safe after pulling a job. "Jimmie's was literally one's home away from home for the elite of the underworld of crime," wrote Pulitzer Prize–winning reporter Ray Sprigle of the *Pittsburgh Post-Gazette*.

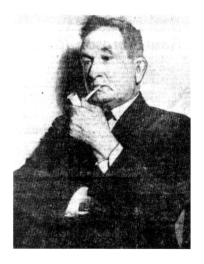

Jimmy McKay, whose saloon in Little Canada was known as the "capital of crookdom." McKay provided a home away from home for criminals on the lam from police. They knew they were safe in Little Canada as long as they didn't commit any crimes there. *From the* Pittsburgh Post-Gazette *Archives.*

A safecracker known as the Big Swede stole some diamonds in Minneapolis and came to Little Canada to hide. He asked McKay to stash the jewels in his new burglar-proof safe. While McKay was away, Big Swede needed the diamonds and cracked the safe, angering McKay, who called the company he bought the safe from, demanding his money back. "What good is a safe that all my customers can open quicker than I can?"

Jimmy arrived in Pittsburgh from Ireland at the age of eleven, one of thousands of Irish immigrants who came here to work in the mills and mines and on the railroads. He quit the mill, purchased a saloon and became a ward boss and confidante of criminals and politicians who frequented his establishment. Reporters drank free champagne on Christmas Eve and, when they left to retrieve their hats, found a crisp new twenty-dollar bill tucked in the sweatbands.

Journalists rubbed elbows with thieves such as Eddie Guerin, who was the first man to escape from the French penal colony Devil's Island. Guerin once robbed the payroll of the *Pittsburgh Commercial Gazette* and a railroad ticket office. He fled to Little Canada but was nabbed and sentenced to Western

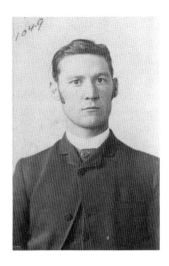

Eddie Guerin, Pinkerton Detective Agency mug shot. *Courtesy of the Library of Congress.*

Penitentiary. After he was released, Guerin moved to Europe, robbed a bank in England and was convicted and sentenced to eighteen years in prison.

He escaped a British prison and made his way to France, where he robbed an American Express office in Paris—located across the street from a police station—of $10,000 in gold. He was arrested, tried, convicted and sentenced to life at hard labor in French Guiana. French Guiana was the home of Captain Alfred Dreyfus, a French army officer convicted of treason in 1894. Supposedly, Guerin's escape was hatched in the backroom at McKay's by his lover, Chicago May Churchill, who was known as Mary Anne Churchill Sharpe and working as a prostitute and pickpocket when she met Guerin at the world's fair in Paris in 1900. Chicago May billed herself as "queen of crook." She was born Mary Anne Duignan in Ireland and lived a life of hard work and poverty until she stole her parents' life savings and fled to America.

Chicago May, who had red hair and blue eyes, provided the money, according to Sprigle, to bribe the guards to allow Guerin to flee the fever-ridden island—it had a jungle infested with venomous snakes and was surrounded by water containing man-eating sharks. Guerin and two other prisoners hacked their way through the dense jungle, found a boat waiting for them and set off into the darkness in the shark-infested ocean and made their way to Dutch Guiana, which is now Suriname, where they lived in the jungle for six weeks before reaching Georgetown, Guiana. Money provided by Chicago May allowed Guerin to buy passage on a steamer to New York.

In 1924, Guerin sold the story of his escape, detailing how Chicago May traveled to Cuba, where she hired three men to spirit her lover off the island. "Chicago May is waiting for you in Paramaribo. This afternoon another convict will be buried as Eddie Guerin," quoted the *Pittsburgh Press.* Guerin was working in the insect-infested jungle when a guard unlocked his shackles. Guerin died in 1940 at the age of eighty and was buried in a pauper's grave. His former mistress died in Philadelphia in 1929.

When the Allegheny River flooded its banks, McKay formed the Piano Movers Association, with the help of patrons and journalists, and moved

Annual flooding on the lower wards of Allegheny City prompted Jimmy McKay to create the Piano Movers Association to lift pianos at the brothels of Little Canada to higher ground. *Historic Pittsburgh Collection.*

pianos at the brothels out of the reach of the floodwaters. McKay also was responsible for turning out the vote on election in his ward. He rounded up various criminal types and made the rounds of polling places before breakfast, after lunch and again after dinner. McKay eventually sold his business and became a detective in Allegheny City and later for Allegheny County. Who knew better the ways of criminals. Ironically, McKay was arrested and charged with extortion, ending his law enforcement career.

Corruption among elected officials and police allowed Little Canada to exist. Reformers complained that prostitutes walked the streets "in short dresses and smoking cigarettes. You can see drunken women come out of drinking places and because policemen are frequently seen nearby it is evident to me that the police department is part of the scheme," complained Dr. Charles Dillinger, a city councilman, to the *Pittsburgh Post.*

Dillinger hired private detectives to gather evidence of corruption, but Allegheny City policemen arrested them to thwart their investigations. Clergymen complained that Sunday church attendance was down because of the unsavory characters that trolled the streets. When an Allegheny County grand jury convened, members heard testimony that as many as one hundred sporting houses operated unmolested because they were under police protection.

Politicians and police officers conducted vice raids in Little Canada but only after pressure from ministers forced them to act. Cops ignored subpoenas for gamblers' court hearings, prompting Mayor William Kennedy to express surprise that gambling existed in Allegheny City. "I am surprised to learn of the existence of gambling dens in Allegheny City as I thought it was free from such evils," he told the *Pittsburgh Commercial Gazette* in 1894.

Poor Irish immigrants lived in the lower wards of Allegheny City, while Pittsburgh's millionaires moved to what they considered the suburbs and built ornate mansions along Ridge Avenue, known as "millionaire's row." Ridge

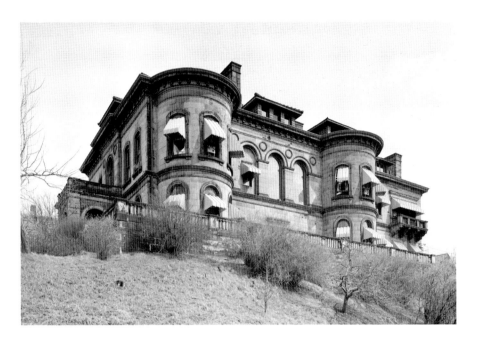

One of the mansions on Millionaire's Row on Ridge Avenue in the Northside. In the late nineteenth century, Allegheny City had more millionaires per capita than any city in the world. *Courtesy of the Library of Congress.*

Avenue went from being a dirt road to a street lined with stately mansions that were home to the richest industrialists in the city. In 1888, A.M. Buyers built a home with ninety rooms, including fifteen bathrooms. Ridge Avenue was the center of Allegheny City's social world. Lines of carriages pulled up to mansions for weddings and parties. The area was populated by families with the names Jones, Laughlin, Phipps, Scaife, Oliver and Denny. B.F. Jones, of Jones and Laughlin steel fame, built a forty-two-room mansion while J.B. Oliver, another steelmaker, constructed a thirty-room palace.

On the lower rung of Allegheny City's social ladder were the world-famous crooks who lived in Little Canada. Dutch Alonzo, whose real name was Alonzo Henn, was a world-class con man who stole millions in the United States, England, Canada and Switzerland but died penniless. Henn's alter ego was "Count Papenheim" in London or "Luke Swith," a Texas oilman, in the United States. He spoke German-accented English. He was sentenced to two years in a Swiss jail for burglary and robbed a bank messenger in France. Alonzo killed himself by swallowing poison.

Hobnail Riley escaped from Pittsburgh's Central Police Station when a girlfriend dropped a rope so he could climb up onto the roof and escape.

He was arrested two days later and sentenced to nine years in Western Penitentiary on the Northside. Riley's eyesight began to fail as he grew older, and he was unable to pick a pocket with ease because his fingers were no longer nimble.

At sixty-eight, he was desperate for money, so he went into a department store and stole a handbag without anyone noticing. Then he stole a second one and was amazed when no one noticed, so he turned himself into a detective that he knew. "I'm ashamed of myself. I know theft in a store is petty larceny but the old fingers just won't work," he said. "I just want a warm place for the short time left."

Riley appeared in court to plead guilty but the judge berated the detective for arresting an elderly man who should be cared for, not prosecuted. "But judge," the detective replied, "he did this job to get arrested." When Riley reached the gates of Western Penitentiary, a familiar guard was there to greet him. "Welcome home, Hobnail," read an account in the *Gazette Times*.

Dice Box Miller went to prison for the last time when he was seventy. He had been arrested for stealing a fifty-cent item from a variety store. Miller had pulled jobs in France, Germany and Belgium. Ed Brant robbed a Philadelphia department store of $40,000 and was hiding out in Little Canada when he was nabbed. He went on a twenty-two-day hunger strike while in jail and began acting insane so the courts ordered him released. He was arrested a second time and placed in an insane asylum. He escaped two weeks later and never was seen again.

English Bill, whose real name was William Edward Raymond, used the aliases of Sir Edward Raymond, Sir George Bartlett or Louis Haverstraw to pull jobs in St. Louis, San Francisco, London, Berlin, Paris and Melbourne. He once told a journalist that being a swindler was a difficult job. "It is a strain on the brain. He has to study and work. He may have the genius to develop it just as in any other crime."

Little Horace Hovan was a famous yegg, a safecracker who burglarized a Pittsburgh bank of $12,000. He was caught, convicted and sentenced to three years in prison. He escaped, robbed a bank in Charleston, West Virginia, and was placed in a hospital, where he escaped again and made his way back to Little Canada. Hovan designed a cane with a spring running through the shaft that was attached to a pair of tweezers hidden in the bottom. He would enter a bank, distract the teller, reach the cane across the counter and pick up wads of cash with the tweezers.

Fainting Bertha fainted during court appearances to avoid going to jail. Bertha's real name was Margaret Reilly, and her mug shot adorned the walls

of every police station from New York to San Francisco. Tall, blonde and blue-eyed, Bertha spoke in a tone of voice barely above a whimper and would fall to the floor when arrested.

Once, she was caught in a city department store with her hand in another woman's purse. When she was brought before a judge, she began to sob. A detective who arrested her nudged a reporter. "Now watch Bertha put on her act. She'll cry and faint her way right out of the building." A short time later, Bertha was released, according to an account in the *Post-Gazette*.

As she approached old age and was no longer blonde, Bertha was arrested in another department store and became indignant when she was nabbed: "The idea of questioning me like this. Why I'm 69 years old. You can't treat a poor old woman like this." The next day, detectives were looking at police photos and realized they had let Fainting Bertha slip through their hands. They bemoaned to the *Post-Gazette*: "We had Fainting Bertha and let her cry her way out."

Praying Emma preyed on churchgoers while Scissors Mary stole purses by cutting off the straps of handbags. Criminals were vain about their nicknames and jealously guarded their monikers from interlopers. "Weeping Mary," who broke into tears every time she was arrested, got into a brawl with a woman known as "Weeping Agnes." Fingers Sullivan fought Fingers Maguire over the right to use the name.

English Bill and Sheeny Mike were attempting to rob the Second National Bank in Pittsburgh. They tied and gagged the night watchman and were working on opening the safe when they heard a knock on the window and fled without the money. The knock came from the watchman's son, who routinely stopped by to spend time with his father.

Ben Brill led a gang of burglars who returned to Little Canada after their heists. Brill was arrested in 1883 and sentenced to thirteen years in the penitentiary. After he was released, he was beaten to death in what the *Pittsburgh Post* called a "probable murder"—Brill still was alive but barely, according to the newspaper.

The nicknames also denoted a criminal's specialty. Dick the Waltzer worked dance halls while Steamboat Murphy worked the boats along the Allegheny, Monongahela and Ohio Rivers. Mother Murphy ran a gang of street urchins who picked the pockets of pedestrians in Allegheny City and returned each night to deposit their take with her. Police referred to Murphy's boardinghouse as the "buzzard's roost."

Mary Ann Worley was known as the "Queen of the Dirty Dozen," even though her gang of female pickpockets only numbered six. A member

would pretend to faint on the street, and when a Good Samaritan came to her aid, the woman picked the man's pocket. A member of her gang, Mary Ann Quinn, was convicted and sentenced to the penitentiary where her son, Grover Cleveland Quinn, was born.

Gambling was rampant in Allegheny City. The police protected gambling joints and were reluctant to raid these places because the officers needed the extra income to supplement their meager salaries. Police Chief John Murphy was accused of accepting bribes after a local gambler testified he paid Murphy $1,200 for protection.

In the late nineteenth and early twentieth centuries, New York City, Boston, Detroit and Chicago grew through annexation of outlying municipalities. Allegheny City was annexed by Pittsburgh in 1907 after a vote, but the anti-annexation forces mobilized Little's Canada's criminal element to "vote early and vote often" in hope of defeating the measure. "Each highway man, forger, pickpocket and others of the underworld clan is under instruction to defeat annexation," reported the *Pittsburgh Post*. Money was flowing from the underworld into the pockets of opposition forces.

A prior state law required a majority vote in both Pittsburgh and Allegheny City to approve any merger, but a new law was enacted that required a majority of the total votes cast. Pittsburgh passed the measure unanimously, while Allegheny City rejected annexation by a 2–1 margin. Allegheny City appealed, but Pittsburgh carried the day in a case that went all the way to the U.S. Supreme Court, which rejected Allegheny's appeal.

By World War I, many of Little Canada's criminals had left town, were in prison or went straight by getting jobs in defense plants. One criminal arrived in Pittsburgh one step ahead of the police and asked another thief, "In which direction is 'Little Canada?'" "There ain't no more 'Little Canada,'" said the man. "Little Canada is off the map," reported the *Daily Post*.

BOOTH & FLINN

The Company that Built Early Pittsburgh

Who made the world?
God made the world
Who filled it in?
Booth & Flinn

Schoolchildren recited this poem about the politically connected firm of Booth & Flinn Ltd., which played a role in nearly every major building project in the late nineteenth and early twentieth centuries, helping transform Pittsburgh from a city of dirt-covered and trash-filled streets into an urban center.

The story of Booth & Flinn also is a tale of corruption and bribery. The firm prospered through backdoor political wheeling and dealing orchestrated by the infamous William Flinn–Christopher Lyman Magee political machine that ruled Pittsburgh from the 1870s through the early twentieth century. The company became a leading builder in the state and nation until it was sold in 1951 and closed. It reopened in 1961 but closed permanently in 1968, never regaining its former stature.

The Magee-Flinn machine oversaw a period of urban growth that witnessed the development of a downtown, new businesses and neighborhoods, modern transportation, telephones and public amenities such as paved streets, water, gas, electric and sewage lines and clean drinking water.

The success of Booth & Flinn was aided by Magee's cousin Pittsburgh planning director Edward Manning Bigelow, known as "Bigelow the Extravagant," who steered millions of dollars' worth of city business to the construction company, making Flinn very rich. By the time he died in 1924, Flinn had amassed an $11 million fortune. As an engineer, Bigelow wrote bid specifications in such a way that guaranteed that city public works projects would go to Booth & Flinn.

Visitors to the city are surrounded by Booth & Flynn's legacy. The company built the Liberty, Wabash and Armstrong Tunnels and erected the Westinghouse, Manchester and McKees Rocks Bridges along with Ohio River Boulevard. Booth & Flinn drilled a hole through Mount Washington, creating the Mount Washington Transit Tunnel, which allowed the development of the Mount Lebanon, Beechview and Dormont communities in the South Hills. It removed a mountain known as Grant's Hill in the middle of Grant Street, enabling expansion of the downtown area. The company also built Highland Park, where Flinn lived. Even Pittsburgh's cobblestone streets were the product of work done by Booth & Flinn.

In 1895, Booth & Flinn constructed the Apollo Iron & Steel Company in the Armstrong County town of Apollo for steelmaker George Gibson McMurtry and developed McMurtry's utopian community of Vandergrift in Westmoreland County, which was designed by architect Frederick Law Olmsted. When the massive Johnstown flood devastated the Cambria County city, Booth & Flinn dispatched 1,300 men and 280 teams of horses to aid in the cleanup. In 1905, steel magnate Andrew Carnegie built Carnegie Tech, now Carnegie-Mellon University, on land donated by Flinn and Magee.

Booth & Flinn built the city's early water and sewage systems. By 1880, the company had installed the first natural gas lines for Pittsburgh and, by 1895, had begun laying track for electric streetcars. Between 1895 and 1910, the company installed underground utility lines for telephones and telegraph, allowing 30 percent of homes in the city to have telephones.

After Flinn's death, the company continued to prosper. In the early 1930s, Booth & Flinn won contracts to lay the foundations for the federal building and post office in Pittsburgh as well as the Gulf Building. The company was known nationally for building the Holland Tunnel beneath the Hudson River in New York City and part of the New York City subway system. It erected bridges in Rochester, New York, and Nashville, Tennessee, and sections of the Chesapeake Bay Bridge. It also constructed the Bethlehem-Fairfield Steel shipyard in Baltimore, Maryland; the Dravo

Shipyard, Bethlehem Steel, Carnegie-Illinois, Jones & Laughlin Steel and the Pittsburgh–Des Moines Steel Company on Neville Island—as well as sections of the Pennsylvania Turnpike.

By the late 1940s, Booth & Flinn's major clients included the B&O and Pennsylvania Railroads, the Blaw-Knox Company, Gulf Oil, H.J. Heinz, Equitable Gas, Mesta Machine Company, Republic Steel, Standard Oil and U.S. Steel. Booth & Flinn became one of the most prosperous companies in Allegheny County, with an annual income of $4 million.

The company prospered in the late nineteenth century because the city was unable to cope with the massive influx of immigrants arriving in the smog-covered city to work in the glass factories, steel mills, foundries and coal mines. As urban areas developed, so did the need for civic improvements. Pittsburgh absorbed the Southside in 1872. In 1907, it annexed Allegheny City, now the Northside, which boosted the population to more than 521,000. City fathers were faced with decisions about public improvements such as sewer and water systems, new streets and gas, electric and utility lines along with parks and bridges. The development of streetcars created new neighborhoods such as Highland Park, Squirrel Hill, Oakland and Shadyside.

Residents of these new neighborhoods traveled by horse-drawn streetcars to get from their homes to downtown until George Westinghouse founded Westinghouse Electric Company in 1886 and sent an electrical charge a distance of four miles—lighting four hundred lamps in downtown Pittsburgh. The discovery allowed Booth & Flinn to build an electric railway system crisscrossing the city. Flinn held interests in several trolley firms, and Booth & Flinn laid railway track that increased the distance streetcars could travel from 114 miles in 1890 to 469 by 1902.

Booth & Flinn also paved most of the city's streets using a special block that Flinn provided. Flinn saw to it that city contracts called for the use of "Belgian block," which was chiseled out of the Loyalhanna Gorge in the Chestnut Ridge near Ligonier in Westmoreland County, where Flinn owned a stone quarry. When a competitor opened a quarry near Ligonier that produced a similar block, Flinn arranged for Bigelow to specify the stone had to be gray-colored rather than the pinkish color of his competitor's. When Pittsburgh decided to cover its cobblestone streets with asphalt, Flinn went to Ventura, California, and drilled for oil to ensure a steady supply to make asphalt. That endeavor proved profitable for Flinn.

Flinn owned the California Asphalt Company in Ventura, which produced one thousand tons of asphalt a day for Booth & Flinn. He owned 60 percent of the company, while Booth & Flinn, which he controlled, owned the balance.

The Asphalt Trust, formally known as the General Asphalt Company, purchased Flinn's company in 1902, according to the *Asphalt Journal*. Flinn sold his holdings back to the trust, earning $715, 000 in profit for himself. Adjusting for inflation, that figure amounts to $19.2 million in current buying power.

Pittsburgh reformer Oliver McClintock, a member of the Citizens' Municipal League of Pittsburg, charged that Booth & Flinn "did abominable work while charging outrageous prices" for paving streets. When Governor John Tener inspected a street paving job on Liberty Avenue, he was appalled by the quality of the construction.

"The ruts and holes are a disgrace to a great city like Pittsburg," Tener said "I'm surprised that citizens have not sought out those responsible for the frightful condition of Liberty Avenue and taken them to court."

"If you want to be anybody or make money in Pittsburg, it is necessary to be in the political swim and on the side of the city ring," wrote muckraking journalist Lincoln Steffens in "Pittsburg: A City Ashamed" for *McClure's* magazine in 1903. "This is corruption but it is called 'good business' and it is worse than politics."

Pittsburgh was a dismal-looking city during the reign of Magee-Flinn. A visitor could taste the smoke from the steel mills and iron foundries in every breath. "Pittsburgh is a place where the inhabitants breathe, move and have their being in soot and crime," reported the *New York Daily Graphic* in 1882. The smoke was so thick "that a cyclone would only scare the people by making the sun visible for a few minutes." The *Century* magazine called Pittsburgh "the dirtiest city in America." Journalist H.L. Mencken, no fan of Pittsburgh even though his brother lived here and Mencken visited frequently, said the soil of the city was of a particular quality, "being composed of almost equal parts of coal dust, grease and garbage, and is plainly too rich for small plants."

Drinking water drawn from the Allegheny, Ohio and Monongahela Rivers was filled with slag and human waste. The temperature of the Monongahela River sometimes reached 120 degrees because of the discharge from mills. Raw sewage ran into the streets. The lack of clean drinking water in the late 1900s spread typhoid fever, which ravaged the city, afflicting over 5,600 residents and killing more than 600, according to a history of the Pittsburgh Water and Sewer Authority.

From its office on Forbes Avenue, the company employed three thousand workers plus seventy-five clerks. Allegheny County hired the firm to build the foundation for the Allegheny County Courthouse and Jail. The company

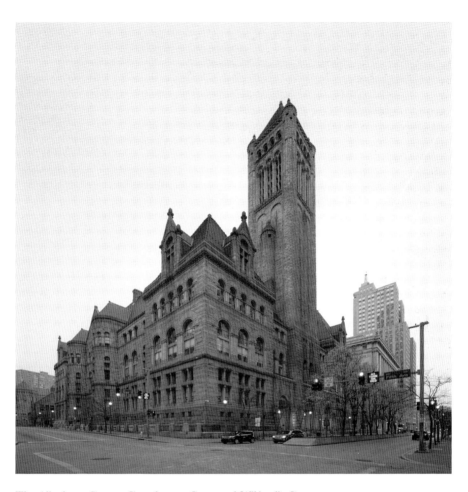

The Allegheny County Courthouse. *Courtesy of Wikimedia Commons.*

then shifted to building infrastructure such as water, sewer, oil and gas lines. By 1880, it had installed the first natural gas lines for Pittsburgh and, in 1895, had begun installing track for electric streetcars. Flinn's life was a rags-to-riches story. He quit school at nine and received an education on the streets of Pittsburgh's Sixth Ward, hawking newspapers, shining shoes and working as a bricklayer until his uncle "Squire" Tommy Steele, president of the city council, got Flinn a job in city government and he began his climb to power. Magee studied how state political boss Matt Quay ran Pennsylvania and the machinations of Boss Tweed and Tammany Hall in New York and then applied those same methods to Pittsburgh.

Flinn and Magee formed a political alliance in 1879 that dominated both Democrats and Republicans in the city, Allegheny County and the state legislature—sometimes with a deft political sleight of hand and other times by brute force, according to a 1912 investigation by the *Gazette Times*.

In 1887, Magee and Flinn orchestrated a change in the city charter by transferring appointment power from city council to department heads, whom they controlled. At the same time, state legislator John Upperman of Pittsburgh, a Magee-Flinn crony, introduced the Upperman Bill calling for construction of public works projects "that set the table for a veritable banquet table of public works."

"A political ring can be made safe as a bank," Magee once boasted.

By 1895, Flinn was a state senator and pushed a bill giving county commissioners authority to impose a two-mill tax on personal property to finance road construction. When the tax failed to generate enough contracts, Flinn introduced a measure to give the commissioners power to levy a 1 percent tax on real estate. That revenue would be used to finance construction projects that benefitted Booth & Flinn.

Flinn started a contracting company in 1876 and merged in 1881 with a firm owned by James Booth to form Booth & Flinn Ltd. Flinn was elected to the statehouse in 1879 and to the senate eleven years later. Booth & Flinn was awarded $16 million in contracts for public projects orchestrated by Flinn and aided by Bigelow. Flinn went after government contracts "with a club," steering work to his firm over two decades, mostly for street paving, road building and garbage collection. Flinn once gave a speech on roads that lasted over two hours—even though he had been allotted only twenty minutes to talk. He said public projects were "a labor of love" for him.

"Magee wanted power, Flinn wealth," wrote Lincoln Steffens. "Each got both those things; but Magee spent his wealth for more power, and Flinn spent his power for more wealth. Magee was the sower, Flinn the reaper." Magee and Flinn treated Pittsburgh as if they owned it, said Steffens:

Magee and Flinn, made Pittsburg their business and, monopolists in the technical economic sense of the word, they prepared to exploit it as if it were their private property. For convenience, they divided it between them. Magee took the financial and corporate branch, turning the streets to his uses, delivering to himself franchises, and building and running railways. Flinn went in for public contracts for his firm, Booth & Flinn, Limited, and his branch boomed. Old streets were repaired, new ones laid out; whole districts were improved, parks made, and buildings erected. The improvement of

their city went on at a great rate for years, with only one period of cessation,
and the period of economy was when Magee was building so many traction
lines that Booth & Flinn, Ltd., had all they could do with this work.

Thirteen days after his election to the senate, Flinn introduced a series of bills that allocated $7 million of contracts for paving city streets and alleys and the construction of sewers. Flinn's name didn't appear on any of the measures. Instead, he used political cronies to sponsor the legislation, which was designed to benefit his company.

Journalists of the time described Flinn as a "regular old pirate" and a "fierce swash-buckler type with a cutlass in his hand and a lurid bandana wound around his head." Pittsburgh newspapers described Flinn as a physically imposing man, six feet tall, over two hundred pounds, with a firm jaw. He wore his iron-gray hair combed straight back. His managerial technique was a "fist and sledge hammer style," and "no honey ever drips from his tongue," wrote a reporter. Other described him as a "rough-spoken, tactless politician who rode roughshod over political opponents. Magee was the diplomatic of the two patching up quarrels with other politicians that Flinn started."

Bigelow was crucial to Booth & Flinn's success. As the city's engineer and later head of public works, he wrote the bid specifications in a way that awarded contracts based on the "lowest responsible bidder." Booth & Flinn were always found to be the most responsible of the competing bidders, even though its cost estimates were higher. The company once won a contract with a bid of fifty cents per square yard for forty-four thousand square yards of paving material, while a competitor's bid was fifteen cents. In a nine-year period, the firm won 193 contracts despite having higher bids that competing construction companies.

When competitors challenged the bids submitted by Booth & Flinn, city officials couldn't produce the cost estimates that other contractors submitted, so no one could challenge the contract. On one sewer project, Flinn submitted a $138,000 bid, but the final cost of the project was $293,559. City council never blinked an eye and approved the overpayment.

Bigelow was instrumental in developing Highland Park, where Flinn lived and where the city's zoo now is located. Bigelow did it with, and without, the approval of city council. When council refused to approve a purchase, Bigelow simply purchased the property and submitted the bill to city council later. Bigelow personally sold the city ten acres that he owned for more than $1,200 an acre while his wife, Mary, sold one lot for more than $38,000.

Flinn was paid more than $118,000 for fourteen acres. After Bigelow bought parcels of property for nearly $1 million, 30 percent of that amount was paid directly to Booth & Flinn for construction work.

Booth & Flinn developed the South Hills for development by building a shorter way to travel between the city and the South Hills, which was then farmland. Mount Washington stood between the city and the southern suburbs. To travel between the two regions, people had to ride inclines or travel through West End to get back and forth. In 1905, Booth & Flinn built a streetcar tunnel and, fifteen years later, began construction of the Liberty Tunnel, which opened in 1924. Workers cut an opening that was 5,889 feet long, 28.6 feet wide and 16.5 feet high through the mountain of rock. Workers removed 500,000 tons of rock and dirt, which workers dumped at a city park. Pittsburgh officials complained about the disposal and estimated it would cost $100,000 in taxpayers' money to remove the debris. The city sued Booth & Flinn, which settled the case for $20,000.

During the construction of the Armstrong Tunnel, which is under the bluff near Duquesne University, Booth & Flinn crews blasted into the hillside, causing $100,000 in damage to nearby buildings. The company settled the dispute for $16,000. On one project, Booth & Flinn had been awarded a $1 million contract but couldn't account for $410,000 in overcharges.

When two city attorneys were charged with embezzling $300,000 in public funds, it was revealed that a portion of the missing money—$118,000—was paid to Booth & Flinn. Flinn said he thought the money was a loan—which he repaid—but investigators could not find any receipts because they had been destroyed in a fire at the offices of Booth & Flinn.

Flinn spent $121,000 in taxpayers' money to build a road leading from Pittsburgh to his country home, Beechwood Farms, in Indiana Township, where Flinn raised livestock, German shepherds and Belgian draft horses and dabbled in horticulture.

A large mountain of dirt and rock known as Grant's Hill sat in the middle of Grant Street, named after British colonel James Grant, who was ambushed by the French and Indians in 1785. The hump was one hundred feet high and half a mile in diameter and rose on Fifth Avenue from Smithfield Street to beyond Sixth Avenue east from Fourth Avenue to Sixth. Cuts were made in the hump over the years to aid transportation because streetcars and wagons were unable to climb the steep grade. Freight haulers were forced to transport smaller loads and make more trips in order evade the obstacle.

Landscape architect Frederick Law Olmsted was hired by the city to study the problem, and he recommended the hump be reduced by sixteen

The Booth & Flinn Company removed the hump on Grant Street and allowed the city's business district to expand. City council couldn't find the money to remove the obstacle until Booth & Flinn expressed interest in the project. *Historic Pittsburgh Collection.*

feet and the areas between Fifth and Sixth Avenues be widened. "Every delay adds to the expense of manufacturing; the costs being borne by wholesale merchants and the price charged consumers by retail dealers. In short, inadequate traffic facilities add to the cost of doing business and living," he said.

Mayor William Magee complained there wasn't any money in the city's budget to do the work, but when Booth & Flinn expressed interest in the project, Magee suddenly found more than $800,000 in the city's coffers. Critics charged that removing the obstacle would only benefit certain financial and political interests, namely the Mellon family, Henry Clay Frick and department store magnate Edgar Kaufmann. The trio had spent millions of dollars improving their downtown properties and believed removing the hump would make their holdings even more valuable.

A Pittsburgh newspaper wrote that the mayor must be a "magician" to make the money appear. "Mayor Magee of Pittsburg, long suspected of occult powers, now takes his place as one of our foremost magicians," read an editorial. Magee "made the astounding discovery of $800,000 he didn't know the city had."

The hump's removal sparked a downtown building boom. A sixteen-story office building was erected at the corner of Seventh Avenue and Smithfield Street that was known as the Chamber of Commerce Building. The new City-County Building was erected. The Union Arcade was built along with the William Penn Hotel, the Davis Theater, Jones Law Building and three department stores. Booth & Flinn also lowered streets within a thirty-block area. Some older downtown buildings had second floors where basements used to be.

Pressure for reform forced Bigelow to change the method he used for writing contract specifications, opening up the process for more competition. An angry Flinn ordered city council to fire Bigelow, but his brother, Tom

Bigelow, with help from State Senator Matthew Quay, introduced a "ripper bill" that ousted the machine's mayor, William J. Diehl, which ended the political reign of Magee-Flinn. Tom Bigelow became Pittsburgh's new political boss.

Magee died in 1901 at fifty-two leaving an estate valued at $4 million. "When Magee died, I died politically," said Flinn, who remained active in the firm until his death at seventy-two on February 19, 1924. Newspapers had kind words for Flinn, citing his "zeal for public betterment" and never mentioning how he had enriched himself in the process. Flinn had four sons involved in the company: A. Rex, George, Ralph and William. Before he died, Flinn turned ownership over to his sons Rex and George, who changed the company name to Booth and Flinn.

The company continued to be a major force in the construction industry under the leadership of Rex Flinn until his death in 1950. Flinn owned 100,000 shares of stock in the firm, but he failed to make changes in his will before his death, creating tax problems for his heirs—the firm was sold to pay a $3 million estate tax. A New York City construction firm purchased Booth and Flinn in 1951 and closed it. A decade later, it was purchased by former Booth and Flinn executives, but its rebirth would be short-lived. In 1968, the company was placed in receivership and its assets sold. Pittsburgh newspapers noted the company's demise in a short article that said the sale of Booth and Flinn "marked an end of an era."

PITTSBURGH BY THE NUMBERS

*I*n 1926, Pittsburgh police inspector John Claney hauled two young black men before a magistrate, but he wasn't sure what crime to charge them with. "What did they do?" asked the magistrate, Albert Brandon. "It's some kind of racket they're pulling among the colored people up on the Hill," the cop said. "They sell these little slips of paper with numbers on them for anything from a cent up. The whole Hill District is going crazy over it," reported the *Pittsburgh Post-Gazette*.

Brandon said it sounded like the men were operating a lottery, so he fined them $50 each. Neither man had any money, so the magistrate ordered the two sent to the Allegheny County Workhouse in Blawnox, a dungeon-like fortress north of Pittsburgh located along the Allegheny River. One of the men asked to make a phone call, and a short time later, a third man arrived with $100 and the men were released.

The two men were Gus Greenlee and William "Woogie" Harris, who are credited with introducing the numbers racket to Pittsburgh. That story, retold over the decades, may be nothing more than urban legend, but city newspapers referenced every story about Greenlee and Harris as the originators of the game of chance in Pittsburgh until the day they died.

The numbers racket was the scourge of Pittsburgh for decades, until the Pennsylvania lottery essentially killed the business with its televised daily numbers drawings. The game generated millions of dollars that were used to pay protection to police, public officials, constables and police magistrates. Racketeers' battles for control over the lucrative game triggered murders and bombings but provided jobs for thousands of people.

Left: Gus Greenlee at table with William "Woogie" Harris. *Courtesy of the Carnegie Museum of Art.*

Below: Gus Greenlee. *From the* Pittsburgh Post-Gazette *Archives.*

Greenlee was a soft, doughy man with a red tint to his hair and freckles, which earned him the nickname "Mr. Red" or "Big Red." He stood six feet, three inches tall and weighed 210 pounds. He was a quiet and unassuming man born in a log cabin in Marion, North Carolina, on December 26, 1896. Greenlee was the grandson of Marcus Greenlee, a slave at the Turkey Cove Plantation in North Carolina, which was owned by James Hervey Greenlee, a prosperous planter in McDowell County. Greenlee's father, Samuel, was a bricklayer. His mother, Julia, was the daughter of a white businessman and is listed as a mulatto in birth records.

Gus Greenlee was a flashy dresser, favoring custom-made suits, white ties, black shirts and white shoes. He loved baseball, and sportswriters

called him an "18 carat baseball fan." He owned six cars: a Lincoln, a Packard, a Chrysler, a Cadillac, a Dodge and a Ford. "He's got the heart that is big as a whale and the wisdom of Socrates," gushed an admirer in the *Pittsburgh Courier*.

In 1916, Greenlee dropped out of college after a year and hopped a freight train, arriving in Pittsburgh, where he worked as a bootblack and cab driver. He earned the nickname "Gasoline Gus" when he and a white partner, Joe Tito, sold booze out of the back of Greenlee's taxicab. Tito was a major bootlegger in the city and later became partners with his brothers in buying the Latrobe Brewing Company, which brewed Rolling Rock Beer. Greenlee served in the army during World War I as a machine gunner, was wounded at Verdun and returned to Pittsburgh after the war.

William "Woogie" Harris was a small man, the son of one of the city's few black police officers, William "Monk" Harris, who drove a paddy wagon. The money Harris made from numbers allowed him to vacation in Miami and Europe. A fan of boxer Joe Louis, Harris attended Louis's bouts, traveling around the country in a private railroad car with his Pittsburgh cronies. He sat front row center ringside at every bout. When Harris traveled to these matches, he rented the whole floor of a hotel, doling out $100 tips to bellhops and waiters. He also traveled around the country playing in high-stakes poker games with pots as much as $50,000.

Once the numbers racket was established in the Hill District, the game became embedded throughout Pittsburgh and spread throughout the mill towns along the Ohio, Allegheny and Monongahela Rivers, snaring police and politicians in its corrupt web until the Pennsylvania lottery began in the 1970s.

Pittsburgh was a corrupt and crime-ridden city in the throes of Prohibition-era violence. One journalist called the city the "Metropolis of Corruption" because of the crime and political corruption that government allowed to exist. Murders and bombings were common. In a five-year period during Prohibition, there were two hundred unsolved murders and bombings. There were so many stills operating in Pittsburgh that you could smell mash in the air. Speakeasies, saloons and stills dotted the city's landscape, and city residents and police acted as if Prohibition didn't exist.

The Great Depression nearly killed the numbers racket because people were so poor that they couldn't afford to even spend a penny. The New Deal brought some relief—numbers writers knew when relief checks arrived. The Works Progress Administration brought jobs, and that money put the rackets back on sound financial footing.

Greenlee and Harris were numbers barons, and the Hill District was their fiefdom. The money generated from numbers made them wealthy. Their money, for a time, bought them protection from police and politicians.

No one is certain how Greenlee and Harris discovered the game, but there are several stories surrounding the game's origin in Pittsburgh. One tale claims Greenlee saw a Cuban version of the game *la bolita* played during a visit to Cuba to scout baseball players for his team, the Pittsburgh Crawfords, but Greenlee was not involved in baseball until 1930. Another story has it that Effa Manley, owner of the Newark Eagles in the Negro League, may have seen la bolita played in Cuba and told Greenlee and other team owners about it.

La bolita is played by placing one hundred numbered balls into a bag. The bag is shaken, and players wager small bets on what they hope will be the last number pulled from the bag. Even though the bets were small, the game paid off ninety to one. The game eventually was brought to Florida in the 1880s by a man named Manuel "El Gallego" Suarez. By the 1920s, the mob in south Florida had taken over control of the lucrative game.

Greenlee and Harris may have learned about the game from Swifty Howard, a waiter on a railroad dining car who booked numbers for passengers traveling between New York City and Pittsburgh. Carlton Hays, a Philadelphia numbers operator, reportedly came to Pittsburgh and discussed the game with Greenlee and Harris, who set up their own network. Regardless of how the game came to Pittsburgh, playing the numbers became a daily ritual in western Pennsylvania for decades.

Hill District residents scrimped together their pennies, nickels and dimes trying to pick three consecutive numbers from 000 to 999 based on the closing results of the New York Stock Exchange. The payoff for picking a winning number was 600–1 but the odds at picking three consecutive numbers were 1,000–1. Each morning, numbers writers appeared on the corners along Wylie Avenue, scribbling on pieces of paper after accepting coins from passersby. Runners carried satchels bulging with coins accompanied by stern-looking bodyguards to thwart any robbery attempts. The clanking sounds of adding machines tallying the day's take could be heard in the back rooms of the storefronts that served as counting houses.

Black clergy bemoaned the lure the numbers game had on young people. "The lure of new cars, clothes and cash added to the attraction. We ignore the fact that the thousands of our young men and women coming out of school and confronted with the real difficulties of making a living have come to look upon this vicious way of life as desirable," read an editorial. But the

numbers writers were an important part of daily life on the Hill. "We depend on two people—the minister and the numbers writer," said one resident in the *Pittsburgh Courier*.

Playing the numbers dates to sixteenth-century Venice, where the winners of an Italian lottery received gold, silk, cloth or live animals as prizes. Playing the numbers is as old as the United States. The original thirteen colonies used lotteries to raise money, but scandals forced officials to enact laws against the game. The First Presbyterian Church of Pittsburgh held a lottery in 1807 to pay for the construction of a church, but the contest was mired in scandal.

Pennsylvania authorized the Union Canal Company to hold a lottery in 1833 to raise $400,000 to build a canal along the Susquehanna River. The company distributed $33 million in prizes between 1811 and 1833, but only $225,000 went toward construction because of the sticky fingers of ticket brokers.

Lotteries were used by churches, colleges and government to raise money but became magnets for swindlers and confidence men. When St. Richard's Catholic Church in Pittsburgh held a lottery in 1912 to raffle off a car, authorities issued arrest warrants for Fred Clarke, manager of the Pittsburgh Pirates, and star pitcher Marty O'Toole, who sponsored the contest. A watch was placed in a safe-deposit box, and contestants bet on when the watch would stop working. The person with the closest time won a $3,000 car. A judge dismissed the charges against Clarke and O'Toole, ruling that a lottery is legal if the proceeds are for charity, according to the *Pittsburgh Post*.

Bingo was banned for a time. The game as we know it was invented in Pittsburgh in 1935 by cabbie Hugh Ward, who staged games at carnivals and fairs in western Pennsylvania. The Catholic Diocese of Pittsburgh banned bingo at 444 churches in ten counties in the late 1930s because it was infiltrated by professional gamblers.

The Great Depression spawned widespread gambling. Lotteries in Pittsburgh and Allegheny County were big businesses, employing five thousand and raking in an estimated $30 million annually, which far surpassed the money government appropriated for relief. Movie theaters during the Depression held "bank nights," awarding cash prizes based on three numbers printed on tickets. These events were held to increase attendance at films because ticket sales had fallen 25 percent between 1930 and 1933.

Greenlee and Harris were economic pillars of the Hill District. They helped families with loans and mortgages at a time when white-run banks would not loan money to African Americans. They invested in black-

owned businesses and helped students pay for college. They operated soup kitchens when the Great Depression sent Pittsburgh into an economic tailspin and thousands of people were searching for food and jobs that no longer existed.

The two numbers barons were based on Wylie Avenue, where the intersection with Fullerton Avenue made the Hill District the "crossroads of the world," in the words of Harlem Renaissance poet Claude McKay. From 1930 through the mid-1950s, the neighborhood was a thriving area for music and the arts. Jazz joints were filled on the weekends by blacks and whites. Wylie Avenue was known as the "Broadway of the Hill District" because of its proliferation of speakeasies, theaters, restaurants, burlesque houses and jazz clubs with names like Hurricane, the Ritz, Bambola Social Club, the Leondi Social and Literary Club and the Savoy.

The Hill never slept. At night, men and women waited outside one of the many jazz clubs along Wylie Avenue to listen to Lena Horne and Billy Eckstine. People flocked to restaurants selling steak dinners and sweet potato pie. "Food joints, fresh with smell of barbecue ribs, wings and fries, were served with jazzy sounds that made one happy to be alive and hanging out on Wylie Avenue in the Hill District," wrote John M. Brewer Jr. in his book *Pittsburgh Jazz*.

Greenlee opened the famous Crawford Grill on Christmas Eve 1933, and it became a mecca for jazz artists and a hangout where blacks and whites gathered to eat lobster and steak, throw back shots of bourbon and listen to Erroll Garner, Roy Eldridge, Earl "Fatha" Hines, Mary Lou Williams and John Coltrane. It also was a place where arts, literature, music, sports, business and politics intersected.

The Grill was three stories high and a block long. The first floor was known as the Rumpus Room. The second was the main floor, where bands played on a revolving stage. The third housed Club Crawford, where Greenlee held court and hosted regulars such as Duke Ellington and Count Basie when they performed in Pittsburgh.

Harris opened the Crystal Barber Shop across the street from the Crawford Grill, and it featured a lavish poolroom in the back. The spacious shop had six chairs, three on each side of the room. Florescent lights hung from the ceiling. A neon sign flashed in the front window. At one time, Harris also owned Club Apple Street in the East Liberty section of Pittsburgh, where a young Billy Strayhorn worked as a pianist.

The men were reputed to be millionaires living in mansions on the outskirts of the city. Harris's home was a large Victorian—later purchased

William "Woogie" Harris atop a piano at the Crawford Grill bar in the city's Hill District. *Teenie Harris Photograph Collection, Carnegie Museum of Art.*

by the National Negro Opera Company—located between Homewood and the Lincoln-Lemington neighborhoods.

Beyond the culture of the Hill were serious economic problems. Black unemployment was high, and few black men were working in the city's major industries, such as steel. The Hill District was a slum. More than 44 percent of the homes and apartments had no running water, and 5 percent had no electricity. People crowded into apartments that had no indoor plumbing.

Greenlee ran the Third Ward Voters League in the Hill, a hotbed of political corruption. Greenlee supported the corrupt Mayor Charles Kline for reelection. Kline, who was convicted and sentenced to prison for malfeasance in office, needed Greenlee's support to defeat James Malone in the GOP primary. Even though the Third Ward Voters League supported Malone, Greenlee made a deal to deliver votes for Kline if the mayor allowed Greenlee to remain in control of the numbers racket and bootlegging. Hill District elections were rife with fraud. In 1932, Greenlee was arrested but acquitted of voter fraud.

Greenlee and Harris suffered a financial setback that almost ruined their operation. Number 805 hit during heavy play, wiping out every dime Greenlee and Harris had. They had to mortgage their homes and sell their jewelry and cars to cover the loss, but they paid off every winner, further cementing their reputation on the Hill. Before people placed a bet, they would ask the bookie if he was associated with the "black pool" because Greenlee and Harris never welched on a bet.

In 1934, Jewish gamblers—aided by vice cops who raided their competitors' banks and arrested their runners—moved in on Greenlee and Harris's operations. Greenlee retreated from the numbers racket and purchased the Pittsburgh Crawfords. In 1933, he founded the Negro National League, which the Crawfords dominated. The "Craws," as they were known, may have been the greatest baseball team, black or white, ever, with future Hall of Famers Satchel Paige, Josh Gibson, Cool Papa Bell, Oscar Charleston, Judy Johnson and Martin Dihigo.

When Forbes Field refused to allow black ballplayers to use the dressing rooms, Greenlee built his own stadium, Greenlee Field, a concrete and steel edifice that cost him $100,000. Greenlee and Joe Tito formed the Bedford Land and Improvement Company, purchased the land and built the stadium. In 1938, the defection of a star player to a league in the Dominican Republic weakened the squad and led to its eventual sale.

Greenlee returned to baseball in 1945, teaming with silent partner Branch Rickey to form the United States League to integrate baseball. "I don't care if I never own another Negro team or promote another game. I want to see Negro players in the Major Leagues and I know that all other Negroes do too," he said.

Greenlee left baseball for good two years later and went into boxing. He built a gym at his home to train his stable of fighters. It was Greenlee's goal to have a champion in every weight class. His best chance at achieving that goal came when he signed John Henry Lewis, a middleweight fighter who became world champ.

In 1935, Lewis signed with Greenlee and moved up in weight class so he could fight Joe Louis. Greenlee and John Roxborough, Louis's manager, set up the bout. Lewis was tough but blind in one eye. On January 25, 1939, Lewis and Louis made history by becoming the first black boxers to fight for the heavyweight championship of the world. Louis was 35-1 and a powerful boxing machine. Thirty of his thirty-five victories came by knockouts. The fight was over in two minutes and thirty-nine seconds. Joe Louis never broke a sweat and pummeled Lewis to the canvas.

Greenlee's health began to fail. He was admitted to the Veterans Hospital and returned home to die in July 1952. Just before his death, the Crawford Grill was destroyed by fire, but his family kept the news from Greenlee. Hundreds turned out to pay their respects for the man they called "Mr. Red." "He had played the game of life hard, fast and clean," wrote a columnist for the *Pittsburgh Courier*.

Harris's barbershop was the target of raids by vice detectives, who repeatedly arrested him on gambling charges. Harris ran a crap game in the poolroom. When detectives raided the place, they found dice hidden in a hollowed-out cue stick. Harris always appeared for his hearings and paid his fine, never appealed or complained about the arrest.

"Woogie Harris couldn't be described as a saint," wrote the *Pittsburgh Courier*. "He wouldn't want it that way. But he was a man of the streets and it was the people of the streets and alleys who looked up to him the most."

The Pennsylvania Lottery killed the numbers business in Pittsburgh, although some people still placed illegal bets with bookies because the odds were higher. The state unveiled its televised daily number drawing on March 1, 1977, paying 500–1 odds for a three-digit number in correct order.

In 1980, the lottery drawing was rigged when "666" hit for a payout of $3.5 million, including $1.18 million to scammers including Pittsburgh

Numbers baron Tony Grosso. Whenever Grosso got into legal trouble, he informed on police officers he had been paying for protection. *From the* Pittsburgh Post-Gazette *Archives.*

television personality Nick Perry and a state lottery official. The scam was known as the "triple 6 fix." Perry experimented with a number of substances to make certain balls float to the top of the machine to be selected for the daily drawing. Experiments were made using baby powder, sugar and Vaseline to see which balls floated to the top of the machine. They settled on white paint, which they used on all the balls except 4 and 6.

This allowed possible combinations of 444, 446, 464, 466, 644, 646, 664 and 666. Before the drawing, cohorts of Perry went around the state, purchasing large blocks of tickets in various combinations. On the night of April 24, 1980, 666 was chosen.

Perry was sentenced to seven years in prison but released after two. Edward Plevel also served two years, while others convicted were sentenced to lesser terms.

Pittsburgh numbers boss Tony Grosso, who grew up in the Hill District and ran a bookmaking operation that raked in millions a year, publically complained to reporters that the lottery had been fixed. Grosso was right. A state grand jury investigation confirmed the findings by issuing a series of indictments.

A BLIND EYE

*B*uried in the National Archives in Washington, D.C., is an October 26, 1946 FBI report linking Art Rooney Sr., founder of the Pittsburgh Steelers, to organized crime. The report details the partnership between Rooney and Kelly and Sam Mannarino, two brothers who went on to become major Mafiosi in western Pennsylvania and in pre-Castro Cuba, according to the FBI. The Mannarinos were part of the crime family bossed by the late John LaRocca.

The numbers racket and ownership of slot machines were controlled in the city's neighborhoods by different gangs with the blessing of ranking Mafia leaders. Under an agreement, Rooney owned all the slot machines north of the Allegheny River, while the Mannarinos ruled south of the river, according to a 1996 *Greensburg Tribune-Review* series, "Mob Rule."

When FBI agents questioned Rooney in 1959, he told them he had gambling connections and considered himself a professional gambler and that his gambling habits sometimes "frightened him." "There's no question that my father did own horses and wagered on them, but that is the only thing that I know, and he may have known the people you mention," his son, Dan Rooney, told the *Tribune-Review*.

Art Rooney Sr. was an athlete who boxed and played baseball and football, but his first love was the ponies. According to legend, Rooney purchased a franchise for a football team for Pittsburgh from the National Football League in 1933 and supported it financially after winning anywhere between $125,000 and $300,000 at the racetrack three years later. Rooney, known as "The Chief," owned the Steelers from 1933 until his death in 1988.

Art Rooney Sr., founder of the Pittsburgh Steelers. Rooney had an agreement with the Mafia that allowed him to operate slot machines. *From the* Pittsburgh Post-Gazette *Archives.*

The Great Depression reinvigorated the game. Numbers writers knew when relief checks were due or when men working in the Works Progress Administration were paid. Bookies gathered outside government offices, waiting for potential customers eager to cash their checks and try their luck.

The end of World War II brought a crime wave across the nation, as criminal syndicates blossomed into a $20 billion business through numbers, horse racing, prostitution and sports betting. The expansion of telephone and telegraph networks allowed the widespread dissemination of racing results and the daily number published in the business pages of newspapers. The winning numbers were based on the closing figures of the Dow Jones Industrial Averages and paid 600–1 odds, even though the odds against winning were 999–1, so the take for bookies was huge.

Politicians and police also realized the money that could be made in the rackets and began demanding payoffs for protection. Some numbers operators raked in more than $30,000 a day in bets. The protection money supplemented the salaries of police inspectors and the political campaigns of city councilmen, ward leaders and constables who saw to it that the gambling parlors remained unmolested.

After the war, Pittsburgh police lieutenant Al Florig, who was nicknamed the "Green Hornet" after the popular radio series, triggered a grand jury investigation into the rackets, charging that the police were in the pockets of mobsters. When four patrolmen under his command were found drinking on the job, he suspended them, but Mayor David Lawrence immediately reinstated the foursome—even though they were intoxicated. Florig was busted to patrolman for his effort.

The numbers racket spread throughout the city and Allegheny County. No one was immune. State police arrested a clerk in the city treasurer's office for taking bets and a pickup man who came to collect. Police raids were infrequent unless Pittsburgh clergymen or civic reformers complained; bookies understood they would have to stand a few raids to make the police look good.

According to the *Pittsburgh Post-Gazette*, the rackets openly operated in every police precinct in Pittsburgh. Police assigned to the Northside had to pass a bookie parlor every day they came to and from work. Allegheny County Republican district attorney Artemus Leslie wrote to Mayor Lawrence—listing nineteen gambling joints in the city—to force him to act

"Why don't police know about these places?" Leslie answered his own question, "I don't know." The district attorney began conducting his own raids of city gambling spots to embarrass the mayor. Lawrence retaliated by selecting Democrat William Rauhauser to run for district attorney, and he eventually defeated Leslie in the next general election.

Cleaning up vice in Pittsburgh fell into the lap of Mayor Lawrence, who tolerated the rackets as part of the price of running a big city. He didn't consider the rackets to be a serious problem because he was more concerned about ushering in the city's renaissance and cleaning up the smoke-filled air hovering over Pittsburgh. He was hesitant to face controversy unless it was absolutely necessary.

"Lawrence was never puritanical about what you call police corruption," said Jack Robin, who helped Lawrence transform downtown Pittsburgh from a smoky city where the sun seldom shined into a modern urban center of gleaming skyscrapers. In Michael Weber's biography, *Don't Call Me Boss*, he asserts that Lawrence regarded vice as a fact of life. "What the hell can you do about it anyhow? And if the ward leaders, and the alderman, and the police inspectors were doing this or that in relation to gambling, etc., he wasn't going to run around closing them to uncover corruption," said Robin.

Lawrence believed juries were reluctant to convict gamblers because many jurors liked to play the numbers and didn't see anything criminal in it. "They don't give a rap about charges of this sort," Lawrence said, "and have a great deal of sympathy for [numbers] writers."

When police raided a place, they confiscated the numbers slips as evidence but allowed the arrested bookmakers to see the slips to determine if they had any hits that day so they could make payoffs. Police decided to charge the bookies $100 for the privilege of seeing the slips then discovered another way to fleece the gamblers. They would find out the winning number, write it on a piece of paper, insert it among the pile of numbers slips and give the bookmaker a dollar—so the bookies would have to pay the officers $600, as if they had hit the winning number.

Bookie Bennie Plotkin complained to *Post-Gazette* reporter Ray Sprigle, who wrote about the Pittsburgh rackets for decades, that he was paying 60 percent of his gross to the police and politicians for protection:

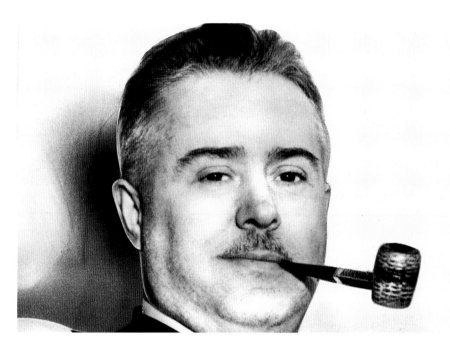

Post-Gazette reporter Ray Sprigle, who wrote about corruption in Pittsburgh. Sprigle spent decades writing about the rackets and political corruption. *From the* Pittsburgh Post-Gazette *Archives.*

You'll take care of the constables of the ward which your headquarters are. You'll sweeten a couple of the deputy constables, too. You'll take care of the alderman. If your operation operates in other wards, you'll take care of the aldermen, constables and deputies there. You'll take care of the police inspectors in every district in which you operate and the lieutenants, too.… You'll take care of anywhere from one to fifty policemen in the neighborhoods where business is best and you have a crew of writers working.

Plotkin complained to Sprigle that the cost of paying for police protection was putting him out of business. "Bennie moans to friends that he's broke," wrote Sprigle in his series "Inside the Rackets." "He complains bitterly the law has so boosted the cost of protection that there's scarcely a nickel left for all honest numbers men."

Plotkin was no ordinary bookie. In 1951, his name surfaced during a U.S. Senate committee hearing led by Senator Estes Kefauver investigating organized crime. The committee subpoenaed mobsters Frank Costello, Meyer Lansky, Mickey Cohen and Joe Adonis to testify. Milwaukee gambler

Sidney Brodson testified he won $250,000 after placing bets to an unlisted phone number, HE-1-1222, in Pittsburgh that was registered to Plotkin's Atlantic and Pacific Cleaning Company. When police searched the office, they found the telephone located in a soundproof room. "I'm in a legitimate business and this isn't going to do any good," Plotkin told the *Pittsburgh Press*.

Sprigle had been exposing police corruption since the 1920s and 1930s. In the 1940s and '50s, his stories about graft and corruption within the police department and the department's relationship with racketeers drove Lawrence to distraction. He had good relationships with most of the reporters covering politics and city hall, but he hated Sprigle for Sprigle's continuing attacks on his administration.

"Forty years I've been a police reporter, most of them in Pittsburgh," Sprigle said. "Forty years, off and on, I've watched one corrupt police administration succeed another. Year by year I've watched police administrations in Pittsburgh become more fumbling and inefficient, more venal and more arrogant."

In March 1950, Lawrence pushed a measure through city council barring police officers from holding elective office or getting involved in political campaigns. He also was angry over the police department's failure to solve the Garrow, Evans and Gianni murders and ordered a citywide crackdown. Police Superintendent Harvey Scott mobilized one thousand officers for a sweep of gambling spots. He issued a stern warning to his inspectors: "You have three hours. If you haven't cleaned up your district by then or made real progress, I'll personally lead a vice squad and do it for you."

The mayor also created a special unit to go after the numbers bosses and placed Lieutenant Lawrence J. Maloney in charge. The unit was dubbed "Maloney's Marauders" but was better known for making headlines than arrests. Maloney began racking up thousands of arrests—mainly small-time bookies—without ever touching the major operators.

Out of 5,400 arrests the squad made during its existence, 4,220 were "visitors" who were placing a bet when police arrived, according to an analysis by the *Post-Gazette*, which stuck its journalistic finger in the eyes of the police force with the headline, "Numbers Big Shots Unmolested as Police Round Up Small Fry." A grand jury questioned why police inspectors were unable to find gambling spots in their own precincts when every resident of the district knew where to place a bet.

Maloney's rise in the police force was meteoric. In just eight years, he went from working as a janitor, garbage man and furnace stoker at the city zoo to police lieutenant thanks to his Democratic Party connections

as a committeeman. He was hired as a part-time patrolman in 1942 and was promoted to full-time eight days later. He was elevated to detective the following year and eventually became an inspector and then assistant superintendent of police.

The police force was controlled by the Democratic Party, which determined promotions and assignments. During the Lawrence administration, out of ten inspectors, only three came up through the ranks. Three inspectors were ward chairmen, one was a committeeman and another was appointed by an Allegheny County Commission. Only seven of thirty-seven detectives were promoted on merit. The remainder were political appointees working as prison guards, pitchmen, boxers, truck drivers, barbers and hotel clerks before becoming detectives. Ward chairmen also played a role in the appointments of the public safety director and police inspectors.

"For half a century, politics has always kept a dirty finger in the operation of Pittsburgh's police system," said Sprigle, but it was Lawrence who "brought it to a perfection it had never known before."

In 1948, when New York City police tipped off their colleagues in Pittsburgh that a multimillion-dollar racing syndicate from Yonkers was openly operating in the Fort Pitt Hotel, it took Pittsburgh two years to act. Finally, a grand jury was formed and heard testimony from 238 witnesses, including 40 police officers. The panel targeted thirteen clubs, horse rooms, illegal casinos and slot machine operations and recommended sixty indictments that were a who's who of Pittsburgh gamblers. The grand jury's report, however, absolved Lawrence and blamed police for allowing the enterprises to continue.

Maloney was the target of several investigations into police corruption, but he was never convicted. Former city detective Al Florig sent a letter to Lawrence, the district attorney, city council and the newspapers claiming that Maloney was running an extortion and protection ring shaking down bookies for bribes. "No racketeer can open up a peanut stand in the city of Pittsburgh for illegal purposes unless they clear through the mayor and Democratic headquarters," Florig asserted.

Maloney was charged with extortion. The principal witness against him was bookie Myer "Slick Man" Sigal, who testified he paid Maloney nearly $2,000 a month for protection plus an extra $1,000 at Christmas and $5,000 to subsidize his annual vacation. Sigal also said he delivered between thirty and forty cases of Canadian whiskey to Maloney, who denied the charges. "I drink scotch," Maloney said at his trial.

After Maloney was promoted to assistant superintendent, he was charged by the federal government with failing to pay taxes on $250,000 in payoffs between 1958 and 1963. Former detective Clarence Cooper pleaded guilty to tax evasion and admitted he was Maloney's bagman. A string of bookmakers also testified they paid Maloney for protection. Two judges, one a state supreme court justice, appeared as character witnesses for Maloney.

Assistant U.S. Attorney Samuel Reich told the jury in his closing argument that the amount of money Maloney was paid over the year amounted to "22 years of base corruption, 22 years of fixing cases, 22 years of disgrace to law enforcement everywhere." Despite the testimony from the gamblers, Maloney was acquitted but fired by the mayor. He died of bone cancer in 1969 at fifty-eight.

Maloney's fall was hastened by testimony from Tony Grosso, a dapper, polite bookie who ruled a multimillion-dollar empire in Pittsburgh for decades. Grosso had no qualms about giving up police officers who protected him. In fact, Grosso made a career out of turning in his police protectors.

Grosso's testimony led to the downfall of Allegheny County district attorney Robert Duggan and his chief of the racket squad, Lieutenant Samuel Ferraro, in the 1970s. In 1982, law enforcement caught wind that gambling investigations were being compromised after investigators reviewed the calling patterns from the wiretaps, which indicated someone inside the police department was tipping off the bookmakers. Calls to bookies from the numbers writers lessened during peak times of the day, when numbers writers should have been phoning in their wagers.

Investigators suspected there was a mole within their ranks. In 1985, Grosso was charged with fourteen counts of gambling and faced as many as eighty-seven years in prison and a $155,000 fine if he was convicted. Prosecutors offered Grosso a deal. Tell who the mole is and avoid a prison term.

Grosso took the offer and gave them Corporal Donald Hughes, a veteran state trooper who headed the vice unit investigating Grosso. Hughes received $100,000 from Grosso along with subsidized vacations and tickets to Steelers football games. Grosso said he had no choice but to cooperate because Hughes "had me where he could have burned me. He wanted money. He had to make to make a choice with me or put me away. And he accepted the money. It was a mutual understanding between us."

Grosso turned on Hughes after the two met in a motel and Hughes ordered Grosso to strip naked to make sure he wasn't wearing a wire. "I gave him all this money and he didn't trust me. That made me feel bitter," said Grosso in an interview with the *Pittsburgh Press*.

In April 1986, Hughes's body was found in the garage at his home. The garage door was shut, and the car's engine was running. A coroner ruled that Hughes committed suicide.

Grosso couldn't stay out of the numbers business and was sentenced to what amounted to a life term in prison. In 1987, while on probation for ten years, he was arrested for gambling, racketeering, criminal conspiracy and operating a lottery. His probation was revoked, and he was sent to federal prison for six to fourteen years. Then the seventy-two-year-old Grosso received a consecutive ten- to twenty-year state prison sentence.

Judge Raymond Novak reprimanded the aging raconteur: "You know how old you were. You know how sick you were. You got the deal of the century and you threw it away. You forced your incarceration…by your continued defiance of the law."

Grosso, who began writing numbers while selling newspapers as a fifteen-year-old in the Hill District, died while serving his sentence. In 1994, he was taken from a state prison to a hospital where he died.

His political reach may have extended to Mayor Lawrence, who used the money from Grosso's payoffs to finance a political machine—although Lawrence never was implicated. U.S. District Judge Hubert Teitelbaum was a federal prosecutor from 1955 to 1961 before being appointed to the bench. He believed Lawrence allowed Grosso to operate in the city to keep the Mafia out.

"The mob stayed out of Pittsburgh in the 1950s," said Teitelbaum in an interview for a 1985 profile of Grosso in the *Pittsburgh Press*. "The mobsters had a grip on the counties surrounding Allegheny County but they couldn't make inroads in the city."

Grosso liked talking to reporters on occasion and once suggested Hollywood make a movie with Al Pacino or Frank Sinatra playing himself. When Grosso died, Thornburgh said the man ran his numbers syndicate like a major corporation: "I remember one observer once saying that Grosso ran such an effective operation that he made IBM look like it was all thumbs."

CITY HALL SCOUNDRELS

\mathcal{P}ittsburgh has been ruled by a variety of proven leaders, misfits and eccentrics during its history. Some were military heroes, gold miners, liquor dealers and industrialists. Others were downright scoundrels like Joseph Barker, who was elected mayor in 1850 while serving a year in jail for spewing hate-filled speeches on street corners against Catholics, Masons and Protestant ministers. He once arrested the bishop of the Catholic Diocese of Pittsburgh. He also arrested several city councilmen and fired the entire police department's night shift in a political squabble for control of the police, according to an 1850 edition of the *Morning Post*.

Barker's election prompted the *Morning Post* to write, "[H]owever much we regret the results we cannot disguise the fact that for some days we were apprehensive that we would be called upon to make such an announcement." The paper wrote that Barker's election "will give a license to rowdyism, violence and indecency." After leaving office, Barker was decapitated by a train.

William McNair, a perennial political loser until he became mayor, had little interest in running the city and preferred delivering lectures on single-tax theory and playing the violin until he resigned before his term ended.

Democrat David Lawrence flourished by aligning himself with the GOP, surviving political scandals that would have ruined a lesser politician. He went onto become mayor of Pittsburgh and later governor and transformed the city from "hell with the lid off" to a vibrant urban center with clean air.

Despite all his political savvy, Mayor Charles Kline couldn't sweep a scandal involving the purchase of a carpet under the rug—it led to his

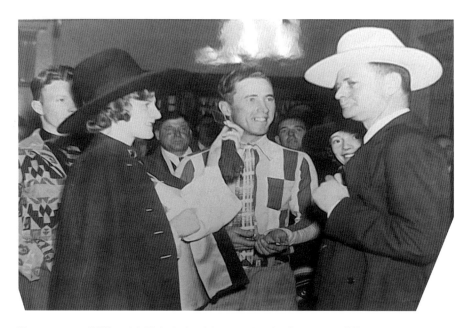

Former mayor William McNair during his campaign for Congress. *William McNair Papers, Archives Service Center, University of Pittsburgh.*

demise and that of his once powerful Republican political machine that ruled Pittsburgh politics from the late 1920s to the early 1930s.

Kline may have been the worst scoundrel to ever grace city hall. His political base was built on corruption; crooked cops, bootleggers, gamblers, brothel owners and racketeers financed his political campaigns through bribes in exchange for protection of their illegal operations. He was convicted of malfeasance in office and resigned to avoid going to prison.

He brought organization to the rackets by dividing the city into districts and appointing a single czar to oversee the rackets in each neighborhood. Kline's ward bosses controlled vice in their districts and dictated from whom speakeasy owners could buy their liquor and sold the concessions for numbers parlors, brothels and an assortment of grafters. Kline limited the amount of boodle police inspectors could earn, in addition to their salaries, to $30,000 a year—the equivalent in buying power today to nearly $500,000.

The *Post* estimated the annual take from graft at $5 million:

> *Vice is organized along ward lines as is politics, and vice and politics are organized as a single entity. In every ward and in every precinct the man*

who handles the vote is the man who handles the bawdy house concessions and the gambling privileges. No bawdy house and no gambling joint and no speakeasy can open up; no lottery can run without the permission of the ward chairman. Vice today is a gigantic business organized on political lines according to wards and precincts and paying rich dividends in graft.

Vice was so widespread during Kline's tenure that reformers questioned police claims that they didn't know racketeers operated. When Allegheny County judge Frank Patterson rejected reports from constables claiming there were no vice operations in their districts, he called the constables a "blind man's parade" for not being able to see vice operators working in full view of the police and public. Church leaders banded together to support Patterson's attempts to rid the city of vice. Kline's administration was corrupted from top to bottom. The political food chain ran from Kline to Police Superintendent Peter Walsh to Walsh's inspectors and lieutenants, according to the *Post*.

The Citizens' League of Allegheny County blamed Kline for the spread of vice and demanded that he fire Walsh. Kline couldn't move against the superintendent because Walsh was aligned with the ruling Republican Party. Investigators hired by the Citizens' League to gather evidence of graft were arrested and refused bond. Walsh forced ranking police officers to kick in three days' pay to help finance Kline's election and reelection campaigns.

The *Pittsburgh Press* asserted that the rackets couldn't exist without Kline's permission: "Rackets cannot flourish in any city without at least the tacit acquiescence of the political leaders and police officials in the city.…The people of Pittsburgh are looking to Mayor Kline for an answer. Is he or is he not going to smash the rackets in the city? The answer rests with Mayor Kline."

In another editorial, "Mayor Kline Course Offers No Hope," the *Press* criticized the mayor for putting his political interests ahead of the public so he could build a political machine "capable of thundering over any protest at the polls." The police force, it added, was "a laughing stock [*sic*]": "The police are his, his police magistrates are his, the ward chairmen in the vast majority are his. His power for good is tremendous, but so is his power for evil. This one man is Mayor Charles Kline."

Kline was unmoved by the criticism. Police Superintendent Walsh was one of the most corrupt cops in the city's history. He allowed Inspector Charles Faulkner, who oversaw the Northside, to administer justice as he saw fit, so long as the money kept flowing into the Republican Party's coffers.

Faulkner once raided an illegal gambling casino and arrested the patrons but not the owner. A gambling syndicate had its headquarters in the same building where Faulkner owned a bowling alley and poolroom a few doors from the Northside police station. The *Pittsburgh Daily Post* published photos of the building with arrows pointing out the entrance and showing the syndicate's proximity to Faulkner's businesses. Faulkner ordered a *Post-Gazette* photographer beaten and arrested while he was covering a fire on the Northside. He banned reporters and photographers from covering news in the Northside.

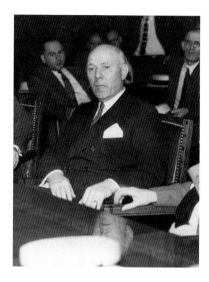

Police superintendent Peter Walsh allowed vice to flourish in the city during the reign of Mayor Charles Kline. *From the* Pittsburgh Post-Gazette *Archives.*

The *Post-Gazette* defied Faulkner's edict by announcing in an editorial, "Inspector or Dictator?," that it would continue to cover events regardless of Faulkner's threats:

> [I]*t will continue to present the news from the Northside whether it be an account of the meeting of the Chamber of Commerce or the news that the gentleman in charge of the police in that district has been indicted....And incidentally, the* Post-Gazette *will determine from some authoritative source, whether the law of the commonwealth runs north of the Allegheny River.*

Faulkner was indicted by federal and county grand juries for bootlegging but escaped conviction. In 1932, Faulkner was demoted to patrolman during a shakeup of the police force and quit. Walsh was fired by Mayor John Herron after he assumed office following Kline's resignation for allowing corruption to continue.

During Prohibition, Pittsburgh police refused to cooperate with federal agents because officers and elected officials helped protect bootlegging operations. When Edgar Ray was appointed federal Prohibition administrator in Pittsburgh, he raided a garage used by bootleggers and confiscated 150 cars and $250,000 worth of liquor. Then he turned his attention to Allegheny Chemical Products, whose stockholders included city politicians. Ray had

evidence the company was diverting hundreds of thousands of gallons of alcohol for illegal distilling and subpoenaed the company's records to determine the profits.

Pittsburgh politicians, led by Allegheny County commissioner E.V. Babcock, lobbied Secretary of the Treasury Andrew Mellon of Pittsburgh to have Ray removed from his post as Prohibition administrator in Pittsburgh. Ray resigned after forty-three days on the job. "Prohibition is the biggest swindle in the history of the country," wrote Walter Liggett in "Pittsburgh: Metropolis of Corruption."

Ray was succeeded by John Pennington, another aggressive administrator, who delivered "blow after blow" to bootleggers until he was eventually transferred to Philadelphia. During his tenure, Pennington conducted 5,540 raids; closed 413 distilleries, 16 breweries and 44 alcohol plants; and confiscated 1,855 cars and 3.3 million gallons of mash and 113,000 gallons of alcohol. He also seized 75,000 pounds of corn sugar and 657,000 gallons of beer. Despite Pennington's efforts, Pittsburgh was still "wringing wet," wrote Liggett.

In 1928, Pennington was about to raid a political gathering at the Hipper Dipper's Club where the "booze flowed freely." Attending the event was William Larimer Mellon, the founder of Gulf Oil and a power in the Republican Party in Pittsburgh and Allegheny County.

Pennington's raiders were en route when Mellon got wind of the raid and made a telephone call, presumably to his uncle, Secretary Andrew Mellon. The federal agents promptly turned around and returned to the headquarters in Pittsburgh. Guests at the Hipper Dipper's Club toasted Mellon as "one hell of a grand guy," according to Liggett.

Pennington gathered evidence to indict Walsh and Faulkner plus other ranking officials and magistrates along with two state lawmakers for violating the Volstead Act. By the time their trials were scheduled to begin in November 1928, many of the witnesses disappeared and recanted their earlier testimony. Most of the defendants were exonerated.

During the Kline administration, there were sixty-three unsolved gang killings in the city, but it was the slaughter of three brothers in a run-down Hill District coffee shop that put pressure on Kline to act. John, Arthur and James Volpe were part of a bootlegging ring operating in the Turtle Creek Valley. Violent and politically powerful, the brothers were meeting on a July day in 1932 when three men arrived just as John Volpe left the building that served as the gang's headquarters. He was gunned down in the street. Then the men entered the shop and killed his brothers.

The bold daylight killings shocked the city and led to an outcry by newspapers to stop the bloodshed. Only Kline had the power to smash the gangs, and he was reluctant to do anything that would interrupt the flow of racket money into the political coffers of the Republican Party. The *Pittsburgh Post-Gazette* castigated Kline for refusing to join Allegheny County district attorney Andrew Park in cracking down on vice: "[Park] does not have the cooperation of Mayor Kline and his police force."

Prohibition in Pittsburgh was marked by bombings and murder as bootleggers battled for control of the yeast and sugar markets and turf. Gangland bosses were cut down in a hail of machine-gun fire or shotgun blasts, and the police seemed powerless, or unwilling, to find the killers. Major bootleggers had short life spans.

The Volpe brothers had moved their operation into Pittsburgh but were met by stiff resistance from rivals who resisted the interlopers' attempts to dictate prices for bootleg liquor. The public outcry was intense. Kline said he was taking personal charge of the investigation, and he assigned one hundred detectives to hunt down the killers.

After the killings, a Volpe business associate, John Bazzano, who had cornered the market on yeast and sugar needed to make moonshine, vanished after leaving his suburban Pittsburgh home for a meeting with Mafia bosses in New York City. Bazzano had ordered the Volpe murders. His butchered body was found stuffed in a burlap bag and dumped on a street in the Red Hook area of New York City as punishment for carrying out the unauthorized killings.

Bazzano's murder was never solved. Mike Spinelli, the alleged killer of the Volpes, was tracked down in Italy, but the Italian government refused to extradite him, tried him in that country and sentenced him to life in prison.

The rackets operated so openly throughout the city that the *Pittsburgh Post-Gazette* wondered why everybody but the police knew where they were located. Reporters entered the parlors and played craps and booked numbers without any problems as patrolmen sauntered over sidewalks littered with discarded numbers slips.

Kline was born in a small town in Indiana County, Pennsylvania, on Christmas Day 1870. He became a lawyer and moved to Pittsburgh, where he became a political protégé of Senator Max Leslie, who guided Kline to seats in the Pennsylvania House in 1904 and the Senate two years later before helping him gain appointment to the county bench in 1919. When Kline was elected mayor in 1926, he began building a political organization using the police, ward chairmen and bootleggers as the foundation.

Kline was a big spender when it came to the public's money. He spent nearly $6,000 to move a fire station that was then torn down. He purchased one hundred gold-plated keys to give to visiting dignitaries. But it was an oriental rug that was his downfall.

He angered the city's GOP committee by becoming the first mayor in seventy years to succeed himself, thereby usurping the party's power within Pittsburgh. There had not been a two-term mayor since 1865 because of a rule that a mayor couldn't succeed himself without an intervening term. A provision in the city charter changed that requirement in 1925, and Kline easily won reelection.

With the election of FDR in 1932, Kline's power began to crumble. City treasurer Roy Schooley and his aide, Arthur Burgoyne, came under scrutiny for the way Schooley handled the city's finances. The failure of the Franklin Savings and Trust Company initiated an audit of the treasurer's office that revealed that the city's money was not protected by bonds, as required by law.

Burgoyne had allowed the failing Franklin bank to use the bonds as collateral. Other irregularities soon developed, leading to a grand jury indictment of Schooley on embezzlement and misdemeanor charges. Schooley was then removed from office by Charles Kline, who himself was under fire for the scandal. Burgoyne was charged with embezzling $60,000 in public monies, but he was acquitted.

Schooley was born in Canada and came to Pittsburgh as a hockey referee before becoming manager of the Duquesne Gardens arena, home of the Pittsburgh Yellow Jackets hockey team, which later became the Pittsburgh Pirates of the National Hockey League. He began his career as a journalist for two city newspapers—the *Chronicle-Telegram* and *Gazette Times*—before his political skills helped John Fisher win the governor's office and led to jobs as campaign managers for Mayors Edward Babcock and Joseph Armstrong and the reelection of Kline.

Schooley also exonerated politically connected friends, some of whom were ward bosses, of delinquent taxes. "All I ever did was try to help my friends," he said. "I'm suffering for what I tried to do for my friends. All I did was try to help them." Schooley was too ill to attend his trial and died in 1933 while his trial was underway.

Bertram Succop had a distinguished career as a soldier fighting Mexican revolutionary Pancho Villa and in World War I as a lieutenant colonel during the Battles of the Marne, Château-Thierry and the Argonne Forest. After the war, he became a businessman and was

appointed by longtime friend Kline to be his director of property and supplies for the city.

Succop's purchasing practices violated municipal law and led to his firing by Kline and then to his indictment by a grand jury. Succop routinely awarded contracts without the required legal advertising and for ignoring the lowest price for items such as furniture, coal, food, cars, trucks and tires. He once purchased three used trucks, valued at $1,500, at a cost of $6,700.

Kline's political downfall began in February 1931 when grocer John Houston accused Succop of favoritism in the awarding of city contracts. Succop responded that it was just sour grapes on Houston's part, but Kline began a secret investigation. Kline's only criticism of Succop was that Succop exercised bad management and failed to correct "visible irregularities." Nevertheless, Kline fired his friend on May 24, 1931, prompting the *Pittsburgh Press* to question the thoroughness of Kline's probe. "Where are the 'visible irregularities' to which the mayor refers?" said the *Press* in an editorial. "The mayor should fire the mayor."

Succop's dismissal triggered a grand jury investigation, resulting in the indictments of both Kline and Succop. The law required that any purchases over $500 had to be advertised for bids, but Succop found a way around that requirement. One company seemed to have a monopoly on selling food to the city, earning $50,000 in taxpayer money over several years.

When it came to the purchase of canned goods for the city's poor home and hospital, Succop ordered $10,000 worth of supplies but split the deal into twenty separate contracts, each less than $500. When it came to ordering meat, the price per pound was added to the lowest bid. The bidder who submitted prices for all varieties of meat submitted higher prices on meat that was not ordered and lower prices on meats delivered.

Succop purchased milk that was two cents a quart higher than the lowest bid and cream that was twenty-five cents higher. A salesman, who happened to be the brother of a city attorney, was awarded $50,000 in soap contracts. He also purchased products from two straw parties who were secretly working for a Pittsburgh company that had been disqualified from doing business with the city. When he was asked about his purchasing practices, Succop told a reporter it was "none of the public's business."

In 1926, the Republican Party split over its candidates for U.S. senator and governor in the primary. The Philadelphia faction supported William Vare, who served seven terms in the House, while the western end of the party pushed incumbent Senator George Wharton Pepper and John Fisher for governor. Governor Pinchot also sought the Republican nomination. Kline

warned city payrollers they would lose their jobs if they failed to support Pepper and Fisher even though they were protected by civil service.

"Let me tell you ladies and gentlemen, it doesn't require any intelligence to cheat. But, the only unfortunate part of it will be it will take me only to May 19 to find a man who has cheated—notwithstanding we have Civil Service in Pittsburgh. I would not keep him five minutes after I discovered it," said Kline.

Vare defeated Pepper, with Pinchot coming in third. Pinchot refused to certify the vote totals because of allegations of voter fraud and questionable campaign spending. Pinchot's refusal led to the U.S. Senate's refusal to seat Vare and an investigation in which Kline was subpoenaed to testify about the threats he made to city employees.

Pittsburgh Press reporter A.W. Brown, who knew shorthand, covered Kline's speech to city workers and his newspaper published the speech verbatim on April 29, 1926. Kline threatened city workers with dismissal if they didn't support the Pepper-Fisher ticket. He reminded them that they owed their jobs to him and he expected them to vote for Pepper and Fisher. If they didn't, they could have to appeal to Vare for work.

When Vare won, Governor Gifford Pinchot refused to certify the election because of the amount of money Vare spent on the race. The Senate refused to seat Vare and held hearings into campaign spending and Kline's threats against city employees.

Kline testified to an incredulous committee of senators that he couldn't recall making or reading such a speech. Senators asked Kline if he read the story in the newspaper and didn't make the speech, why didn't he contact the newspaper and demand a retraction. "I never take a newspaper—read a newspaper—that is antagonistic to people that I am trying to represent," he replied.

The *Pittsburgh Press* said Kline must have had a "lapse of memory" since the story was entered into the record. Pepper had been one of Kline's professors in law school, and Fisher was a "bosom friend" who had grown up with Kline.

By 1931, Kline's support was eroding in the wake of the Schooley and Succop scandals. When Kline wanted to spruce up his office, he purchased an eighteen- by twenty-foot oriental rug costing $1,350 from a Pittsburgh department store without advertising for bids. Kline and Succop were indicted but were tried in Butler County, Pennsylvania, because of the amount of publicity the investigation generated in Pittsburgh. Kline was charged with thirteen counts of malfeasance in office; Succop was charged with thirty-nine.

Kline ordered his ward chairman to shake down racketeers in their districts for contributions to his defense fund. A parade of racketeers came to the home of Northside ward boss Johnny O'Donnell to protest having to contribute to Kline's legal woes. Nettie Gordon, the city's most famous madam and a Republican committeewoman, arrived in her limousine to talk to O'Donnell. After Gordon left, reporters pounced on O'Donnell. "I don't know anything about collecting," he said.

At his trial, Kline blamed his problems on Succop and city council. He testified that council president John Herron had urged him to order new carpets and had the department store send over several for his approval, telling the mayor council would approve the purchase. Kline quoted Herron: "Go ahead and present the resolution to council." The mayor testified that he had nothing to do with the purchase.

George Rieland, the salesman who sold the rug to the mayor, testified at Kline's trial that Kline personally viewed rugs at the Joseph Horne Department Store and said he just wanted a plain-looking rug. "I told him the dignity of the mayor demanded oriental rugs," Rieland testified. "I sent the rugs up on approval."

"What was the purpose?" special prosecutor Earl Reed asked. "I wanted him to live with them for awhile so that he could see I was right," Rieland answered.

Councilman W.Y. English and council president John Herron, who would succeed Kline as mayor, tried to take the blame. They said it was their fault that the rugs were purchased without bidding, not Kline's.

A jury found Kline guilty of only one count of malfeasance while Succop was convicted of twenty-five counts and faced a year in prison. In a surprise decision, the trial judge set aside Kline's verdict. "Congratulations, mayor," Succop said after the jury's verdict. "You've only started to fight, haven't you, Bert?" Kline replied.

Prosecutors appealed to the Pennsylvania Superior Court, and that body reinstated Kline's guilty verdict, which carried a six-month jail sentence and a $5,000 fine. Kline's attorneys mulled over whether to appeal to the Supreme Court, but the legal ordeal had taken its toll on Kline's health and left him few options. He would appeal to the Supreme Court or ask the trial judge to grant him a new trial. He was physically and emotionally drained and bitter over his fall from grace.

The two sides worked out a deal that spared Kline prison if he resigned as mayor. In a thirteen-word resignation letter, Kline left city hall and was succeeded by John Herron, the last Republican to serve as mayor. Kline

resigned in April 1933. Four months later, he was dead. He was sixty-two years old, reported city newspapers.

Kline left his estate to his wife, according to the *Pittsburgh Press*. The Klines had no children. His will did not list the value of his estate, and the legal document stipulated that his wife not be required to file an inventory of his assets—perhaps to hide from the public the extent of graft he had had accumulated during his time in office.

"Pittsburgh's government is sick," read an editorial in the *Pittsburgh Press*. "It has been sick for years." It noted that Kline's years as mayor were filled with police corruption, mismanagement and his personal extravagances. His moto when it came to taxpayers' dollars was "easy come, easy go," without any thought to the burden his spending practices placed on taxpayers. Public spending had increased while Kline was in office from $20 million to $29 million.

"The whole mess is just one more symptom of what's wrong with Pittsburgh. How much longer must Pittsburgh suffer?" read the *Press* editorial.

VOTE EARLY, VOTE OFTEN

*L*ong before he was mayor of Pittsburgh, a young Davey Lawrence was a Democratic Party worker moving his way up the political ladder that would take him to ward boss, chairman of the city and state party, mayor and then governor of Pennsylvania. On his way to party headquarters one morning, he saw two staffers jumping up and down on pieces of paper as if they were dancing. "What are you doing?" asked a bewildered Lawrence, according to Michael P. Weber's biography, *Don't Call Me Boss! David Lawrence, Pittsburgh Renaissance Mayor*.

"We're aging tax receipts," replied one of the men.

Bogus tax receipts, stuffing ballot boxes, night riders, phantom voters and chain voting were just a few of the tactics Pittsburgh politicians employed to alter the outcomes of elections over the decades in Pittsburgh. The main ploy was through tax receipts. Night riders were political partisans who altered election returns after the ballots were counted to ensure their candidates ended up winning the election.

To vote in Pennsylvania through the 1930s, a citizen had to provide a tax receipt to prove he paid his personal and property taxes so he would be eligible to vote in the primary and general elections. Residents could obtain a tax receipt for fifty cents from Allegheny County to provide their eligibility to vote. It was, essentially, a poll tax, a practice used since colonial times designed to limit voting to property owners. Wily political bosses used it as a tool to enhance the outcome of an election in their favor.

Politicians purchased thousands of tax receipts, depriving legitimate voters of a chance to cast a ballot. They also forged tax receipts or made

counterfeit receipts that were rumpled and made to look worn so the documents would fool election board officials. Then the receipts were distributed to individuals who could be counted on to vote for machine-backed candidates again and again.

Within two blocks of Treasury secretary Andrew Mellon's Pittsburgh home, investigators found residents who voted multiple times in the same election in 1931 or were registered as boarders at homes where they did not live. When investigators questioned one landlady about her tenants, she said they never lived there. "We never heard of them," the woman told the *Pittsburgh Press*. Investigators also found voters living in vacant houses, apartments, a barbershop and a church. Even the exclusive Duquesne Club, a haven for Pittsburgh's ultra-rich, became embroiled in the scandal. Twenty-one registered voters supposedly lived in the club's boiler room, according to the *Press*.

Registered voters were found living at nonexistent addresses and in dives, warehouse, empty garages and vacant lots. More than three thousand of these phantom voters cast ballots in the 1933 municipal primary in Pittsburgh, according to the *Post-Gazette*. "He steals your vote. He kills your vote," read an editorial in the *Pittsburgh Press* urging stern punishment for people caught voting illegally. In 1936, more than twenty thousand voters in Pittsburgh's Fifth Ward were registered to vote at more than one address.

A clerk at the St. Clair Hotel in Pittsburgh mistakenly gave a reporter for the *Pittsburgh Press* the names of thirty-six hotel guests, thinking the journalist was a member of the ruling Republican machine. Some of the names were marked with an asterisk and a notation: "Not likely to be here but can be voted by pinch hitters." Only six of the thirty-six "guests" resided at the hotel.

Pittsburgh Steelers star running back Fran Rogal's voting eligibility was cast into doubt after investigators discovered he didn't live at the address he claimed as his legal residence. He claimed he lived in his family home in North Braddock, which was occupied by his brother William and his wife. The address was the family homestead. "He keeps his clothes there, that's where his auto is registered and that's where he sleeps when he's in town," said his brother. "If that's not a home I don't know what you would call it."

Fraudulent elections brought corruption to city government along with graft and waste. Social programs aimed at improving public welfare were ignored by public officials more concerned with winning or retaining office. The public favored reform but the Pennsylvania General Assembly wouldn't allow bills introduced to end voter fraud be enacted because it wasn't in the interest of the Democrat or Republican Party.

Voter fraud is as old as elections, and in Pittsburgh, it's as old as the city. Pittsburgh had ousted a tyrannical mayor in 1841 only to see another elected, according to the *Pittsburgh Daily American*. The newspaper complained that fraud and corruption likely would continue under the new regime: "The scenes of fraud, corruption, and overbearing insolence of office, from which we had just escaped, are returned upon us, the armor which we buckled on so cheerfully a year ago, and had thrown aside after our victory, must be again resumed, to fight the same battle in the same cause."

In 1866, the *Pittsburgh Gazette* called for the creation of registries of voters to control the issuance of tax receipts to prevent unqualified citizens from voting. In 1902, the paper called for officials to stamp out voter fraud: "If the guilty are punished as they deserve to be there will be less likelihood of similar attempts at future elections." That never happened.

The main obstacle to ridding elections of fraud in Pittsburgh and Allegheny County was State Senator James Coyne of Pittsburgh, the head of the GOP in the city and county. Coyne had little formal education but understood the science of ward politics. The *Pittsburgh Press* singled out Coyne as an example of a corrupt political machine led by William Larimer Mellon, the founder of Gulf Oil and nephew of Andrew Mellon:

> *He is politically representative of all that is bad and iniquitous in our local government; he is the boss of a gang whose members have been repeatedly indicted and often convicted in offenses all the way from dishonesty at the polls to corruption in office; his attitude as politician and legislator has been opposed to the best interests of Pittsburgh and the state at large; he is carrying on this campaign with himself and many of his principal leaders under federal indictment—and the list might be carried on and on.*

Federal and Allegheny County grand juries routinely issued sweeping indictments for voter fraud rolling up ward heelers, police officials and entire election boards. Coyne, along with 8 of his lieutenants, was among 107 indicted for voter fraud during the congressional election of Republican M.J. Muldowney of Pittsburgh. The defendants included Coyne's brother, Tom; Hill District boss John Verona; Pat Maloney, a state lawmaker; and P.J. O'Malley, GOP leader in the Strip District.

The Democratic candidate, Anne Felix, cried after FDR and other Democratic candidates swept into office by landslides in 1932—except for Pittsburgh's Thirty-Second Congressional District, which favored Muldowney through the help of Coyne and his cronies. In the city's Thirteenth

Congressional District, incumbent Democrat Twing Brooks charged that night riders swayed the race in favor of Republican Edmund Erb.

Felix accused city Democratic chairman David Lawrence of trying to block an investigation into voter fraud because Lawrence and Coyne were close friends and political cronies despite being in separate parties, according to the *Pittsburgh Press*. Lawrence called the allegations an "untruth."

Her charges triggered a federal grand jury investigation that issued 1,100 subpoenas for politicians, election board officials, ward chairmen, constables and justices of the peace. Muldowney polled 24,875 votes to 18,986 for Felix. She said a large majority of voters voted straight Democrat by writing an X on the ballot. After the ballot boxes reached the office of the justice of the peace in the district, someone placed Xs besides Muldowney's name.

Coyne's rule as GOP boss in Pittsburgh was a "dark era in Pittsburgh politics," the *Pittsburgh Press* noted. Vote fraud was rampant, and attempts to introduce social programs were crushed politically. "If these charges of fraud are found to be true, this is an opportunity for the greatest cleanup of crooked politicians in Pittsburgh history."

On election night in 1932, Coyne and other GOP bosses huddled at the William Penn Hotel watching FDR and state and local Democrats winning by landslides. "The whole damn works is sunk," lamented O'Malley. Coyne was busy making phone calls, and witnesses testified that Coyne gave his brother orders to send out the night riders to alter votes in specific wards. Nettie Llewellyn, an election board clerk, was counting ballots when she received a message that her mother was dying and quickly headed home before realizing she had been tricked.

Coyne's first trial ended in a hung jury. He was acquitted following a second trial, but his political grasp was eroding. Out of the 106 individuals indicted, 59 were convicted of vote fraud and 17 were acquitted. The charges against the rest were dismissed.

Coyne came to the United States from Galway, Ireland, and drove a beer wagon pulled by a team of horses. He had little formal education but understood the science of ward politics. He later bought a saloon, a gathering spot for local politicians, and began his climb up the political ladder with the slogan "a vote is a vote."

After Coyne was unseated in the state senate, he tried to make a political comeback by running for commissioner of Allegheny County. "An electorate which had respected his potency for so many years appeared unwilling to admit the giant had lost his strength," wrote the *Pittsburgh Press*.

Coyne still found himself in hot water as Prohibition neared an end. He was subpoenaed to appear before a grand jury to explain $753,000 in bank deposits, money he received from distilleries and wine companies. Coyne said he owned large stocks of whiskey before the enactment of Prohibition and had government permits to sell whiskey for medicinal purposes and to licensed wholesalers. He invoked the Fifth Amendment against self-incrimination.

In a petition to the U.S. Board of Tax Appeals, Coyne said he was simply a stakeholder in deals between friends and his "reputation for integrity in financial matters was such in his community that he was frequently entrusted upon oral agreements with temporary custody of large sums of money which were paid to him in trust and repaid by him."

"I now find I am going to pay income tax on a lot of the bets and business deals of my friends," Coyne told reporters. "I know now that I was a damn fool for putting this money in my own bank account but we live and learn." He settled the tax dispute with the government for $90,000.

Winning an office is one part of the electoral process. Keeping the office is another, and for these politicians, breaking the law to remain in power was often required. Entire election boards were in on the fraud. Phantom voters existed to cast ballots for machine-backed candidates. Night riders stormed polling places after they closed, opened the ballot boxes and altered the vote totals. Sometimes, boxes were thrown into one of the city's three rivers. The *Press* reported that interference in the vote totals in eleven ballot boxes out of a dozen turned a Democratic landslide into Republican victories.

The law required election results be taken to the offices of a justice of the peace or alderman for safekeeping before they were taken to the county courthouse in Pittsburgh for the official count. By that time, the results had been altered, so an accurate count was impossible. A judge said there was no use in holding a recount "because there is so much fraud in this box that's impossible to get an honest return."

Reformers railed against these dirty machine tricks. Governor Gifford Pinchot once dispatched state troopers to Pittsburgh to stand guard at voting sites to protect the integrity of the election. Competing Pittsburgh politicians took elections seriously, often engaging in street brawls and gunfights in public. Pittsburgh police officers waged war against the constables working for police magistrates and justices of the peace over political turf.

Riots broke out in some districts before an election, as the Democrats and Republicans debated politics with guns, knives and fists. The *Pittsburgh Press*

detailed a story about an Election Day riot in front of a police station after city detectives interrupted a vote count by kicking over tables.

Constables in one precinct pulled their guns on police officers holding them at bay. In the Southside, bricks and fists flew between rival factions, reported the *Gazette Times*. Gunmen threatened poll workers and locked the doors to another polling place, forcing police to storm the polls. County detectives arrested city police officers for interfering with voting. Pittsburgh police detective Joe "Bozo" Lavery was arrested by county detectives after he closed a polling station for twenty minutes.

Lavery once walked into the campaign headquarters of John Murphy, a candidate for Allegheny County recorder of deeds, and slugged Murphy. When Murphy's son tried to intervene, Lavery threw him down the steps. The Murphys, along with a third man, were arrested and held without bond until the charges were dismissed.

George A. Faber Jr., twenty-two, was killed during an election dispute in 1927 during a battle between two ward bosses. Faber was leaving a store with two friends when gunmen in a speeding car sprayed the street. The *Press* reported the car contained "gangsters" involved in a political battle.

Patty Colangelo was charged with the murder, but the charges were dropped after a witness was unable to identify him as the gunman. A coroner's jury ruled Faber was killed by "person or persons unknown," according to the *Press*. Two political factions staged a running gun battle on a city street. Rival gangs shot up offices of opposing candidates to intimidate voters into staying home. The *Post* reported that when a young woman expressed her preference for a certain candidate, a city fireman knocked her to the ground.

Grand juries routinely investigated incidents of voter fraud, but the illegal practices continued. In 1929, the *Pittsburgh Press* noted thirty people had been subpoenaed to testify before a grand jury investigating the use of names of people not listed on tax rolls. In 1933, another grand jury questioned three thousand individuals during a vote fraud investigation and discovered some voters had not lived at their addresses for the required sixty days but had tax receipts allowing them to vote. When questioned, they were unable to explain how they obtained the receipts. Investigators who went to various wards to investigate allegations of vote fraud were stoned by residents.

In the first half of the twentieth century, the police force was dominated by politics. Officers were hired, promoted and awarded plum assignments based on their political connections. Depending on who was in office determined whether a ranking police official remained on the job or ended up walking a beat. Men with no training or law enforcement experience

Pittsburgh Hymie Martin. *From the* Pittsburgh Post-Gazette *Archives.*

could end up becoming lieutenant, captain, inspector or assistant police superintendent if they were close to the right politicians.

Lawrence J. Maloney was one of those police officers whose links to politics led him from a job as a janitor to assistant superintendent of police. Maloney headed a special unit tasked with breaking up the numbers racket in Pittsburgh. Known as "Maloney's Marauders," the force racked up an impressive number of arrests of gamblers and racketeers until it became known that Maloney was only arresting low-level bookmakers who were in competition to the bookies he was being paid to protect.

Maloney made a fortune by taking bribes from gamblers such as Pittsburgh "Hymie" Martin, Martin "the Wig" Walkow, Abe "Piggy" Rabinowitz, Walter "Pavo" Crisanti and Myer "Slickman" Sigal, who would testify they all paid protection to Maloney during his years as head of the racket squad.

Maloney was a Democratic Party committeeman when he became a cop. He was hired part-time in 1942 and eight days later was made a full-time officer. He was promoted in 1943 to detective and joined the navy in 1944 but only served forty days before being discharged for medical reasons. After the war, he was made a police lieutenant.

A year later, he was named head of the racket squad. In 1948, the unit was disbanded and Maloney was promoted to inspector. He was named assistant superintendent of police in 1958. In 1964, he was accused of failing to report $230,000 in income from 1958 to 1963 when he was assistant superintendent. He was charged with bribery and extortion in 1967 for accepting payoffs from gamblers, but the charges were dismissed because the statute of limitations had expired.

Maloney was charged again in 1968 for taking payoffs but was acquitted despite the testimony from a string of bookies and a former member of the squad who testified he was Maloney's "bagman." He died of bone cancer in 1969 while awaiting trial in federal court for income tax evasion for failing to pay $645,000 in back taxes. A federal grand jury indicted him for income tax evasion, but he was acquitted by a jury—then fired by the city.

In the 1930s, the Republican political machine also employed chain voting. Poll workers handed out ballots already marked with the names of preferred candidate to voters, who then cast ballots in machine-controlled wards. Party workers and city employees entered voting booths to help voters pick candidates. Charles McGovern, who would become an Allegheny County commissioner, testified in 1923 before a Pennsylvania House committee investigating voting fraud and said that "the elections in Allegheny County the past few years have been so corrupt it was hardly worth holding them."

PITTSBURGH'S CLOWN PRINCE OF POLITICS

William Nissley McNair was the clown prince of Pittsburgh politics, and in his thirty-four months as mayor during the 1930s, he turned his abbreviated tenure into a three-ring circus. Democrats had high hopes for the fifty-three-year-old Mennonite whose election ended twenty-eight years of Republican control of city government. Their hopes were quickly dashed, as McNair wrote one of the most chaotic chapters in Pittsburgh political history. McNair's sudden resignation in 1936 was a surprise, but few were sorry to see him go.

He came into office on the coattails of FDR's election in 1932, buoyed by disaffected Republicans and an electorate sick of GOP corruption. McNair polled more than 102,000 votes to incumbent John Herron's 75,507, smashing the political machine of W.L. Mellon and Senator James Coyne. "I have promised the people of this community a new deal at city hall and that's what they're going to get," he pledged. The *Pittsburgh Press* editorialized that voters weren't expecting miracles but noted, "They do expect honesty. They do expect decency."

Democratic Party chairman David Lawrence became patronage boss of western Pennsylvania after FDR's election in 1932, and Lawrence expected McNair to heed Lawrence's hiring recommendations. But McNair took control of jobs, leaving Lawrence to stew.

"You know, I made an agreement with Davey Lawrence that I'd let the Democratic Party handle all the patronage if I was elected," he told a reporter. "But if I'm elected, who'll be the Democratic Party? As

mayor of Pittsburgh, I'll be the most important Democratic office holder in Pennsylvania and I'll be the Democratic Party. How'll Davey like that? David Lawrence thought I was going to be a puppet," McNair said. "Poor Davey, he certainly was fooled."

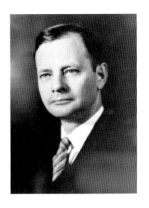

John Jones, a veteran city hall reporter for the *Pittsburgh Press*, recalled Lawrence lamenting his decision to support McNair for mayor. "He picked McNair as a candidate and he later said in a half joking and half serious way, 'If I had known that he was going to be elected I'd have never put him up,'" said Jones in an oral history among the Michael P. Weber papers at the University of Pittsburgh. "I'd have run myself."

Mayor William McNair.
William McNair Papers, Archives Service Center, University of Pittsburgh.

McNair's rise from the political dustbin to mayor had little to do with McNair's political skills and more to do with the people who used him to achieve their political goals. Lawrence hustled McNair off to Washington, D.C., where he met with President Roosevelt, whose Pennsylvania election campaign was managed by Lawrence and Senator Joe Guffey.

Lawrence used the election to build a political machine that has kept the Democratic Party in power ever since—then he stood aside and watched McNair destroy himself by becoming a political buffoon.

Some thought McNair was crazy. The Central Labor Council of Pittsburgh passed a resolution questioning his sanity after he criticized the American Federation of Labor. The mayor, the resolution read, "is either mentally unbalanced, mentally underdeveloped or a tool, either wittingly or unwittingly, of the vicious reaction forces of the city and state." McNair immediately challenged the Labor Council to a public debate over his sanity. He proposed holding the debate in Forbes Field, the home of the Pittsburgh Pirates; Pitt Stadium, home of the University of Pittsburgh football team; or spacious Schenley Park. "I'll debate them anytime," he said. Pat Fagan, an official of the Labor Council, replied, "You can't reason with a clown."

McNair opposed the Works Progress Administration because he considered the awarding of jobs as pork barrel politics despite the number of unemployed during the Great Depression. He charged Roosevelt "has killed a lot of little pigs but all it's done is raise the price of ham." He complained the WPA in Pennsylvania was controlled by Senator Guffey and "the setup is political throughout," reported the *Pittsburgh Press*.

The WPA was part of Roosevelt's New Deal to put unemployed men back to work building public buildings and highways. McNair went on vacation to Atlantic City in 1935 to avoid a meeting held to open bids for WPA projects. Council couldn't approve the projects unless the mayor was present. Governor George H. Earle ordered state relief cut off for Pittsburgh because McNair refused to cooperate.

McNair cut jobs for public health and child welfare workers during the Great Depression when help was needed the most. "A child who is in the slums now is going to have to stay there until business gets better," he said. He refused to sign checks to pay for the purchase of shoes—which had already been distributed— for needy children, causing the director of public welfare to quit.

On his first day on the job, January 2, 1933, McNair strode into city hall munching on an apple. When reporters pestered him about his pending appointments to city departments, he avoided answering by replying, "This is a fine apple." Then he placed his desk in the lobby of city hall after his inauguration and, for a time, held court while an orchestra played music as he worked. Anyone who approached the mayor was likely to get a lecture on his longtime obsession—Henry George's single-tax theory, an economic idea that a single tax on land could finance government operations.

While sitting in the lobby, a man asked McNair for a city job. "What sort of job?" McNair asked. "Digging," replied the man. "What sort of digging?" McNair countered. "If you want to dig for Pittsburgh you've got to take an examination. How far is it to China?" A destitute man approached the mayor for help in getting coal to heat his home. "Why come see me? Go out and dig some." McNair said.

During his first six months as mayor, he hired and fired city employees on a whim. He fired four public safety directors within a year. He appointed a numbers writer as the city's transit director even though he tried to wipe out the numbers racket by personally conducting raids. In the span of a week, he fired the fire chief and public safety director without explaining why. He fired Public Safety Director A. Marshall Bell by leaving a message with Bell's wife. The *Pittsburgh Press* accused McNair of spreading fear and terror through city hall. "Workers saw a savage side to the Mayor; his conduct was no longer merely a laughing matter," wrote the newspaper.

In 1935, McNair proclaimed Jubilee Day in the city to "put a little life into the old town." He staged a parade with floats and forced city workers to march the five-mile route with him to Forbes Field. One newspaper said the event was a waste of time and money. "The McNair administration

finally arrives in the big time, transferring its showmanship from city hall to Forbes Field. The city employees haven't done any work for the past two weeks except sell tickets and the beauty queen…has been selling pulchritude coupons," wrote the *Post-Gazette*.

In 1936, McNair invited Congressman Marion Zioncheck of Washington to visit Pittsburgh. Zioncheck was a heavy drinker who loved the nightlife. He arrived at McNair's home early one morning, but McNair refused to get out of bed to greet him. Zioncheck showed up at the mayor's office the next morning, but McNair wasn't there. Instead, a drunken Zioncheck and a professional wrestler, Ali Baba, held court during a live radio broadcast for fifteen minutes, cussing over the air and staging an impromptu wrestling match in the mayor's office, according to an account in the *Press*, before Zioncheck lay down on McNair's desk to rest.

The *Pittsburgh Press* was critical of McNair for allowing the mockery to take place. "The mayor is a magnet for queer visitors and he always has plenty of time to devote to them," read an editorial, "because there's never anything to do." While the farce was going on, McNair refused to authorize payment, putting the city's credit rating in jeopardy because he was too busy.

"Mayor McNair is now trying to destroy the credit of Pittsburgh by refusing to sign warrants for the payment of bond interest. He is deliberately trying to lower the credit rating of Pittsburgh. Not only that, he admits it," reported the *Press*. "Almost from the day he took office Mr. McNair has sought to destroy Pittsburgh's credit."

Among his closest advisors were "Hunky Joe" Lewandowski, a former numbers boss and "Bozo" Lavery, a former bad boy cop turned McNair bodyguard. Father Peter Tkach, a Russian Orthodox priest, served as McNair's Rasputin. McNair appointed an alcoholic playboy to a city post, but the appointee promptly got drunk his first day on the job and was fired.

Lavery had been a policeman in Pittsburgh and was fired and reinstated three times and promoted to detective by McNair. Lewandowski had run the numbers racket in the Southside and became transit commissioner under McNair along with Tkach, who wrote a fawning biography of the mayor.

McNair had a confrontational relationship with city council, which caused municipal government to grind to a halt. After councilmen failed to show up for a meeting, he declared all but one of the seats vacant. Council ignored his edict. He tried to promote one of his public safety directors rather than fire him, but council refused to approve the promotion. McNair was jailed for refusing a judge's order to return an unlawful fine he had assessed a bookie.

Lawrence initially viewed McNair as an honest, well-spoken politician who was the Democratic Party's best chance to break the Republican stranglehold on Pittsburgh politics. Lawrence intimately knew the problems facing the working class—poor housing and healthcare, unemployment and a polluted environment—and embraced the New Deal.

McNair was impulsive and erratic. He loved the notoriety that came with being mayor and was constantly in the news. A newspaper devoted six stories to him in one edition. The *Pittsburgh Press* published 961 column inches about him in a six-month period, but McNair grew tired of questions by journalists, threatening to charge reporters ten dollars for a fifteen-minute interview so they would leave him alone. "If a newsman cannot get my ideas in that time, it is useless to continue the discussion and he would only resort to ridicule to cover up his ignorance."

He was paid $1,500 to appear onstage at the Alvin Theater with a jackass. *Pittsburgh Press* writer Kaspar Monahan said McNair needed the cash to finance a lawsuit to stop pollution on the Clarion River, which flows through the central Pennsylvania counties of Clarion, McKean, Forest, Elk and Jefferson. The emcee presented McNair to the audience, proclaiming, "Dots, dashes and lots of flashes." McNair also appeared on the *Major Bowes Amateur Hour* with crooner Rudy Vallée. He saw little difference between politics and vaudeville.

"The mayor cut many a merry jape and caper," Monahan wrote. "He sang an operatic bit in Italian, he told stories, one partly in Pennsylvania Dutch, borrowed a fiddle from a bandsman and fiddled a tune and even did a bit of heel and toe work."

McNair was born on October 5, 1880, in Middletown, Pennsylvania He graduated from Gettysburg College and the University of Michigan Law School. He was a humble man who lived simply in a modest house with his wife and two daughters. He didn't care what people thought of him.

"I'm just a commonplace, everyday kind of person striving for simplicity in everything," he said. "One day I was attorney William McNair, candidate, without much success for mayor of Pittsburgh and my comings and goings were of no concern. The next day I was mayor-elect McNair and I wore out one hand accepting greetings from people who suddenly developed an interest in me."

McNair had politics in his DNA. He got involved in politics after graduating from law school because "it was a way for a young, struggling lawyer to be able to eat." His father was involved in politics in eastern Pennsylvania, and his brother was once mayor of Harrisburg. In 1904, McNair campaigned for

a candidate for district attorney and another for city controller. He stumped for William Jennings Bryan in 1908 and ran and lost for Allegheny County district attorney the following year.

He campaigned for Woodrow Wilson. McNair first ran for mayor in 1921 and was arrested during the campaign for giving a speech. McNair jumped up on a soapbox that he had brought with him and began railing against the corruption in the police magistrate system when a police officer hauled him off to jail.

He ran for the U.S. Senate in 1928 and lost. McNair lost a bid for Congress in 1936. He ran again for mayor in 1937, losing in the primary. In 1944, he served one term in the general assembly and was defeated for reelection. McNair said he lost more campaigns than the Italian army. "My psychology has been accustomed to defeat. You might say I`m a defeatist. It's almost natural for me to be a loser."

After a string of losses, McNair became the forty-ninth mayor of Pittsburgh, but he was ill-prepared to govern. On the day he was elected, McNair returned home after the polls closed and was greeted by supporters listening to election news on the radio. He was headed off to bed, thinking he had suffered another defeat, until his daughter pointed at him and said he was the new mayor of Pittsburgh. "That isn't the mayor," said his disbelieving wife. "That's just papa."

After his election, McNair asked city council to cut his salary from $15,000 to $10,000, but the body wouldn't authorize the reduction. "I'll take everything that's coming to me. I can't change my salary and council wouldn't," he said.

McNair shunned political gatherings and banquets if he had to sit at the head table. "That's what gives a fellow a swelled head—sitting like a stuffed shirt in front of everybody where they have to look all the time." He once left a banquet held in his honor because he didn't like the way the food was prepared. McNair was a Mennonite of German stock. After he was elected, a group of German women, dressed as Mennonites, staged a banquet in his honor featuring *schnitz un knepp*, a Pennsylvania Dutch dish made of dried apples, dumplings and ham. McNair was supposed to sit between David Lawrence, then chairman of the city's Democratic committee, and Robert Garland, the Republican president of city council.

Before the dinner began, McNair went into the kitchen to thank the cooks. He never returned, so the event went on without the guest of honor. "Where did he go?" someone asked. "I guess he went out to eat," quipped Lawrence. When asked about his sudden departure, McNair said, "Why I wouldn't think of eating schnitz un knepp that didn't have ham cooked in it. They cooked the ham separate. Can you imagine that?"

The first time he ran for public office, he campaigned on his honeymoon. He learned to speak Italian so he could read a book on the single-tax theory by Italian economist Gaetano Filangieri, an eighteenth-century economic theorist and philosopher. McNair once conversed with Pope Pius XI in Italian during a visit to the Vatican and offered the pontiff a Pittsburgh-made cigar. "I couldn't understand much of the pope's Italian but his secretary was surprised that I could speak Italian. I said, 'yes,' with a Pittsburgh accent. The pope was a fine fellow," reported the *Pittsburgh Post-Gazette* on the visit.

McNair built a Lilliputian house—dubbed "McNair's Manor" by the press—in the shadow of the Allegheny County Courthouse. The Cape Cod–style house was to be a model to house the homeless rather than to allow them to live in the shantytowns that dotted the city's urban landscape. His plan was to build five hundred houses at a cost of $750 each on vacant lots throughout the city, but the project never got off the ground. Two years later, the model was dismantled and sold to a farmer for $1,200.

When a city plan to build an incinerator to burn garbage met with public opposition, McNair suggested closing the South Hills tunnels and filling them with trash. "I dunno, maybe it would be for the best," he said.

In 1936, McNair went to Washington to testify before the House Ways and Means Committee about a pending tax bill that would tax the budget surpluses of Pittsburgh corporations. He was being questioned by one of the congressman on the committee, but McNair began answering the congressman's question before the congressman finished asking it. "You can't act like that," the lawmaker said. "You must show the committee some courtesy."

"This committee isn't showing Pittsburgh any courtesy when it passes this tax bill," he replied. "You must not interrupt," the congressman said. "You fellows are interrupting me," said an agitated McNair. "I'm the mayor of Pittsburgh. I've got some rights. This is a free country. I can make a statement if I want to and nobody on this committee and nobody else can stop me." The committee had enough of McNair. "You can get out. Isn't there a policeman here to put this fellow out?" said a congressman in an account in the *Pittsburgh Press*.

"You fellows tax us for everything, even for a few cigaretes [*sic*]. I've even given up smoking cigarets. I smoke Pittsburgh stogies but I'm going to stop that, too, so you fellows won't get it." Back in Pittsburgh, McNair met reporters, produced a box of cigars and lit one. "You are witnessing me smoke my last cigar until those congresmen stop putting a tax of two cents on every one a man smokes." Newspaper praised McNair for his stance: "It is rather refreshing to have someone tell a committee of

congressmen exactly what he thinks of its policies and mince no words in the process."

When Prohibition ended, Pennsylvania had 12.5 million gallons of whiskey stored in warehouses. The liquor, nicknamed "Sweepstakes" whiskey, went through a quick aging process. Detractors called it "Pinchot Whiskey," after Governor Gifford Pinchot, which the governor ordered the state to sell for $1 a bottle in the hope of generating $575,000 in much-needed revenue. McNair opposed the sale of "Sweepstakes" whiskey and tried to start another Whiskey Rebellion by going to war with Pinchot, who wanted to use the sale of the whiskey to generate revenue for relief during the Great Depression.

As mayor, one of McNair's duties was to sit as magistrate in morals court hearing liquor-related cases. He dismissed some cases and refused to listen to testimony in others, allowing the defendants to get off. He dismissed a charge against a woman for having a bottle of untaxed whiskey in her possession, saying the only crime the woman was guilty of was "competing in the rotten liquor business with Governor Pinchot."

When sixty drunks appeared before him on charges of public intoxication, they blamed their stupor on "Pinchot Whiskey."

"How do you feel?" asked the mayor. "Rotten," they replied in unison, according to an account of the hearing in the *Pittsburgh Press*. "What have you been drinking? Some of Pinchot's liquor?"

"Yes, sir," they replied. "Well, let's tell the governor about that," said McNair, who immediately called Pinchot's office in Harrisburg and talked to the governor's wife, Cornelia Bryce Pinchot. After talking with Mrs. Pinchot, McNair gave the telephone to one of the drunks.

"I tell you this is pretty bad stuff. I just took three drinks and I woke up in the police station," said the man.

"The drunks talk much more coherently and intelligently than the mayor did," Mrs. Pinchot told a *Press* reporter.

McNair released all sixty.

Then at a speech at the Pittsburgh YMCA, McNair said he would lead the Woman's Christian Temperance Union against "Sweepstakes" whiskey by removing the liquor from the city's state stores. He urged the young men in the audience to join him on a raid. He left the podium and marched to the lobby, followed by an aroused contingent, when he suddenly stopped.

"I was just joking," McNair said. "I have an appointment to play bridge."

By 1935, Lawrence had enough of McNair. Lawrence instructed his political operatives in Harrisburg to introduce a ripper bill, legislation to remove McNair from office and abolish the post of mayor. "I put him in.

Former mayor William McNair roping a steer in a publicity stunt during his campaign for Congress. *William McNair Papers, Archives Service Center, University of Pittsburgh.*

I'll take him out," Lawrence told the *Pittsburgh Press*. "Davey Lawrence cracks the whip in Harrisburg and McNair walks out as mayor of Pittsburgh. It is your right to say who should be mayor, not Davey Lawrence," McNair countered.

When the bill passed the House and went to the Senate, McNair placed a bed in his office and vowed to resist state police attempts to remove him. Senate Republicans blocked the bill in committee, but newspapers began to lose confidence in McNair and questioned his competency. The *Post-Gazette* said McNair should resign or be removed from office. McNair threated to leave office when the legislature considered the ripper bill and the *Pittsburgh Press* called him on it.

"It is inconceivable how Pittsburgh can weather another year of the sort of mis-government it has had for the last year," read an editorial. "The Democrats, upon whom falls the largest responsibility for getting Mr. McNair into office, are logically the ones to bear the brunt of the fight to get him out. They owe that much to the public."

In March 1936, a flood on St. Patrick's Day caused $250 million in damage, killed 47, injured 2,800 and inundated the downtown business district. More than 67,000 were homeless. Factories and steel mills were flooded as the three rivers peaked at forty-six feet, twenty-one feet above flood stage.

While a darkened city was trying to recover from the devastation and loss of heat and electricity, McNair threatened to arrest the president of the electric company because the lights and elevators at city hall were not working. He vetoed a $100,000 grant to the Red Cross aimed at providing aid to residents displaced by the flood waters. Council overrode his veto.

After the floodwaters receded, city council authorized McNair to call a conference of Pittsburgh's business and industrial leaders to discuss recovery,

but the chamber of commerce usurped McNair's authority, seizing the initiative from him and taking over the task.

In October, he fired the city treasurer, whose signature was needed to sign checks. Council refused to confirm a replacement, so McNair decided to resign. He retreated to his law office after handing a one-sentence letter to city clerk Edward Schofield: "I hereby resign from the office of mayor of the City of Pittsburgh effective immediately."

McNair had second thoughts and tried to rescind his resignation, but city council quickly accepted and swore in Cornelius Scully as his successor. A reporter for the *Pittsburgh Press* calling

Cornelius Scully succeeded Mayor William McNair, who turned city government into a three-ring circus. *From the* Pittsburgh Post-Gazette *Archives.*

McNair for comment asked if the mayor was in. "No, the mayor's not here," McNair replied. "This is Mr. McNair. My shingle is out again." McNair faded into obscurity after he resigned. His phone no longer rang. People no longer came to visit him. "I'm sort of a forgotten man. I'm just a lawyer now."

He waged an unsuccessful campaign for Congress while smoking a cigar on a steer, carrying a lasso and wearing a ten-gallon cowboy hat in front of city hall. His stunt snarled traffic, according to a story in the *New York Times*.

McNair hadn't given up on politics even though politics seemed to have given up on him. He was elected to the state legislature in 1944 by twenty-six votes but was defeated after one term. In 1948, he announced he would run for president but abandoned that idea to unsuccessfully run again for the Pennsylvania House.

That same year, McNair and his wife were in St. Louis, where McNair gave a speech on the single-tax theory. His wife was traveling to Texas to visit relatives. The former mayor went to Union Station to bid her goodbye. As her train pulled away, McNair collapsed and died of a heart attack. "There was never monotony when McNair was around and it will be a long time before there's another like him," observed the *Post-Gazette*.

Newspapers praised McNair for his honesty but wrote that his election was a mistake. He loved the publicity, cared nothing for governing and cared even less about what people thought of him. "For though Bill McNair was as honest a man who ever held public office, his friends and foes will agree he should never have been mayor."

BOSS LAWRENCE

David Lawrence was a shanty Irishman born in one of the poorest neighborhoods of Pittsburgh. He grew up to become mayor and later governor of Pennsylvania—but not before his political path was blocked by several scandals that would have ruined a lesser politician. Even after he became mayor, Lawrence faced scandals that rocked his administration but failed to deter him from reaching the governor's mansion in Harrisburg.

Lawrence was dogged by scandal since his start in politics. In 1929, he was a partner in a struggling insurance business along with partners State Senator Frank Harris and Senator James Coyne, a Republican power in Pittsburgh and Allegheny County who had invested in Lawrence's firm. Lawrence's financial situation soon improved. The state, undoubtedly with Coyne's help, started purchasing all of its surety bonds from Lawrence and three other firms, generating badly needed income for Lawrence.

While he was chairman of the State Democratic Committee, Lawrence weathered allegations that state architects kicked back $1.2 million to Lawrence in fees from a $65 million building program. He also was accused of accepting a $20,000 bribe from brewing interests for influencing legislation affecting brewers.

The first major scandal Lawrence faced involved gravel. John Verona, a political power broker from the city's Hill District, was promised the job of purchasing agent for the state liquor system while Lawrence was state party boss. The job never materialized, so Verona was promised a cut from

the purchase of gravel for state road projects in various counties. Verona would get $0.10 for every ton of gravel the state bought, which amounted to $30,000 for him.

Verona, Lawrence and Spurgeon Bowser—president of Pioneer Materials Company, who was promised his gravel company would be awarded the contracts through the intercession of county Democratic Committee bosses—worked out the deal. Verona escorted Bowser to Lawrence's summer home at Conneaut Lake in Crawford County to seal the arrangement. At the meeting, Lawrence told Bowser that Verona owed him $10,000, and Lawrence expected Bowser to make good on the debt if Pioneer was to be awarded the contracts. Bowser later gave Lawrence a $5,000 down payment in a room at the Roosevelt Hotel.

Lawrence went on trial in 1939 for rigging the gravel bids. Arthur Colgrove, head of the Democratic Party in Erie County, testified that he was told by a "Mr. So-and-So" to make sure Pioneer was awarded the gravel contract. Pioneer was awarded 128 of 138 contracts to provide stone for townships in Erie County. Later testimony revealed that "Mr. So-and-So" was Lawrence, who testified in his own defense that he had no role as party chairman in deciding who was awarded state contract and never received $5,000 from Bowser.

What Lawrence didn't know at the time was that Sidney Toy, a bookkeeper for Bowser, was hiding under the bed in room 826 of the Roosevelt Hotel and testified that he heard Lawrence accept the money. He also told the jury how Lawrence told Bowser he also had accepted a $10,000 bribe in 1936 and $25,000 from an attorney working for the Pennsylvania Railroad.

Lawrence, according to Toy's account detailed in the *Pittsburgh Press*, asked Bowser what he told a grand jury investigating the gravel scandal. Toy said Lawrence asked at least a dozen times if the grand jury asked Bowser about any other payments he had made to Lawrence.

"Did they ask you if I ever did any favors for you or if you had asked any favors of me?" Lawrence asked.

"Yes, they asked me that question. I told them you had not," Bowser replied.

A jury composed of Republicans acquitted Lawrence, who returned to Pittsburgh to find five thousand cheering supporters to greet him at the Pennsylvania Railroad Station.

Lawrence went on trial in March of the following year for macing, which is the illegal practice of forcing government payrollers to contribute money to a politician's election campaign or face losing their jobs. Macing is as old as

politics and was practiced by Democrats and Republicans to raise campaign donations. State employees earning over $1,200 a year were expected to contribute 3 percent of their salaries to the Democratic Committee, while workers making over $1,500 were required to kick in 5 percent.

Lawrence testified no state employees were fired for failing to contribute. "I don't know of one employee," he said. "The first I heard of it was when these charges were filed," according to an account in the *Pittsburgh Press*.

Lawrence was again acquitted after the prosecution was unable to produce evidence that any state workers were fired for failing to donate. The state committee also fell short of its fundraising goal of $901,000, only receiving $351,000 in donations from state employees.

His attorneys argued that macing was a tradition used by both parties to raise money to finance campaigns. He was acquitted again after the jury decided that the contributions were voluntary.

Mayor Cornelius Scully told the *Pittsburgh Press* after Lawrence's acquittal that he disapproved of macing: "I never believed in macing and there has never been any macing in my administration regardless of what anyone may say." That brought a chuckle from a city worker, who said, "[I]t's just the way you interpret things."

Lawrence was a product of the Point, where the Allegheny and Monongahela join to form the Ohio River. When Lawrence was born on June 18, 1889, the area was known as "Point Irish" or "Little Ireland" because it was populated by immigrants from Galway who worked as blue-collar laborers. The Point was a poor, filthy, unsanitary place to live. Irish families lived squeezed together in tenements.

As a boy, he worked as a *Shabbos* goy, doing jobs for Jewish families they were forbidden to perform on the Sabbath, according to Robert C. Alberts in *The Shaping of the Point*. Lawrence had a limited education but became a clerk for a lawyer who was a power in the city's Democratic Party in 1903. He eventually rose to become chairman of the Allegheny County Democratic Committee in 1920. By 1934, he had scaled the political ladder and became chairman of the state party. Lawrence was elected mayor in 1945 but faced scandals involving underworld murders and the death of a city employee that triggered another probe into his administration.

Salvatore DiIelsi was a city cement mason on his way to Butler County, north of Pittsburgh, to do some renovation work on summer home of Pittsburgh City Council president Thomas Kilgallen when he was killed in a traffic accident on April 26, 1949. The driver of the truck, George Manko, a city painter, was seriously injured.

After the accident, DiIelsi and Manko were taken to a hospital in the city of Butler, where DiIelsi was pronounced dead. Manko, who had a broken neck, mysteriously vanished from the facility, claiming he had a "blackout" and no memory of being in a wreck or taken to a hospital. He claimed that when he awoke he was in a Pittsburgh hospital and suffered the injury in a fall at home. The grand jury concluded the "blackout story is pure invention and is incredible" and ruled the cover-up began soon after the crash occurred. Several city workers already were busy at Kilgallen's house and fled, leaving their tools, as soon as they heard about the crash.

DiIelsi's widow, Josephine, sued Allegheny Asphalt for $60,000 because her husband was riding in a truck that lost a wheel and swerved into an oncoming vehicle. Allegheny Asphalt was owned by Michael and Daniel Parish, close friends of Lawrence's and major donors to the Democratic Party. Their company built a private driveway at Kilgallen's summer home, and the lawsuit alleged that Salvatore DiIelsi and other city workers performed private work for Kilgallen and another city official when they were supposed to be working for the city. Kilgallen built a summer home in Butler County while city controller Edward Frey had a home in the city and a summer retreat in a rural area of Allegheny County. City workers renovated both residences for Frey.

The lawsuit triggered a grand jury investigation in what became known as the "Free Work Scandal" and led to indictments of Kilgallen, his brother-in-law William Weaver, Frey, supervisor Howard "Buck" Gross, Manko and the Parish brothers.

Noted criminal defense attorney Charles Margiotti was a lifelong nemesis of Lawrence's and represented DiIelsi's widow in the lawsuit. He accused Allegheny County district attorney William Rauhauser of impeding the grand jury investigation by alerting Lawrence about the panel's progress.

Allegheny Asphalt did $1 million worth of paving work for the city each year. Kilgallen tried to defuse the scandal by paying Allegheny for the paving project two years later. The price for paving the one-thousand-foot driveway was $2,177.99, but Kilgallen paid only $1,077.99, claiming he was given credit for shoddy work. He told the Parish brothers in 1948 he couldn't pay them for the work then but would when he had the money. The grand jury concluded the Parishes did the work because they wanted to influence Kilgallen in obtaining future work with Pittsburgh.

City council had a hearing, but it was little more than a whitewash. Before the hearing began, a city clerk, Robert Laun, killed himself after Gross asked

him to tamper with work records and to lie during the hearing. Laun's wife said her husband shot himself rather than commit perjury.

Kilgallen's colleagues said he was an honest man but used poor judgment in that situation. They criticized Frey for allowing city workers "to putter around his country home" and said the charges against him were "petty." Council disregarded Josephine DiIelsi's accusations "because of obvious bias."

Kilgallen testified at the hearing and said Mrs. DiIelsi tried to coerce him into getting her a job with the city and paying her $64,000 in hush money. "This is extortion and blackmail," he said. "I hardly know Mrs. DiIelsi." He said the widow accused him of killing her husband and then reneging on a promise to help pay for his funeral. "I told her we would help with the funeral bills," Kilgallen said—although he never did.

Mrs. DiIelsi said she never asked Kilgallen for any money or job. "That was his figure, not mine. I never mentioned any amount or salary for the jobs."

The hearing also revealed that city workers performed private work on public time at Gross's farm, which was near Kilgallen's. Gross, who had been convicted of jury tampering during the administration of Mayor Charles Kline, was fired, as was Manko, who testified he was helping DiIelsi pick up a load of manure and had no idea where they were going. Manko said he called off sick that day. City attorney Anne X. Alpern asked Manko, "Were you too sick to go to Butler?" "I was too sick to go to work," he answered.

In 1954, a judge dismissed the charges against Kilgallen. Weaver was found not guilty of perjury. The Parish brothers were acquitted. Gross was indicted but died before his case came to trial. Manko was fired but tried to regain his painter's job in 1956, arguing his firing was illegal, but the city's Civil Service Commission rejected his appeal, ruling Manko's testimony before the commission "was evasive, improbable and lacking in truth and candor." Manko died in 1971 at sixty-seven.

There were more scandals to come during the Lawrence administration. In 1951, a special state grand jury recommended the indictments of Lawrence and six other city officials for bribery and conspiracy in connection with contracts for Pittsburgh's streetlights and the purchase of coal to heat city-owned institutions. The jurors wanted Lawrence indicted on twelve counts of malfeasance in office for his failure to hold Broadway Maintenance Company of New York to the terms of its $1.5 million contract with the city. A regular grand jury ignored the recommendations of the special grand jury and refused to charge Lawrence.

The grand jury discovered that the company installed light fixtures that cost $36.00 each but charged the taxpayers $37.50. The firm also purchased light bulbs at $0.26 apiece, while the cost to the city was $5.65. E.W. Coal Company was accused of selling coal to the city even though the company's bid was not the lowest.

The grand jury report called its investigation "one of the most deplorable and shocking chapters in the history of the city" and discovered overcharges of at least $75,000.

Lawrence had spent the summer on vacation in Europe but told the *Pittsburgh Press* by transatlantic telephone that the charges were "ridiculous. The [street lighting] contract, as far as I know, is perfectly alright."

Six city officials were charged, but not Lawrence. Three more problems involving misconduct by city employees soon followed. Six workers were fired by Lawrence after it was revealed they stole salvage materials, sold it to scrap dealers and kept money that should have gone to the city. "City truck drivers have been selling scrap to various dealers for years. Everybody knows that," a dealer told the *Pittsburgh Press*.

A city radio dispatcher was on extended sick leave so he could work for a radio company. The dispatcher never obtained medical records from his physician or permission from the city to stay off work. Then a supervisor in the public works department was discovered using a city vehicle and materials to remodel his home. Lawrence was livid by the exposure of wrongdoing and ordered city attorney Anne S. Alpern to stop the misconduct.

"I want this stopped. I want this cleaned up. I don't care who is involved. I don't care [to] what ends you go to stop it," said Lawrence in a story in the *Pittsburgh Press*. Then thousands of pounds of ham, bacon, eggs, coffee, roasts, steaks, sugar and butter disappeared from the city's tuberculosis hospital, which resulted in the firing of six hospital employees but no criminal charges.

The numbers racket flourished during Lawrence's two terms as mayor. Police were inept. An Allegheny County grand jury issued sixty-six indictments of gamblers but also criticized the police force for failing to enforce gambling laws and ignoring open gambling throughout the city's neighborhoods.

The grand jurors reported of open gambling in the downtown area, East Liberty and the Northside. The Fort Pitt Hotel had two major horse betting operations in play for more than a year before the police took notice. The jury's report criticized Lawrence's police superintendent Harvey Scott for his "do-nothing attitude."

County detectives wondered how bookies were able to get so many telephone lines. An investigation revealed gamblers leased large offices and created a phony business. Then the office was subdivided, and more fictitious businesses were formed and more phones ordered. After a while, the walls subdividing the offices were removed, and long tables were placed in the offices—as many as twenty numbers writers worked the phones taking bets. There were often long lines of people waiting to play a number.

Mobs divided the city into sections. The Cangelliere mob ruled the Northside for two decades, while the Encardona gang ran a numbers syndicate for fifteen years, raking in $30,000 a day in bets. The Grosso brothers, Tony and Sam, ruled the Hill District. Gus Gianni controlled the rackets in Oakland and Shadyside until he was assassinated while Billy Sarkis ran his organization from a state prison cell. Racket operations were monitored by Lawrence's ward chairmen, who oversaw everything from numbers to prostitution and ensured that police did not interfere.

Pennsylvania attorney general Charles Margiotti accused Lawrence's political family of accepting bribes from underworld figures and charged that Allegheny County district attorney William Rahauser leaked secret grand jury testimony to Lawrence, alerting him that no one in his organization would be indicted in a numbers investigation.

It took two brutal murders for Lawrence to act and crack down on his police force. In 1948, twelve-year-old Carole Lee Kensinger was stabbed thirty-six times in her home. Jean Brusco was a thirty-eight-year-old sales clerk who was bludgeoned to death with a pipe near her Shadyside home in 1949. An FBI report concluded that Pittsburgh was the worst-policed city in the United States in the late 1940s.

In the Brusco case, Police officers took an hour to respond to the crime scene because they were sent to the wrong address, allowing the killer time to flee the area. When officers finally arrived, the sergeant on duty failed to notify homicide detectives that there been a killing. Investigators didn't find Brusco's body until a milkman making his deliveries early the next morning stumbled on her. Brusco had been pulled over two fences and dumped in a nearby yard. Seven officers were charged with neglect of duty before a police trial board, and the case went unsolved.

The *Pittsburgh Post-Gazette* questioned the competency of the police department, asserting that the department was so rife with politics that officers forgot their main duty: "The Police Bureau will never be worth a darn until its members know their jobs depend upon law enforcement rather than upon their ability to help get out the vote."

Lawrence weathered the scandals because of the tight control he exercised on city hall. He was a political boss in the truest sense of the word but bristled at the characterization every time the word was used in his presence. He once lectured a reporter who used the word *boss* and refused to speak to another for six months after the journalist referred to him as "boss Lawrence."

"Who ever told you I was a boss?" he asked a reporter. "Who did I ever boss? Can you find me one person who I ever bossed? Now let's get things straight right now. I am not and have never been a boss and if that term is ever used again in my presence, you'll never be at another news conference," according to Weber's biography of Lawrence.

Longtime KDKA-TV news anchor Bill Burns once used the term during a television interview, prompting Lawrence to bristle and slam his fist on the desk. "Don't you call me a political boss. I'm a politician and a political leader but I'm not a political boss."

"He ran things. He was the boss of the city," said Burns. "He picked the police heads, he picked fire department heads, he picked his department heads and he did pick the members of city council. No doubt about that."

CRIME NEVER PAID
FOR ROXIE LONG

Roxie Long began his life as a career criminal in 1917 when he was caught stealing silk shirts from a clothing store. By 1922, Long had been pinched 150 times for various crimes and, by 1940, had been lodged in the Allegheny County Jail 42 times. He served time in the Allegheny County Workhouse in Blawnox as well as in state and federal prisons for bootlegging and truck hijacking.

Long was dubbed Pittsburgh's most arrested criminal by city newspapers until his death in 1983 at the age of eighty-seven. Long, whose real name was Rocco DiPippa, was a burglar, thief, robber, gambler, bootlegger, counterfeiter, draft dodger, hijacker, blackmailer, con man, snitch, perjurer, tax evader and escape artist. He was a suspect in several gangland murders, although he eventually was cleared. He broke his promises to reform and become a law-abiding citizen—Long just could not stay out of trouble. He begged a judge to parole him from the Allegheny County Workhouse in Blawnox.

"I have learned my lesson," he pleaded. "I will go straight forever if you give me a chance. Put me on parole for five years if you want to but let me turn this because I got a job waiting for me when I get out and I won't be back in jail. I know I have a long criminal record but there won't be any repeat."

An editorial in the *Pittsburgh Press* expressed doubt Long would ever go straight:

The trouble is that Roxie and his kind are not made of the same stuff as martyrs and poets and do not have the quiet minds and innocence. They are troubled spirits to whom prison is hell. It is this kind of hell that is the reward of all of Roxie's nimbleness, quick-wittedness, fertility of stratagem, ingenuity of device. Roxie, hearing the clang of the iron doors behind him smiles. But his smile is only skin deep. He said that when he gets out he is going to do better. We trust he means it. But you must wait until you are let out and not when you break out.

Long was born on March 12, 1896, in a working-class Pittsburgh neighborhood where streets were unpaved and covered with raw sewage—outdoor privies were often full—that left a lingering odor throughout the community. He was one of two sons and four daughters of Michael and Catherine DiPippa. Tenement roofs leaked, soaking a family's living space. Workers in the region's mines and mills labored twelve hours a day, seven days a week in a demanding existence that destroyed families. An estimated six thousand children were under the care of welfare organizations because their parents were too poor to care for them.

There was no indoor plumbing, so residents had to carry buckets of water from spigots on the streets up flights of stairs. Alleys were strewn with trash. Some families were so hard-pressed to care for their children that many young ones were abandoned and placed in orphanages. Writer H.L. Mencken remarked in 1910 that Pittsburgh was a place of "distressing extremes of wealth and poverty." Half of Pittsburgh's 3,364 tenement houses were built to house single families, but more than 1,300 families were living in 505 rooms.

Long came into his prime in the 1920s and 1930s, when Pittsburgh was a wide-open city rife with gambling, bootlegging, prostitution, corrupt police and politicians and gangland murders. During Prohibition, there were one hundred unsolved killings between 1927 and 1932. Long was in his element.

In 1922, he jumped bond on the eve of his trial for a series of grocery store robberies and fled to New York and then Europe. He obtained a passport by using his birth name and boarded the SS *Aquitania* bound for Italy. When the ship docked in France, Long was arrested by French police and turned over to Pittsburgh police detective P.E. "Happy" Moran. When Long and Moran reached Pittsburgh, Long regaled reporters about French food, hospitality and prison conditions. A large crowd met Long and Moran at the train station. Newspaper photographers snapped pictures of the smiling, diminutive Long wearing a straw boater surrounded by a throng of people.

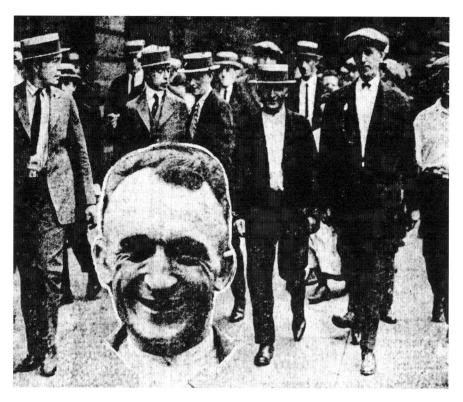

Roxie Long was met by reporters after his extradition from France. Long's return was a big story and an even bigger one after he escaped. *From the* Pittsburgh Post-Gazette *Archives.*

A shackled Long was supposed to be placed in the county jail, but Moran allowed Long to visit his sister before taking him to jail. While the detective waited outside the woman's home, Long slipped out a back door, and the manhunt was on.

He was spotted at various places around the city. Police warned him to surrender, or they would hunt him down. His wife blamed police for not handcuffing her husband when he visited his sister. "I never thought he would be foolish enough to try and get away again but then the police were foolish not to handcuff him. I wish they would catch him," she said.

Long taunted police and stayed one step ahead of his pursuers, openly meandering around Pittsburgh. In a letter to the *Pittsburgh Press*, Long promised to surrender but failed to give up. A $500 reward was offered, and one newspaper columnist penned a poem about Long:

Where, oh where, is Roxie Long?
Where, oh where, has he gone?
Maybe the title of a song.
About this bird called Roxie Long
Behind the bars yesterday
About me you'll have much to say
And when he blithely slipped away,
The gang had a lot to say
And sang, "Oh, where is Roxie Long?"

An editorial in the *Press* called the Long affair shameful. "To bring a fugitive from justice clear from Cherbourg, France, only to turn him loose a few hours after he arrived does not admit any satisfactory explanation. It is such a thing as this that explains the prevalence of crime." In a letter to the *Pittsburgh Press*, Long wrote he would surrender as soon as he came up with enough cash to make bail:

> *No use having all the police and detective* [sic] *looking for me because I am staying in town here and where I am staying no one will find me. I am reading all the news. I know every move that is made and so tell bondsman not to worry about $500 hundred dollars reward, he can pay me the reward when I come in.*

Long had no intention of giving himself up, because he wasn't in Pittsburgh. Moran, who wanted to avenge the embarrassment of allowing his prisoner to escape, tracked the fugitive to Wilkes-Barre, Pennsylvania, where he found Long sitting in front of a grocery store. He had been using the name Michael Johns to evade his pursuers.

Moran took the handcuffed Long to the Wilkes-Barre police station, where Long gave a voluntary statement implicating his attorney, S.H. Reichman, in the escape. He said he paid Reichman $450. Reichman denied the allegations, and Long eventually recanted in an affidavit. "I hereby give my statement to S.H. Reichman, stating that he didn't have anything to do with my escape," Long wrote. After he returned to Pittsburgh, merchants in Wilke-Barre filed charges against Long for passing bad checks to purchase large quantities of cigars, ten thousand cigarettes, flour and sugar.

Long was in and out of jail and prison in the ensuing years. He was serving a sentence in Pittsburgh's notorious Western Penitentiary on the Northside when he was charged with instigating a riot. He was transferred

to the Fayette County Jail south of Pittsburgh, where authorities suspected he was plotting to escape. No way, said Long. "The Fayette County Jail suits me fine. Why would I want to escape?" he told reporters.

Long opened a speakeasy in the early 1930s, purchasing beer and liquor from Jack Palmere, known as the "yeast king" of Pittsburgh, and his partner, Argenti "Toto" Amarosa. Palmere had assumed the mantle after the murder of Giuseppe Siragusa. New York mobsters offered to buy Palmere's business but he refused and was later shot in the head as he walked along a city street. Amarosa was murdered eighteen hours later.

Police initially suspected Long was behind the killings. A truck driver who delivered bootleg booze to Long told police he heard Long say he had fallen behind in his payments to Palmere, and another witness said he heard Long threaten to kill Palmere. Eventually, Long was ruled out as a suspect.

During Prohibition, Long was arrested numerous times for making bootleg liquor. Agents confiscated stills, mash and alcohol from buildings where he made moonshine. He was nabbed after authorities seized 35 gallons of liquor, 1,000 gallons of mash and a still capable of producing 200 gallons of whiskey. By 1931, he was back in the Allegheny County Jail for violating the Volstead Act but was pardoned on New Year's Eve. He was arrested eleven days later after federal agents confiscated a 150-gallon still and 40 gallons of moonshine during a raid on his home.

When a federal grand jury indicted Long in 1932 for running an extensive bootlegging operation that resulted in the arrests of forty-four individuals, he already was facing charges for running a two-county liquor network. Long turned government witness and testified against his fellow defendants, eliciting cries from defense attorneys that Long was the "supreme weasel of the underworld" in Pittsburgh and the "Al Capone of Allegheny County."

Even after repeal, Long continued to sell bootleg whiskey into the 1950s. He was arrested in 1938 for bootlegging and told the judge he would act as his own attorney since he couldn't afford to hire one. "I'm familiar with court procedures," he said. He ended up pleading guilty.

Long tried his hand at being a businessman, opening a grocery store and stocking the shelves with goods he stole from a competitor. He was arrested for passing bad checks after he paid for other groceries by check. When he was brought to the courthouse for arraignment, he tried to escape.

Long, forty-seven, was divorced by 1939, when he met seventeen-year-old Truna Fontana and ran away with her to get married. Her father called the police, who tracked down the couple only to discover that the two had been

married by Father James Cox, the pastor of St. Patrick's Church in the Strip District, after the bride's mother gave her consent.

Roxie and Truna divorced after fifteen years of marriage because Long was in the federal penitentiary in Lewisburg, Pennsylvania, serving a nine-year sentence in the 1950s for stealing $38,000 worth of fur coats from a Pittsburgh department store. His wife complained she was left to raise her two children without any means of financial support. In arguing for leniency, Long's attorney, Arthur Boscia, said his client "has a remarkable brain. He could have been a success but when I asked why he didn't change his ways, he told me, 'Arthur, it's my reputation. Nobody will hire me. I just support my family.'"

Boscia described Long as a Robin Hood who went out of his way to help others. "He would be the first to go to the aid of friends even if he had to beg borrow or steal." The judge noted that Long had served six prison terms. "Roxie has learned that crime doesn't pay," Boscia continued. "He's always broke. His wife and two children are on relief. They're living in poverty."

Long turned to bookmaking and hijacking trucks in the 1950s. He was one of thousands of bookies working in the city and Allegheny County writing numbers. Police once arrested Long after they found he was carrying numbers slips. He had placed a $0.75 bet on a number and won $375 for himself. The cops dropped the charge and allowed Long to keep his winnings.

During an arrest in 1945, police found cash and numbers slips in the glove compartment of Long's car. Long said he had no idea how they got there. "I ain't no Santy Clause," he said. "If I was in the numbers business, do you think I'd be dumb enough to carry slips in the glove compartment and it's not even locked." Police magistrate W.H.K. McDonald doubted Long's version but allowed him to continue.

"Well, I don't know nothing about no numbers slips but my wife's auto, it was loaned out on election day to haul voters in, see? That's when the slips coulda got in there. I am as innocent as a baby getting pinched for something I didn't know nothing about."

He was arrested again for writing numbers in 1946, but Long told a judge he had been working for the railroad for six years and had gone straight. "I was an honest brakeman all during the war," he said. "I've had a good reputation for six years." The judge found Long guilty, fined him $200 and placed him on a year's probation.

The next day, a grand jury issued a report on an unsolved gangland murder that involved Long. The grand jury was investigating the 1946

slayings of Frank Evans and Freddie Garrow, whose bodies were found inside a car along Washington Boulevard. Evans had been shot fourteen times—Garrow, eight. Evans was a member of a Homewood numbers ring. When detectives searched his body, they found $6,000 worth of numbers slips in his pocket and $600 in cash.

Long was subpoenaed to appear before a grand jury but balked twice at testifying until he was faced with a contempt charge. The prime suspect in the slayings was Frank Valenti, a Pittsburgh mobster and killer, who later would become head of the Mafia in Rochester, New York. Valenti also attended the infamous meeting of crime bosses in Apalachin, New York, in 1957. Valenti was picked up by police but released. In 1951, a grand jury refused to issue an indictment in the Evans-Garrow murders because of insufficient evidence. In its report, the grand jury singled out Long for criticism, saying an indictment would have been issued if Long had been a credible witness.

When Long was arrested for hijacking a truck in 1957, Allegheny County district attorney William Rahauser asked the judge to set bond at $100,000. "Are you serious?" asked Long. "Of course, I'm serious," Rahauser replied. "Why $100,000? It might as well be $200,000," Long replied.

Long was arrested again for bootlegging in 1958 after Treasury agents raided his home and found a 125-gallon still and two dozen barrels of mash and seized 19 gallons of liquor. Age slowed Long's life of crime, although he occasionally showed up in court. He once appeared as a character witness for a nephew. "I wouldn't do anything wrong. I'm behaving myself now," he told Judge Anne X. Alpern. "Well, you've had plenty of time to learn that crime doesn't pay. Haven't you?" Long was no help to his nephew, who was found guilty and fined $300.

In 1963, he stole $700 worth of women's clothing. By 1964, he had spent half of his life in prison. He was cited for double parking in 1966 when he was seventy. Despite all the publicity he generated for Pittsburgh newspapers over the decades, Long's passing rated a one-sentence notice in the *Pittsburgh Press* and *Post-Gazette* under "Late Deaths."

PITTSBURGH'S GILDED PALACES OF SIN

A red light in Pittsburgh didn't mean stop during prostitution's heyday, from 1900 to 1914. It meant come on in. Pittsburgh had two hundred brothels employing one thousand prostitutes operating downtown and in surrounding neighborhoods in the city. The Pittsburgh Morals Efficiency Commission estimated men spent $2 million a year on sex.

Venereal disease ran rampant among the city's immigrant population, according to a study, "Wage-Earning Pittsburgh," published in 1914. Many of the infected were from Eastern Europe. The Morals Efficiency Commission issued a report in 1913 that revealed an estimated ten thousand people in the city had venereal diseases, and 50 percent of them were prostitutes suffering from incurable forms of syphilis.

Prostitutes dubbed brothels "Johnny" houses because the women were unable to pronounce the indecipherable names of their Slavic clients. Prostitutes were called "sisters of the nocturnal order" by Frank Bolden, an editor at the influential *Pittsburgh Courier*.

"A Study of Dance Halls in Pittsburgh," published in 1925 by the Pittsburgh Council of Churches, said prostitutes used dance halls to drum up trade. "Prostitutes sometimes frequent such places for no other purposes than solicitation," read the study. "When such a girl succeeds in inveigling a man to accompany her, they leave the dance floor together and retreat to some other part of the building where for three dollars, they are furnished a room."

Billie Scheible was the city's most notorious madam. Her brothel in Pittsburgh's Oakland neighborhood, a place filled with well-dressed prostitutes and watered-down liquor, was frequented by some of the city's business and political elite, along with policemen, who climbed the wooden steps to her luxuriously furnished second-floor apartment above a drugstore.

She was considered "Public Hostess No. 1" during the 1930s, a play on the phrase "Public Enemy No. 1" after the FBI began investigating white slavery rings and the well-to-do madams who ran them. She moved to New York City in the mid-1930s, but during a raid on her Park Avenue apartment in February 1935, police found books containing four hundred names of "prominent" Pittsburghers, according to the *New York Times*. Along with the names were descriptions of the women who worked for Scheible such as "Jean Gray Keith," who was a small woman with red hair and a "nice smile," and Carmen, a tall blonde, according to accounts in the *Pittsburgh Press* and *Post-Gazette*.

Scheible was described in FBI reports as a woman "with good taste in clothes" and a "fairly attractive appearance." She was also described as being a "first-class bitch on wheels," according to a report of a study in the *Journal of History and Sexuality*.

One of Scheible's well-heeled customers was William Larimer Mellon Jr., the son of William Larimer Mellon, the founder of Gulf Oil and the grandnephew of Andrew Mellon. The younger Mellon fell in love with a prostitute, Monya Getty, according to a study of prostitution in the *Journal of History and Sexuality*. Mellon wanted to marry Getty, whose trade name was "little Billy Ward," but the relationship ended after Scheible penned a letter to Mellon's mother informing her of Getty's occupation.

When news broke of Scheible's arrest in New York City in 1935 for tax evasion and for violating the White-Slave Trafficking Act, commonly known as the Mann Act, Pittsburgh's gentry grew alarmed that their names might be exposed in court. Her trial was well attended. A near riot broke out in the hall of the federal courthouse when four hundred men pushed and shoved to get one of the coveted seats to listen to the testimony.

Scheible's first name was Mae, but everybody knew her as Billie. Her maiden name was Kagel, according to genealogical records, and she married Fred Scheible of Youngstown, Ohio, in 1911. By 1930, she was a widow. Scheible came from Ohio and started running prostitutes at a roadhouse outside Pittsburgh until she was persuaded it would be more profitable to open a place in the city to cater to wealthy patrons. It was a smart decision. In a three-year period in the 1930s, Scheible earned more than $113,000 but

paid little in federal income taxes, which eventually led to a four-year prison sentence for income tax evasion.

Scheible was greedy. She forced the girls working for her to buy her used dresses and made them pay for room and board. She charged johns thirty-five dollars a visit, made them pay for the liquor they drank and convinced inebriated customers who were short on cash to leave her several of their blank checks so she could pay herself.

When Scheible was indicted by a federal grand jury for transporting women across state lines for immoral purposes, she protested, saying, "I beg your pardon. I made my money from selling liquor. I never transported a girl to New York in my life," according to the *Post-Gazette*.

She pleaded guilty to tax evasion in 1938. Her earnings jumped from more than $18,000 in 1926 to over $271,000 six years later. Her attorney, Thomas Marshall Jr., pleaded with the judge for a lesser term by emphasizing the good points of Scheible's character. "She's a woman who never drank, never swore and didn't even use slang," Marshall said. The judge was unpersuaded and sentenced her to three years in a federal prison in addition to a two-year sentence for violating the Mann Act.

Some of her customers patronized her brothel for other reasons than sex. One wealthy playboy brought an orchestra with him to play music. The *Pittsburgh Press* noted, "He liked to sit around, listened to the orchestra and sometimes play the accordion."

FBI director J. Edgar Hoover said the bureau focused on Scheible in New York because she was involved in the prostitution racket that was controlled by mob boss Charles "Lucky" Luciano. "We're all watching her case with special interest because of her frequent boasts that she has enough influential persons under her thumb to get out of anything," said Hoover in an account in the *Pittsburgh Press*.

Scheible was snared by the FBI while agents were searching for her lover, Count Victor Lustig, a European-born con man and counterfeiter whose suave manner and fluency in several languages earned him the nickname "Count." Lustig was born in Austria-Hungary and plied his trade in Europe and the United States. He was so good at duping people that he sold the Eiffel Tower twice to unsuspecting buyers according to *The Man Who Sold the Eiffel Tower*, a biography of Lustig, whose real name was Robert Miller.

Lustig was arrested in New York with $150,000 in counterfeit money and was held in the Federal House of Detention—which was considered escape proof. Shortly after he was incarcerated, Lustig managed to get a pair of metal cutters, fashioned a rope out of strips of bedsheets and shinnied down

the makeshift rope to the street below. He headed for Pittsburgh, where he was arrested twenty-seven days later. He was sentenced to twenty years in Alcatraz and died in 1947. Lustig never explained how he obtained the metal cutters, but authorities suspected Scheible smuggled them into the prison, because Scheible's visit coincided with Lustig's escape a week later.

Scheible appeared at her trial dressed in a mink coat and wearing a tiger skin hat. The federal prosecutor called her a "menace to society. She never earned an honest penny in her life and her actions have menaced the life and health of a great number of girls."

Scheible operated in Pittsburgh with police protection. Former police inspector James Hoey charged that there was a racket-police alliance operating within the department that was paid to protect places like Scheible's. A Police Research Commission was formed to investigate the charges and picked Hoey to question his former colleagues.

One of the police officials who provided protection for Scheible was former police superintendent Peter Walsh, who claimed he never met the city's most notorious madam. Charlotte Ryan, the mother of John Ryan, who was Scheible's bodyguard, kept Scheible's financial records for her son and turned them over to the commission. Ryan said the account contained an entry showing that Scheible paid $1,000 a month in bribes to police and that the payoffs came in the form of money orders. In the ledgers were the names Walsh and Barry, Ryan testified. Barry was John Barry, a former police inspector. Walsh received a 5 percent cut of Scheible's business.

The commission asked Walsh if he recalled Hoey ever telling him that Scheible needed to talk to Walsh immediately. "She seemed to know you pretty well for you never having seen her," said Hoey, who added that payoffs went all the way to Public Safety Director Bennett R. Marshall, who employed former inspector Frank Boyd as his bagman to collect Scheible's payoffs.

Scheible returned to Pittsburgh after she was released from prison. She was sentenced to nine months in jail for violating probation on an earlier prostitution-related charge. She was arrested again in 1962 and fled to Florida before returning to Pittsburgh and surrendering to authorities.

Newspapers were attuned to the sensitivity of their readers and never referred to the brothels as houses of prostitution. They used terms such as "house of assignation," "bawdy house," "house of ill repute," "disorderly house" or "resort."

Nettie Gordon was another notorious madam; she owned forty-one resorts and was politically powerful because she was a Republican committeewoman in Allegheny City and later in Pittsburgh, paying $1,000 a month to the

Henry J. Heinz, one of Allegheny City's prominent residents, built his Heinz Foods plant in Allegheny City, which now is Pittsburgh's Northside. The company is now known as Kraft Heinz. *Courtesy of the Library of Congress.*

police for protection. She hailed from Keyser, West Virginia, in the state's eastern panhandle and oversaw a twenty-block section of the Northside filled with brothels. She was known as the "Queen of the Underworld." Gordon was talking to a police officer who was smoking a cigar on the stoop of one of her brothels when a customer walked up, quickly turned around and started walking away. Gordon reassured him. "He's one of my coppers," she said.

Gordon outfitted her prostitutes in fine clothes she purchased from Boggs & Buhl, an upscale department store in the Northside that catered to upper-class families such as Heinzes of Heinz Food fame, Joneses of Jones and Laughlin Steel Company and the Mestas of Mesta Machine, according to former store employees.

She had the police in her pocket and evaded prosecution and grand jury indictments through her political influence and ties to the ruling Republican Party machine. Her name first appeared in the *Pittsburgh Gazette* in 1904, when she was arrested for operating a disorderly house.

She was arrested on minor charges in the first decade of the twentieth century and operated in the section of Allegheny City known as Little Canada. In 1904, she was the central figure in the corruption trial of Captain James Wilson, who was charged with accepting bribes from Gordon in exchange for protection. More charges followed in 1905, 1908 and 1917. She remained in the Northside after Allegheny City was annexed by Pittsburgh in 1907, establishing a monopoly on prostitution that continued to her death in the 1930s.

Gordon escaped prosecution on other more serious charges after two police officers committed perjury during a trial and the charges against her were dismissed. Another prosecution ended in dismissal after two key witnesses left town and police were unable to find them. She was indicted along with the wife of another Republican Party official for running a house of prostitution, but for some unexplained reason, the grand jury ignored the evidence presented by prosecutors and refused to indict her.

"Nettie's power of persuasion and her political prestige has succeeded again in squirming her through the arms of the law," wrote the *Pittsburgh Post*.

Crusading rackets reporter Ray Sprigle of the *Post-Gazette* said Gordon "turned the oldest profession into a distinguished career." He dubbed Gordon Queen of the Underworld because of his frequent stories about her. One day, an intermediary showed up in the newsroom and placed two $1,000 bills on Sprigle's desk, asking if he would stop writing about her so much. He refused. "Isn' that Ray Sprigle a lovely guy?" Gordon asked. "But ain't he a dirty SOB when he gets in front of a typewriter?"

Wrote Sprigle, "[T]he wages of sin festooned her with glittering jewels. She mingled with the great and powerful of western Pennsylvania. She made and broke policemen of high and low degrees and moved them from post to post like chessmen."

In one of the rare times she was held for court, Gordon showed up wearing a heavy veil and holding a fan to shield her face. She had an aversion to being photographed that followed her in death. She died following surgery in 1934. As she lay dying, she was asked if she wanted a minister at her side, but she just smiled and said she had lived without God and would die without him.

Mourners held a 150-foot canopy running from the front door of her house to the curb to prevent photographers from snapping a picture of the coffin. A canopy was erected at the grave site to prevent curiosity seekers and photographers from getting a last glimpse of the underworld queen.

Gordon was laid out in an orchid-colored dress and a casket surrounded by roses. The police sent flowers and provided a motorcycle escort for the twenty-two-car funeral procession. Her home now is the location for the Light of Life Rescue Mission.

In 1939, when the Allegheny Centennial Committee prepared to publish a history of Allegheny City by the writers of the Works Progress Administration, the committee faced the question of whether to include Gordon's exploits. The committee fretted over her unsavory reputation and how it would reflect on the history of Allegheny City.

In the end, the history did not include any references to Gordon or to Little Canada. "We all have something in our family trees we don't want to bring out," C.F. Kirschler Jr., chairman of the committee, told the *Pittsburgh Press*.

Reformers and ministers of the city tried for years to rid the city of people like Scheible and Gordon without success because the police ignored the skin trade. On Saturday nights, Pittsburgh streets were filled with mobs of men

standing from dusk 'til dawn in front of brothels. Police kept order outside as the sounds of player pianos filled the streets and women dressed in evening gowns and kimonos waited for customers while local ministers patrolled the streets, writing down the street addresses of the houses of ill repute.

Sprigle wrote that Gordon was the CEO of a prostitution enterprise that spanned the city. The big block of brothels was located downtown, while the Hill District had twenty blocks. The Northside was the most lucrative section of Pittsburgh for vice by the 1920s. Inspector Charles Faulkner's district was the "most lawless and the richest vice center," reported the *Pittsburgh Post*. It was filled with speakeasies, gambling dens, slot machines and houses of prostitution.

When William Magee was mayor of Pittsburgh, he frequented the red-light district of the Northside. "The madams knew him well," said Sprigle. "As mayor, he not only took the lid off the town but threw it into the river. Prostitution and gambling ran high, wide, open and handsome through most of the Magee administration."

When police conducted raids, they were simply carried out to pacify critics, like when the *Pittsburgh Press* accused the force of raiding brothels to reduce the criticism of the department. "The police made another grandstand play at the little game of reform yesterday and raided a number of disorderly houses," the paper reported.

Even by 1887, the public was "tiring of the avocation of prosecuting corner apple women, the leading men in the Law and Order Society concluded to turn their attention to the women who are the proprietresses of the most fashionable houses of ill repute in the city," wrote the *Pittsburgh Post*.

The Law and Order Society was a self-appointed group of citizens, part of the larger Law and Order League in the United States, whose aim was to enforce strict observance of blue laws by closing saloons and banning Sunday sales to the point even newspaper boys were prohibited from selling Sunday newspapers.

Part of their campaign was aimed at houses of ill repute. Whenever prostitutes and madams were arrested, newspapers covered their arraignments. The *Pittsburgh Post* recounted the arrests of "the notorious women of town, dressed in silks and satins, with diamond solitaires in their ears and tears in their eyes" as they were escorted to jail and "placed behind bars amid scenes of hysterical grief and with faces with the marks of degradation. It was all the work of the Law and Order Society."

The *Pittsburgh Sunday Post* reported on the arrests of two councilmen—Edward J. Edwards and Samuel Frankel—who were caught in a house of prostitution

and charged with the "practice of fornication." An indignant Edwards railed at arresting officers. "I don't give a damn for the police department," said Edwards. "You people haven't got anything on me that will hold water. You are in the way and you know it."

The paper published the names of establishments and who was arrested in "Pittsburgh's Roll of Shame" after two reporters went to the Delmont Hotel in Little Canada and inquired about the availability of prostitutes. "What about a few girls?" asked one reporter. "There's plenty of them," said a waiter. Two of the women sauntered over to their table and informed the journalists that a room would cost them three dollars.

Prostitution had been a problem in Pittsburgh since its founding. City fathers and civic reformers complained after the Civil War about the increase in the number of bawdy houses. Pittsburgh had enacted an ordinance in 1828 outlawing "disorderly inns, ale houses, bawdy houses and gambling houses" along with theaters, because they corrupted the public, according to the *Pittsburgh Weekly Gazette*. Newspapers referred to houses of prostitution as "gilded palaces of sin," and a group of reformers, the Law and Order Society, demanded police close the brothels.

Not all the purveyors of sex were women. Ben Hogan, "the wickedest man in the world," as he billed himself, floated down the Allegheny River from Armstrong County in the 1870s in his "floating palace of entertainment," a remodeled river steamer, and dropped anchor at the Point, the confluence of the Allegheny, Monongahela and Ohio Rivers, according to *Oil Country Stories*, published by the Petroleum History Institute. The floating brothel was 125 long and 30 feet wide and came with an orchestra, prostitutes and a large supply of liquor.

Hogan committed murder at fourteen, according to various accounts of his life. He was a blockade-runner during the Civil War and worked as a spy for the Union and Confederacy. He claimed he enlisted thirty-six times in the Union army, earning $600 each time he joined

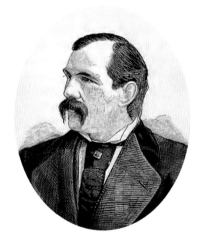

Ben Hogan, the "wickedest man in the world," was a notorious pimp who later found religion and became an evangelist. *From* The Life and Adventures of Ben Hogan: The Wickedest Man in the World, *1878.*

up, and then promptly deserted, according to *Pennsylvania Petroleum*, published by the Pennsylvania Historical and Museum Society in 1947.

Edwin Drake discovered oil near Titusville in 1859, triggering an oil boom that created boomtowns like Parker's Landing and Petrolia. Parker's Landing was located eighty-four miles north of Pittsburgh and consisted of a railroad station, a telegraph office and a hotel. Hogan came to Parker's Landing in Armstrong County to cash in on the oil boom. There, Hogan opened a house of prostitution, which earned him $200 a day. He quickly became known as the "king of the demi-monde establishments in Parker," according to Samuel Young's *History of My Life*, published in 1890.

Hogan wore finely tailored clothes and a gold watch and chain worth $800, according to an account of his life in the *Pittsburgh Post* in 1888. His floating palace was scuttled at the Point by a jilted Pittsburgh prostitute in 1876. Two years later, he walked into a tent revival held by evangelist Dwight Mooney, found religion and became an evangelist for the rest of his life, living in poverty. "Ben is now a reformed man and trying to make amends for the ill spent years of his life," Young wrote.

Scheible and Gordon were not the only purveyors and panderers of porn in Pittsburgh. In the 1970s, there was a bloody battle for control of massage parlors that were fronts for prostitution and had links to the mob. The war led to murders of individuals involved in the massage parlor trade as well as bombings and arsons of the businesses.

The war began after the killing of George Lee, an Alabama-born smut peddler, who was gunned down after leaving a restaurant. Lee knew he was a target, and the stress began to show. He developed a skin rash from tension. As associate, Mel Cummings, who ran a nightclub, Stage 996, nearly became the next victim. He was driving his green Lincoln Mark IV into the parking garage in the apartment building where he lived when he was shot and wounded.

Lee's death left a void that Nick DeLucia and Dante "Tex" Gill tried to fill. DeLucia, a retired Pittsburgh fireman, was related by marriage to Joseph "JoJo" Pecora, an underboss of the crime family led by Michael Genovese after the death of John LaRocca.

Lee had a record dating to the 1950s. He was convicted in the 1960s for transporting women across state lines for immoral purposes and operating a call girl racket and later operated porn shops, X-rated movie theaters, massage parlors and after-hours clubs.

He was a member of an ironworkers' union local and drove a pickup truck to work every day, but at night, he drove a red Cadillac to an office in

Left: Mug shot of Dante "Tex" Gill. *Right*: Portrait of Dante "Tex" Gill. *From the* Pittsburgh Post-Gazette *Archives*.

one of his massage parlors. After Lee was murdered, someone sent a bomb disguised as a Christmas present to one of his massage parlors; it exploded, killing one of his prostitutes, Sasha Scott. Scott's husband, Glenn, was the next to die. He was shot ten times. The war continued.

Susan Dixon, Sasha Scott's onetime roommate, also was murdered. She worked as a masseuse at one of Gill's massage parlors. Deborah Gentile, another masseuse, was found in a room at an airport hotel. She had been shot three times in the head and stabbed sixty-eight times.

Dante "Tex" Gill was born Lois Jean Gill and preferred short-cropped hair and men's clothes. Gill ran a string of massage parlors but wasn't charged with prostitution. The IRS built a case against the entrepreneur for tax evasion, and Tex was convicted and sentenced to seven years in prison. After release, Gill died of kidney disease.

A Gill ally, Anthony "Bobby" Pugh, was shot six times at his residence, and another associate, Mel Cummings, barely escaped death after a sniper shot at him while he was driving his car. Three men died in a fire in a building that housed one of Lee's massage parlors, although ATF agents concluded that the cause of the fire was due to faulty wiring.

Dante "Tex" Gill with associates Frank Cocchiara and Donna Pitts (*wearing masks*) during a court appearance. *From the* Pittsburgh Post-Gazette *Archives.*

Joey DeMarco's body was found in the trunk of a car parked at Greater Pittsburgh Airport in 1979. Although DeMarco was associated with the drug trade, he was the subject of a grand jury investigation into the city's massage parlor industry, according to *Pittsburgh Press* accounts of the murder.

Pittsburgh tried to legislate the massage parlors out of business, and by 1984, most of the establishments had closed. Liberty Avenue, once a hub of massage parlors, adult bookstores and X-rated movie theaters, was cleaned up and now is part of the city's Cultural District, including the August Wilson Center for African American Culture, the Civic Light Opera, the Pittsburgh Ballet and the Pittsburgh Opera.

PITTSBURGH'S IRON CURTAIN

The Lepus Literary Association of Pittsburgh was supposed to be a place where members could read books and intelligently discuss the issues of the day. The club's charter read, "[T]he club is formed for the purpose of promoting literary attainments and furnishing and maintaining a suitable clubhouse as headquarters where members can meet to discuss matters of interest." Whenever police raided the club, a light flashed on and off in a back room, where gambling was underway. Members quickly picked up books and began reading, but the only books police officers found during a raid were a telephone book and Hoyle's rules for card games.

"It was for people who were interested in books and reading but the only thing these folks ever read were the numbers," said Marty Levine, whose grandfather was involved in the Allegheny Hunting and Fishing Club, another notorious Pittsburgh after-hours night spot. Levine wrote a story for the *Pittsburgh Post-Gazette* about the club and other establishments that were mainstays of Pittsburgh nightlife.

There were hundreds of "one-man clubs" that operated throughout Pittsburgh from the turn of the twentieth century to present day that served as fronts for high-stakes gambling and other criminal enterprises. The clubs flourished during World War II, when Pittsburgh industries worked around-the-clock for the war effort. Thirsty workers needed a place to wet their whistles and gamble away some of their hard-earned wages. The clubs became magnets for gamblers and organized crime figures.

Many of the one-man clubs were chartered in the late nineteenth century for sincere purposes, but criminals used the names to mask their real purpose, making money by skirting tax and gambling laws. Members of the American Hunting and Fishing Club never got near the woods or a stream. Members of the DelMoro Canoe Club never paddled a canoe. The Bloomfield Athletic Association's charter was "to foster and promote athletic enterprises," but the only athletic feat performed at the club was bending the elbow.

The Ambrose Club, chartered in 1908, was founded to preserve the faith of members of St. Ambrose Church, but it's doubtful any of its members attended Sunday Mass. The Amerita Club was formed as a cultural outlet for veterans in 1923. The German-American Association was formed in 1890 "to promote fellowship among veterans of the German Army." The Aloysius Club was formed in 1910 for the "protective interests of the sick." The purpose of the Perry Social Club was for the "physical, cultural and intellectual improvements" for Northside residents of Pittsburgh.

The American Hunting and Fishing Club was chartered in 1899 and sponsored hunting and fishing excursions to Canada for its membership. Interest in the organization waned and the club died, but the charter remained alive. A group of gamblers bought the charter at a cut-rate price and transformed it into a private, nonprofit corporation featuring dining, dancing and floor shows along with poker, craps and roulette.

When two detectives raided the Allegheny Hunting and Fishing Club in 1947, the club's bouncer tossed them down a long flight of steps. The club was tipped off about the raid because one of its members was a Pittsburgh police officer who was at the club that night and happened to be the bouncer's brother-in-law.

The term *one-man club* originated from the fact that profits went into one man's pockets. The clubs dodged taxes, abused liquor laws and promoted prostitution. The American Hygiene Association reported the clubs were responsible for the spread of venereal disease.

Some clubs once were speakeasies and became private enterprises after the repeal of Prohibition. Some disreputable organizations included the American Musical Society, the Hazelwood Literary Society, Iroquois Club, the Knickerbocker Social Club, the Chelsea, the Foxy Lady, Showboat, the Beau Brummel, the Ambrose Club and the First National Ukrainian Society.

Among the more infamous clubs was the Bachelor's Club in East Liberty, which was a favorite hangout for gangsters and politicians and operated with the blessing of the police and Democratic Party officials. State police

raided the club in 1941, snaring eighty-five men and forty women, "whose names are in the higher brackets of Pittsburgh's social life," reported the *Post-Gazette*. Raiders found slot machines, poker and dice tables, hundreds of decks of cards and bags filled with poker chips.

Patrons knew when to enter the club or stay away. Two lights above the entrance door signaled when it was safe. If both lights were on, it was safe to enter. If they were off, a raid was in the offing. Police and politicians made halfhearted attempts to close the club. Pittsburgh police once stationed a plainclothes officer inside the Bachelor's Club every night for twenty-five days to make sure no gambling took place.

Officer Sam Karam Jr. was treated to free steak dinners and drinks each night as he lounged around the club from midnight until closing. The club had a chrome and red leather bar and was adorned with intricate carved wood paneling, oil paintings and massive chandeliers that came from the home of the late Richard Beatty Mellon, according to the paper. "Strictly a class place," Karam told the *Pittsburgh Press* in an interview.

The Bachelor's Club was operated by "Pittsburgh Hymie" Martin, a big-time gambler who was convicted of killing a former Cleveland city councilman in 1931 but was spared from a life sentence after an appeal and retrial earned him an acquittal, according to a 1950 U.S. Senate investigation of organized crime. Martin was an associate of Moe Dalitz, known as "Mr. Las Vegas." Martin personally escorted Karam on a tour of the club to prove there was no gambling going on.

Another disreputable club operating during Prohibition was the Monaca, which was located across the street from a Pittsburgh police station in the city's Oakland neighborhood. The club was nicknamed the "Three Toms Club" because its owners all had the same first name. Tom Coyne was the brother of state Senator James Coyne. Tom "Goose" Goslin was a racketeer and sports promoter, and Tom Dolin was a former sparring partner of boxer Harry Greb. The owner of the club was listed as Louis B. Schwartz, a business associate of Senator Coyne, but the real owners were the three Toms, according to a grand jury investigation.

Pittsburgh police refused to raid the Monaca, so Governor Gifford Pinchot ordered state police to investigate. Posing as football fans looking for a night out following a game between Washington & Jefferson College and the University of Pittsburgh, undercover troopers went inside the club and signaled colleagues outside when to start the raid.

Troopers found a supply of moonshine, beer and other liquors along with a still in the basement. Roulette wheels, poker and craps tables and croupiers

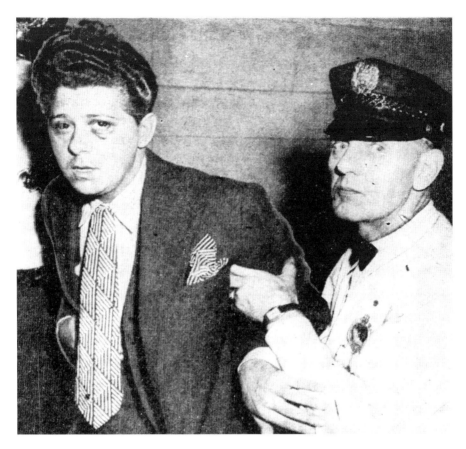

Valenti sports a black eye he received in police custody. Police told reporters Valenti slipped and fell. *From the* Pittsburgh Post-Gazette *Archives.*

wearing tuxedoes tended to the well-heeled patrons, a mix of racketeers and "society folk," according to the *Post-Gazette*. The three Toms escaped conviction for violating the Volstead Act when Prohibition was repealed but were convicted on gambling charges and sentenced to six months in jail. Tom Donlin and Tom Goslin served their sentences, but Tom Coyne's conviction was overturned on appeal.

One of the swankiest after-hours club in the late 1940s was the Chelsea, owned by mobster Frank Valenti, who began his Mafia career in Pittsburgh and went on to become the head of the crime family that ruled Rochester, New York. Valenti kept a high profile in Pittsburgh's nightlife and was a smooth talker and flashy dresser who was linked to, but never convicted of three unsolved gangland killings in 1946.

Valenti, Frankie Evans and Fred Garrow held up clandestine gambling clubs in Pittsburgh and northern West Virginia, making off with over $500,000 in cash and jewelry from gamblers. Evans scouted the targets before he and Garrow staged the robberies. Valenti and Evans had a falling out over Evans's share of the loot, and Evans once stormed into the Chelsea, threatening to kill Valenti.

On May 17, 1946, police found the bodies of Evans and Garrow stuffed in the back seat of a black 1941 two-door Pontiac. Garrow was found in a sitting position, while Evans was lying face-down on the floor, according to a criminal intelligence report filed by the Pittsburgh police. The report noted that Garrow's hands had teeth marks, indicting he was involved in a fight for his life before gunmen shot him.

Evans and Garrow, a bouncer at Allen's Café who sang in a barbershop quartet, had been trying to peddle $20,000 worth of stolen jewelry to Julius "Red" Drosnes, the café's manager. Drosnes told police he knew the jewelry was hot and refused to buy it. Drosnes later told Detective Lee Coleman that he warned Evans not to leave that night to attend a meeting arranged by Valenti, telling him he might never return, according to a May 29, 1946 police report in the archives of *Pittsburgh Post-Gazette* reporter Ray Sprigle at the H. John Heinz History Center.

Drosnes's brother Paul, a Democratic ward committeeman, was summoned before Mayor David Lawrence and quizzed about what he knew about the killings. Lawrence was incensed by the blatant murders

Left: Garrow-Evans. *Right*: Photo of one of the bodies stuffed in the back seat of the car Garrow and Evans were found in. The two men were small-time hoods working with Frank Valenti sticking up gambling clubs. *From the* Pittsburgh Post-Gazette *Archives*.

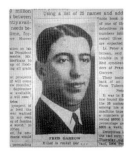
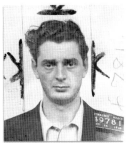
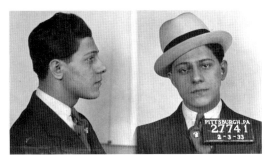

Top: Head shots of Garrow and Evans. *Bottom*: Mug shot of Frank Valenti. *From the* Pittsburgh Post-Gazette *Archives.*

and ordered a crackdown. Police inspectors were told, "You have three hours. Spare no one. Smash the rackets no matter who it hurts," was Lawrence's edict.

Suspicion immediately fell on Valenti. After he was arrested, detectives took him to a police station, cuffed him to a bench and began firing questions—and their fists—at Valenti. Detectives also beat him with a foot-long rubber hose. Whenever Valenti passed out, police revived him with smelling salts. By the time they were finished, Valenti had a black eye, a broken nose and ribs and bruises over the rest of his body, but he failed to talk.

"They never hit me solid in the face but my head was like a balloon," Valenti told District Attorney Artemus Leslie. "They [detectives] said we know that you know who did it if you did not do it. They started to bang, bang, bang on me again. This was all night long." When the detectives were finished, they gave Valenti a vanilla milkshake with two scoops of ice cream, according to the newspaper.

The investigation languished from 1946 until 1951, when Sprigle reopened the case and discovered several leads that police failed to pursue. Sprigle found a statement from Victor Scasserra, who told police two months after the killings that he saw Valenti and Evans together in the murder car.

Then Sprigle tracked down a gun dealer who remembered selling Valenti a unique brand of .45-caliber ammunition in 1946—the kind used in the

Garrow-Evans murders. World War II created a shortage of .45-caliber bullets, and the only ammo available to the public was made from casings scrounged from military shooting ranges. The bullets were made from a cheap alloy rather than copper or nickel.

Sprigle also interviewed two convicts who had knowledge of the slayings. Pete Lombardo gave police a fourteen-thousand-word statement implicating Valenti. Frank Roberts, a childhood friend of Valenti's, said Valenti offered him $1,100 to kill Garrow, but he refused. Lombaro and Roberts died in prison before police could question them.

Sprigle also discovered a statement from Valenti's mistress, Carla Ferrari, known as the "girl with the turquoise eyes," who told detectives she had found the guns used in the murders in Valenti's house that they shared. The *Post-Gazette* blamed the police and politicians for failing to solve the killings. "Bungle and sloth put Frank Valenti back in operation," read an editorial.

Valenti was linked to a third killing. Gus Gianni was a major bookmaker in the city and wanted in on the Chelsea. He offered to buy out Valenti, who refused. According to Sprigle, Gianni warned Valenti he was taking over the club whether Valenti liked it or not. A few days later, Gianni was gunned down near his home.

Tavern and restaurant owners fumed over the existence of the clubs because their licenses were cheaper to buy from the state than a regular liquor license and the clubs could operate later than bars and were permitted to open on Sundays.

There was an "iron curtain" of steel protecting one-man clubs. A steel door with a small peephole in the center made it hard for police to break in and gave the operators time to hide any evidence of gambling. Some clubs had three or four doors blocking the entrance to the gambling rooms. Police and state liquor agents had to break down the doors with axes and sledgehammers to gain entry.

Republican district attorney James Malone chided Mayor Lawrence about the doors, claiming they had one purpose, to give gamblers time to destroy evidence. "It is perfectly obvious that these rigid precautions are there for the purpose to conceal gambling and that purpose alone," wrote Malone.

Malone noted the Bachelor's Club had three steel doors blocking the entrance and four guarding the rear. Other clubs had alarm systems along with doors and two-way glass so doormen could see if police were massing for a raid.

In 1947, nearly one hundred agents stormed fourteen clubs across the city and discovered illegal liquor sales, gambling and violations of tax laws.

Raiders scooped up Jackie Conn, brother of former heavyweight boxing champ Billy Conn, in a raid on a club in Squirrel Hill. It operated during the day as the Veterans Club and at night as the Beacon Club. Billy Conn arrived at the police station to bail out his brother. "I'll tell you what," Conn told officers. "I'll pay you $25 to keep Jackie in for five days," according to an account in the *Pittsburgh Post-Gazette*.

A decade later, Pittsburgh police lieutenant Allen Carnahan was shot inside the Athletic Boosters Association. When police arrived, Carnahan told investigators he accidently shot himself when he was shifting his gun in his holster. He later admitted he was shot during a lover's quarrel with a prostitute at the club, whose patrons that night included police officers and politicians.

The Beacon was a classy after-hours club that used several names to hide the identity of its owners. It operated as the Hollywood Social Club, the Young Men's Thinking Club and the South Pacific Club until it closed in 1975, according to the *Pittsburgh Press*. Hollywood celebrities, including Dean Martin, stopped at the club when they were in Pittsburgh.

There was a close relationship between organized crime and Pittsburgh politicians over the decades. The Pennsylvania Crime Commission reported in 1970 that the Pittsburgh region was the center of gambling, loan sharking and narcotics and was headed by John LaRocca. In the 1970s, state lawmaker Charles Caputo, who chaired a committee that oversaw the Liquor Control Board, was linked to seven one-man clubs that had known Mafia members involved in their operation.

The president of the Showboat was Gino Chiarelli, a powerful figure in the Pittsburgh mob who dealt in drugs and extortion, according to the Pennsylvania Crime Commission. Chiarelli was believed to have been the mastermind who planned a $2.5 million armored car heist in 1982 the theft of $2 million worth of antique weapons four years later.

One of the Showboat's founders was Antonio Ripepi, a *capo* in the LaRocca crime family. LaRocca was facing deportation to Italy in 1954 as an undesirable alien because of his criminal record when Pennsylvania governor John Fine pardoned him, thus short-circuiting the proceeding. A bouncer employed at another Caputo-linked club was Anthony "Ninny" Lagatutta, a convicted arsonist and extortionist who was acquitted of beating a lawyer to death. The Showboat's manager was Anthony DeRamo, an ex-con on federal probation for peddling pornography.

Caputo's political campaigns were financed, in part, by contributions from an assortment of convicted criminals that included drug dealers and

bookies. He bristled at newspaper references to alleged links to organized crime. "One of our local newspapers inferred last week that I work hand-in-hand with organized crime because I appeared as a character witness for a man the State Crime Commission said was a racketeer," Caputo said. He testified on behalf of Ripepi, who was charged with assault and battery.

In the early 1970, a federal strike force of 150 agents cracked down on the clubs, staging early-morning raids that resulted in the closure of nine clubs by federal agents who were gathering evidence of tax violations, hidden ownership and links to organized crime.

Private clubs still exist in Pittsburgh and across Pennsylvania and continue to run afoul of the law. In 2015, the Pennsylvania Liquor Control Board revoked the license of the Greater Pittsburgh Social Club because of gunfights and brawls. In one incident, two men were shot; according to court records, women had been assaulted and gunshots frequently heard in an area outside the club.

Pennsylvania allows gambling in clubs with small games of chance, but hundreds of private clubs are breaking gambling laws. The law requires all proceeds from gambling to go to charity, but many clubs are plowing the money back into food, alcohol and the purchase of large-screen televisions.

THE HARDER THEY FALL

llegheny County district attorney Robert W. Duggan sat outside the grand jury room in the federal courthouse in Pittsburgh in 1973 waiting to testify before the federal panel that was investigating his relationship to bookies and gamblers that controlled the numbers racket in Pittsburgh and Allegheny County.

Duggan testified for ninety minutes before leaving the courthouse without talking to journalists who were waiting outside the room for Duggan to emerge. His appearance was the beginning of the end for the high-living prosecutor, whose political career began as a Republican committeeman in Pittsburgh before his ascension to the district attorney's office in 1964 to the first of three terms.

Duggan gave conflicting testimony to the grand jury and evasive and misleading answers to questions from IRS agents who were investigating the sources of Duggan's income. Duggan's spending was well beyond the $24,000 a year he earned as district attorney, according to an IRS report contained in the papers of former Pennsylvania governor Richard Thornburgh at the H. John Heinz History Center in Pittsburgh. At the time, Thornburgh was U.S. attorney in Pittsburgh. Duggan concealed three bank accounts from agents and lied about the number of safe-deposit boxes he had.

Thornburgh was a rising political star within the GOP establishment and would later be elected to two terms as governor of Pennsylvania. As U.S. attorney, Thornburgh was spearheading the probe into Duggan, who once

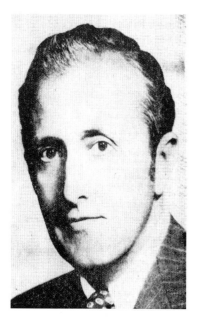

Allegheny County district attorney Robert Duggan, who killed himself the day he was indicted by a federal grand jury in Pittsburgh. *From the* Pittsburgh Post-Gazette *Archives.*

hoped his cousin James Dunn would be named to the post.

Thornburgh was working his way up the criminal food chain. Lieutenant Samuel Ferraro, chief of Duggan's racket squad, was under indictment for evading taxes on bribes from gamblers. A dozen of Duggan's detectives, known as the "dirty dozen," invoked the Fifth Amendment when they appeared before the grand jury. Pittsburgh numbers kingpin Tony Grosso was waiting in the wings to tell Thornburgh that he paid Ferraro and Duggan to protect his gambling empire, which stretched from the city throughout Allegheny County.

Duggan owned a luxury apartment in Pittsburgh, an estate in the ultra-wealthy Ligonier Valley, a home on the Gulf Coast of Florida, a thirty-one-foot cabin cruiser and three cars with monogrammed license plates. He employed a chauffeur, maid and a groundskeeper and was a member of ten country clubs, where he indulged his passions for golf, yachting and deep-sea fishing.

Duggan attended the exclusive Shady Side Academy in the city and the University of Pittsburgh, where he obtained his undergraduate and law degrees. He hobnobbed with the wealthy in Ligonier but never really was one of them. He came from a family of Irish politicians. His father, Frank, was a Republican committeeman and appointed to city council. Frank Duggan was twice urged to run for mayor and once for county commissioner, but he declined all three entreaties. One uncle ran for mayor of Pittsburgh, while another was the Allegheny County treasurer. Duggan headed Richard Nixon's reelection campaign in western Pennsylvania.

His onetime friend and campaign treasurer was the late billionaire Richard Mellon Scaife, who became his brother-in-law. Scaife was from the Ligonier Valley, home to some of Pittsburgh's wealthiest citizens, who rode to the hounds and held steeplechase races where champagne was served from the trunks of Rolls-Royces and members dined in privilege at the exclusive

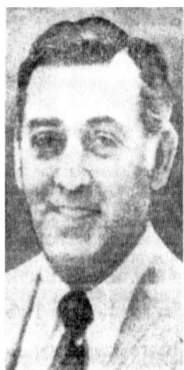

Left: Dick Thornburgh was the U.S. attorney for western Pennsylvania who led the investigation into District Attorney Robert Duggan's ties to racketeers. *Courtesy of Wikimedia Commons.*

Right: Samuel Ferraro, Duggan's corrupt detective who led the "racket squad." *From the* Pittsburgh Post-Gazette *Archives.*

Rolling Rock Club. Duggan inherited a 68-acre Ligonier farm from his late father and expanded it to 240 acres.

Duggan was not old money and never enjoyed the status of his ultra-rich neighbors. His father was an executive at the Consolidated Ice Company in Pittsburgh. Ligonier was dominated by the Mellon family, whose members included Andrew Mellon, Richard Beatty Mellon, Richard King Mellon, Paul Mellon, Richard Mellon Scaife, William Larimer Mellon, a Republican Party power in Pittsburgh, and Duggan's future wife, Cordelia Scaife May, who was worth $800 million when she died.

He was active in Republican politics both locally, statewide and nationally. During one of Duggan's campaigns for reelection, Deputy Attorney General Richard Kleindienst, a member of the Nixon administration,

Richard Mellon Scaife, newspaper publisher and heir to the Mellon fortune, broke with his brother-in-law, Robert W. Duggan, over Duggan's links to the rackets. *From the* Pittsburgh Post-Gazette *Archives.*

spoke on Duggan's behalf. "The re-election of Bob Duggan is absolutely imperative if you and I, together, as concerned citizens, are going to keep together the basic fabric of our free institutions in our great land," Kleindienst said.

Duggan "violently opposed" Thornburgh's appointment as U.S. attorney in Pittsburgh for six months before he was approved, according to a memorandum contained in Thornburgh's papers. Duggan later invited Thornburgh to lunch at the exclusive Duquesne Club and told him he would welcome any information he had about corruption within the detective bureau, yet when Thornburgh told Duggan that his investigators had invoked the Fifth Amendment before the grand jury, Duggan took no action against them, allowing the statute of limitations for prosecution to lapse.

On a cloudy, cool and rainy March day in 1974, Duggan was indicted for tax evasion for failing to pay taxes on unreported income of more than $137,000. Midway through his press conference to announce the charges against Duggan, an aide whispered to Thornburgh that Duggan's body had been found on his farm in Ligonier in Westmoreland County—dead from a twelve-gauge shotgun blast to the chest. State police said Duggan had alerted his groundskeeper the day before to meet him the next morning to kill some groundhogs that were damaging his estate Lochnoc, which means "freshwater lake" in Gaelic.

The individual was not Duggan's groundskeeper but a longtime friend, Floyd Hoffer, who said Duggan never mentioned anything about hunting. He said when he arrived at Lochnoc, he saw Duggan in the field at a distance. "I ran over and he was dead," said Hoffer, according to the *Pittsburgh Press*.

Cordelia Scaife May Duggan, wife of District Attorney Robert Duggan, who committed suicide the day he was indicted by a federal grand jury. The two were married to prevent Mrs. Duggan from answering IRS questions about her husband's finances. *From the* Pittsburgh Post-Gazette *Archives.*

State police investigators reached the scene and found Duggan's body clad in a red cap, brown windbreaker, yellow sweater and yellow corduroy pants. He was wearing thick, crepe-soled shoes. Troopers found plugs in his ears used to soften the noise from the gun's discharge and four spent shells in his pocket.

The troopers questioned if Duggan's death was a murder, accident or suicide. State Police captain Robert Hauth said the Parker twelve-gauge shotgun was dropped several times without firing and had no mechanical problems.

"When found there was an expended shell in the right chamber and one live shell in the left chamber," he told the *Pittsburgh Post-Gazette.* "This shotgun has one trigger and when cocked the right chamber is fired first. There was nothing faulty in the firing mechanism." Allegheny County coroner Dr. Cyril Wecht said an autopsy revealed that the shotgun fired close to Duggan's clothing, leaving power burns on the fabric and on the skin. Forensic experts dropped the loaded shotgun ten times onto a concrete floor, but the weapon never discharged, leading the coroner to rule the death a suicide.

Thornburgh had nailed Duggan by first going after Samuel Ferraro. Then Tony Grosso played his get-out-of-jail-free card. Throughout Grosso's career, he implicated the people whom he bribed in exchange for leniency when his cases came to trial. His testimony helped convict Pittsburgh alderman Frank Bruno. He served up Lieutenant Lawrence J. Maloney, a Pittsburgh detective who was head of the Pittsburgh Police Department's "racket squad" in the 1950s. Grosso testified against Maloney in 1965, and although Maloney was acquitted, he was fired as assistant police superintendent.

The case against Duggan began when IRS agents discovered that Duggan wrote a $37,000 check from a secret bank account to buy a condo in Florida. That check led investigators to another bank account controlled by Duggan

in which he had deposited $250,000. Duggan also used the account to make investments, pay for travel and buy expensive clothes, jewelry, art and a boat.

Duggan's political rise began on election night on November 5, 1964, when he was elected to his first of three terms. He stood among supporters in a Grant Street storefront downtown in a room filled with a stage, folding chairs, a blackboard and posters plastered on the walls proclaiming, "Robert W. Duggan for District Attorney." He had beat incumbent Democrat Edward C. Boyle by accusing Boyle of being soft on racketeers.

Duggan was a small, thin man with brown wavy hair and a "prissy smile," according to a description in Burton Hersh's biography of the Mellon family, *The Mellons: A Fortune in History*. Duggan dressed as if he had stepped out of a fashion magazine ad. He was suspected of being homosexual and given the nickname "Dixie" or "Little Lord Fauntleroy" by his detractors. He lived with his mother and didn't marry until he was forty-seven, and then only to prevent his wife from testifying against him.

Scaife told Hersh about an incident in which a drunk Duggan and Scaife came stumbling home one night. Duggan was so drunk he could barely walk so Scaife hoisted him over his shoulder and put him to bed. Suddenly, Scaife said Duggan kissed him.

Duggan went after bookies, prostitutes, pornographers and doctors suspected of performing abortions. During his first days on the job in 1964, he staged a series of raids on bookie joints that was covered widely in Pittsburgh's newspapers. A picture of Duggan talking on the telephone, wiping his brow and telling a reporter it had been a "busy day" appeared in the *Pittsburgh Press*. He announced the raids were the beginning of a war against racketeers, but soon he was picking and choosing his targets and accepting payoffs to finance his reelection campaigns.

He staged raids on movie theaters, claiming certain films were obscene. He tried to ban a 1968 movie, *Therese and Isabelle*, a coming-of-age story of two lesbian lovers in a Swiss boarding school, from being viewed in city and suburban theaters, arguing it was obscene. A county jury agreed, ruling the movie should be banned, but the Pennsylvania Supreme Court overturned the ruling.

Duggan and Scaife were childhood friends, but they also shared a political ideology that led Scaife to agree to become treasurer of Duggan's campaign committee in the 1970s. Scaife was elated when Duggan was first elected.

"I had always listened to the radio to Mister DA [radio program] and that was the way I looked on Bob," Scaife told Hersh. "I regarded him as a person of high moral character."

Scaife also told Hersh he thought Duggan would be a good candidate for governor of Pennsylvania—until Scaife was shown police reports that linked Duggan to gamblers. Scaife began having second thoughts about Duggan as newspaper stories linked him to the city's major vice lords. Despite the damning information, Scaife attempted to intercede with the Department of Justice in having Thornburgh's investigation stopped by contacting Attorney General John Mitchell's deputy, Richard Kleindienst. "A drumfire of efforts by Duggan and Scaife to squelch the investigation was underway," Thornburgh said.

Thornburgh had received warnings from Pennsylvania senator Hugh Scott and Deputy Attorney General Harlington Wood that Duggan was pressing for an appointment with Kleindienst in Washington, D.C., to discuss the investigation, according to a December 17, 1970 memorandum among Thornburgh's papers.

Scaife resented the fact that Duggan used the death of Scaife's mother, Sarah, to explain away his sudden wealth, wrote Hersch. "He used the death of my mother to explain all this, two hundred and fifty thousand dollars he'd gotten for legal work in helping settle her estate," said Scaife.

The split between the two friends came when Duggan sent $9,900 in cash in a brown envelope to Scaife, telling him they were contributions from staff with a note. "Will forward names to you early next week. Ruth does not have to acknowledge these as I have spoken to each of them individually." Ruth was Ruth Mohney, Scaife's secretary.

After Duggan was elected to a third term in 1971, Scaife resigned as treasurer because he was concerned about the questionable cash contributions. The Pennsylvania Crime Commission began investigating Duggan's campaign fundraising and issued a report in 1974 that revealed that Duggan falsified campaign finance reports and concealed cash to hide the true sources of the donations, which came from Grosso and other bookmakers.

The commission reported the concealment of the sources of the cash contributions and expenses was "because of a fraudulent and corrupt motive. The magnitude of the falsification is substantial," reported the Crime Commission. More than $68,000 in cash was never reported. "Mr. Duggan's violation of the Election Code cast a serious shadow on the District Attorney's Office in Allegheny County which must be resolved quickly," read the report.

The Crime Commission also revealed Duggan maced his employees. Duggan required employees to kick in 3 percent of their annual salaries, plus ten dollars for each year they worked in the district attorney's office. Workers

also were expected to donate five dollars a month for a "flower fund," which was used to hold dinners and for campaign activities.

The $9,900 in cash that Duggan gave Scaife was later revealed to have come from the diminutive Tony Grosso, who funneled payoffs to Duggan through Lieutenant Ferraro. Grosso oversaw a $30 million gambling empire in Pittsburgh and Allegheny County that employed as many as five thousand people. Grosso testified in federal court that he routinely gave Ferraro $9,900 in fifties and hundreds as payoffs for protection of his numbers syndicate. IRS agents tracked Duggan's spending and discovered that he made personal purchases for clothing and paid the wages for his groundskeeper using similar denominations.

When a federal grand jury led by Thornburgh began investigating Duggan, Ferraro already had been indicted for evading taxes on $290,000 in protection payoffs, and Grosso testified at Ferraro's trial that he made payoffs to Duggan via Ferraro. Once, Tony Grosso added, he personally gave Duggan $25,000 in cash as a payoff after Duggan showed up in the parking lot of Grosso's suburban Pittsburgh restaurant demanding the money.

Duggan used a private company, Abstract Inc., he operated in conjunction with his private law practice to launder the payoffs. He said the company was inactive for several years, but its bank account was thriving with the infusion of thousands in cash. The Crime Commission said Duggan's attempted to conceal $68,000 in payoffs during his 1971 reelection campaign was a deliberate cover up.

The IRS subpoenaed Cordelia Scaife May to question her about Duggan's finances, but the couple secretly married in a small town in Nevada so she could invoke spousal immunity and be prevented from answering any questions about the childhood friend who now was her husband. Mrs. Duggan told IRS agents she had been in love with Duggan since they were teenagers.

Duggan realized the walls were closing in on him and couldn't stand the thought of prison. Richard Mellon Scaife told his sister that her husband was going to be indicted: "Out of courtesy to me, the Internal Revenue Service men are allowing me to tell you."

Detective Joseph O'Neill, a former FBI agent who worked as assistant chief of detectives, told the IRS that he suspected Ferraro was taking bribes. He also said Ferraro reported directly to Duggan. Ferraro had been sentenced to six years in prison, and Duggan was likely to get an even longer sentence if he was convicted. He may have viewed death as the only way out of his legal predicament.

After Duggan's death, new district attorney John Hickton discovered that Duggan had stolen $50,000 from a safe in the evidence room—cash confiscated during gambling raids. Hickton said Duggan used the money as his personal petty cash fund and drew money from it when he was short or when he wanted to entertain, according to Hickton.

Duggan's funeral was front-page news in the *Press* and *Post-Gazette*. Nearly two thousand people turned out for the service, as forty-eight honorary pallbearers and an honor guard from the Fraternal Order of Police accompanied his casket. Cordelia Scaife May Duggan, standing erect and blinking away tears, held on to the arms of cousin Curtis Sciafe and her husband's longtime friend Tom Nied, trailing behind her husband's coffin as it left St. Paul's Cathedral.

Cordelia had been married briefly in 1949 to Herbert May Jr., the son of a Pittsburgh industrialist, before her secret 1973 marriage to Duggan before a justice of the peace in Nevada. They were married after she was contacted by IRS agents who wanted to question her about her Duggan's finances.

She always suspected that her husband was murdered and her brother had something to do with Duggan's death, even though the official cause of death was suicide. The two stopped speaking to each other in 1973 and separated their foundations and philanthropic interests, according to a 1981 story in the *Pittsburgh Post-Gazette*. Scaife used his newspaper, the *Greensburg Tribune-Review*, to write scathing stories about his sister until her death in 2005. Richard Mellon Scaife died in 2014.

BIBLIOGRAPHY

Newspapers

Bulletin Index (Pittsburgh, PA)
Harrisburg (PA) Patriot-News
Mount Washington (PA) News
New York Times
Pittsburgh Chronicle-Telegraph
Pittsburgh Commercial Gazette
Pittsburgh Daily American
Pittsburgh Daily Post
Pittsburgh Dispatch
Pittsburgh Gazette
Pittsburgh Post-Gazette
Pittsburgh Press
Pittsburgh Sunday Post
Pittsburgh Sun-Telegraph
Tribune-Review (Greensburg, PA)

Books and Collections

Bauman, John F., and Edward K. Muller. *Before Renaissance: Planning in Pittsburgh, 1889–1943*. Pittsburgh, PA: University of Pittsburgh Press, 2006.

Beers, Paul B. *Pennsylvania Politics. Today and Yesterday*. University Park: Pennsylvania State University Press, 1980.

Brewer, John M. Jr. *Pittsburgh Jazz*. Charleston, SC: Arcadia Publishing, 2007.

Dick Thornburgh Papers, 1932–. AIS.1998.30, Archives Service Center, University of Pittsburgh, Pittsburgh, Pennsylvania.

Fleming, George T. *History of Pittsburgh and Environment: From Prehistoric Days to the Beginning of the American Revolution*. New York: American Historical Society Inc., 1922.

Hersh, Burton. *The Mellons: A Fortune in History*. New York: William Morrow, 1978.

Kaplan, Justin. *Lincoln Steffens. A Biography*. New York: Simon and Schuster, 1974.

Koskoff, David E. *The Mellons: The Chronicle of America's Richest Families*. New York: T.Y. Crowell, 1978.

Mellon, James. *The Judge: The Life of Thomas Mellon, Founder of a Fortune*. New Haven, CT: Yale University Press, 2011.

Michael P. Weber Papers, 1963–1984. AIS.1988.15, Archives Service Center, University of Pittsburgh, Pittsburgh, Pennsylvania.

Nasaw, David. *Andrew Carnegie*. New York: Penguin Press, 2006.

Ray Sprigle Papers and Photographs, 1915–1973. MSS 0779, Library and Archives Division, Senator John Heinz History Center, Pittsburgh, Pennsylvania.

Rooney, Art Jr., and Roy McHugh. *Ruanaidh: The Story of Art Rooney and His Clan*. Pittsburgh, PA: Geyer Printing, 2008.

Ruck, Rob, Maggie Jones Patterson and Michael P. Weber. *Rooney: A Sporting Life*. Lincoln: University of Nebraska, 2010.

70 Years of General Contracting. A Review of Major Construction Accomplishments of Booth & Flinn Company. Pittsburgh, Pa. 1876–1946. Privately published.

Skrabec, Quentin R. Jr. *The World's Richest Neighborhood. How Pittsburgh's East Enders Forged American Industry*. New York: Algora Publishing, 2010.

Stave, Bruce M. *The New Deal and the Last Hurrah: Pittsburgh Machine Politics*. Pittsburgh, PA: University of Pittsburgh Press, 2009.

Stocking, Collis A. *A Study of Dance Halls in Pittsburgh*. Pittsburgh, PA: Pittsburgh Council of Churches, 1925.

"Story of Old Allegheny." Writing Program of the Works Progress Administration. Pittsburgh, PA: Allegheny Centennial Committee, 1941.

Thurston, George H. *Allegheny County's Hundred Years*. Pittsburgh, PA: A.A. Anderson & Company, 1888.

Wage-Earning Pittsburgh. New York: Survey Associates, 1914.

William Flinn Papers. AIS.1968.10, Archives Service Center University of Pittsburgh, Pittsburgh, Pennsylvania.

William N. McNair Papers, 1930–1948, AIS.1966.13, Archives Service Center, University of Pittsburgh, Pittsburgh, Pennsylvania.

Wing, Frank E., *Thirty-Five Years of Typhoid: The Fever's Economic Cost to Pittsburgh and the Long Fight for Water*. New York: Charities and Commons, 1909.

Zahniser, Keith A. *Steel City Gospel: Protestant Laity and Reform in Progressive-Era Pittsburgh*. New York: Routledge, 2010.

Government Reports

Olmsted, Frederick Law. "Hump Project Pittsburgh: Main Thoroughfares and the Downtown District: Improvements to Meet the City's Present and Future Needs," Pittsburgh Civic Commission, December 1910.

Pennsylvania Crime Commission. "Report on Pennsylvania Election Code." January 1974.

Rhodes, Frederic Augustus. "Report and Recommendations of the Morals Efficiency Commission." Pittsburgh, PA: Pittsburgh Printing Company, 1913.

Articles

Ackerman, Jan. "Rub Parlor Operations Are Described." *Pittsburgh Post-Gazette*, October 12, 1984.

Allen, William. "Beacon Club Closing Ends Fabulous After-Hours Era." *Pittsburgh Press*, November 9, 1975.

Altenberger, Christine. "The Pittsburgh Bureau of Police: Some Historical Highlights." *Pennsylvania History* (January 1966).

Andren, Kari. "Hundreds of Private Clubs Are Breaking Pennsylvania's Law on Small Games of Chance, Official Says." *Harrisburg Patriot-News*, June 9, 2011.

Astorino, Samuel J. "The Contested Senate Election of William Scott Vare." *Pennsylvania History* 2 (April 1961).

Ayers, Ruth. "If She Were Mayor, Mrs. McNair Reveals She's Make City Take Notice in New Way." *Pittsburgh Press*, January 4, 1924.

Barcousky, Len. "Eyewitness 1936: Unprecedented—A Pittsburgh Mayor Resigns Without Being Indicted." *Pittsburgh Post-Gazette*, April 18, 2010.

Bauman, John F., and Edward K. Muller. "The Olmsteds in Pittsburgh (Part II), Reshaping the Progressive City." *Pennsylvania History* (Winter 1993–94).

Bernstein, Steven. "Pittsburgh's Benevolent Tyrant." *Westmoreland Pennsylvania History Magazine* (Summer 2003).

Brown, David. "A Giant Force." *Pittsburgh Tribune-Review*, June 11, 2006.

Butler, Ann. "Vice Lord's Friend Lives in Bull's-eye." *Pittsburgh Press*, November 27, 1977.

Cooper, William. "Former Mayor McNair Dies in St. Louis." *Pittsburgh Press*, September 10, 1948.

———. "Valenti Won't Talk to Grand Jury." *Pittsburgh Press*, April 15, 1951.

Deibler, William F. "Crime Group Grows, State Probe Says." *Pittsburgh Post-Gazette*, July 3, 1970.

Donalson, Al. "Jury Claims Suicide Verdict Reached Easily." *Pittsburgh Press*, April 15, 1986.

Evans, J. Kenneth. "Symbolic Moves." *Pittsburgh Post-Gazette*, January 14, 1987.

Gazette Times. "Change in City's Topography." August 16, 1911.

———. "Mayor Magee, Magician!" August 3, 1911.

———. "Millions of Dollars of Public Money Went into Flinn Coffers." April 5, 1925.

———. "Pitfalls for Council in Mayor's Scheme to Dig Down Hump." August 3, 1911.

———. "Roxie Long on Way Here Shackled Hand and Foot." July 24, 1922.

———. "William Flinn Talked and Talked at a Banquet." March 1, 1912.

———. "Working on Tunnel through Hills Starts Now." July 13, 1915.

Gemperlein, Joyce. "Mob Figures' Slayings Probe Gains, Task Force Reports." *Pittsburgh Post-Gazette*, January 17, 1978.

Gigler, Rich. "Vice Kingpin on Bond in Slaying." *Pittsburgh Press*, March 29, 1978.

Gordon, Gertrude. "Roxie Long's Wife Scores Negligence that Allowed Her Husband to Elude Law." *Pittsburgh Press*, May 6, 1922.

Gould, Kenneth M. "Ways Out of Pittsburgh's Civic Mess." *Pittsburgh Press*, June 7, 1931.

Grochot, Jack. "At Smut Shop, Iron Worker Wears Different Hats." *Pittsburgh Press*, April 23, 1972.

———. "Legal, Financial Troubles Swamping Showboat Club." *Pittsburgh Press*, May 14, 1972.

———. "Massive Sweep Carried Off Months of Quiet Preparation." *Pittsburgh Press*, October 7, 1972.

———. "Showboats Debts Placed at $104,000." *Pittsburgh Press*, July 8, 1972.

Grochot, Jack, and Roger Stuart. "House Liquor Panelist Caputo Linked to 7th Club." *Pittsburgh Press*, January 23, 1974.

Guerin, Eddie. "How I Escaped from Devil's Island." *Pittsburgh Press*, November 16, 1924.

Guydon, Linda. "Beechwood Farms: Haven for Naturalists." *Pittsburgh Post-Gazette*, May 31, 1984.

Hollister, Jack. "Garrow-Evans Slayings Open to $5,000 Reward." *Pittsburgh Post-Gazette*, July 31, 1949.

Huntley, Theodore A. "City Elected Barker Who Cannot Be Trusted—Council Assumed Control over Government." *Morning Post*, October 4, 1850.

———. "Inspector's Pool-Room under Big Speakeasy." *Morning Post*, July 26, 1926.

———. "Little Canada, Northside's 'Red Light' District, Due for Cleanup." *Morning Post*, July 10, 1928.

———. "Methodists Urge Northside Vice Wars." *Morning Post*, October 7, 1926.

———. "$306,285 Spent Here, W.L. Mellon Testifies; Pepper Denies Responsibility for Huge Sums." *Pittsburgh Post*, June 11, 1926.

Jensen, Edward. "State Probing Gangland Ties." *Pittsburgh Post-Gazette*, January 17, 1978.

Johnson, Vince. "Grand Jury Clears Mayor, But Indicts 7 Other Officials." *Pittsburgh Post-Gazette*, October 6, 1951.

Jones, John. "Sure to Be There's Only One Bill McNair." *Pittsburgh Post-Gazette*, December 7, 1924.

Lash, Cindi. "Numbers Baron Tony Grosso Dies." *Pittsburgh Post-Gazette*, August 14, 1994.

Levine, Marty. "My Grandfather, the Sportsman." *Pittsburgh Post-Gazette*, February 13, 2011.

Litman, Lenny. "After-Hours Clubs Singing 'Swan Song.'" *Pittsburgh Press*, May 18, 1975.

Love, Gilbert. "McNair Manor—Mayor's Sociological Experiment in Home Building Eyed by Kibitzers." *Pittsburgh Press*, March 19, 1934.

Lynch, Charles. "Reputed Vice King, George Lee Slain." *Pittsburgh Post-Gazette*, February 25, 1977.

Maryniak, Paul. "Greed Was Incited Cop's Downfall." *Pittsburgh Press*, August 11, 1985.

———. "Mole Undermines Local Bookies Probe." *Pittsburgh Press*, March 13, 1984.

————. "Police Aided Grosso by Raiding Rivals." *Pittsburgh Press*, December 31, 1985.

————. "$200,000 Bail Set on Grosso Aide." *Pittsburgh Press*, December 3, 1985.

McCarren, James. "Grand Jury Indicts Duggan." *Pittsburgh Press*, March 5, 1974.

McFarland, Kermit. "Mayor Balked by Council to Smith Ouster." *Pittsburgh Press*, March 20, 1934.

————. "McNair Retorts to Critics Who Says He Lacks Dignity." *Pittsburgh Post-Gazette*, November 17, 1933.

————. "This Man McNair." *Pittsburgh Post-Gazette*, November 13, 1933.

————. "This Man McNair." *Pittsburgh Post-Gazette*, November 16, 1933.

Moffitt, Mary Irene. "Cops Lift Green Door, Encounter 'Mr. Fish.'" *Pittsburgh Post-Gazette*, January 25, 1957.

Molyneaux, Robert. "Scandal Hinted in $3½ Million City Light Deal." *Pittsburgh Press*, March 25, 1971.

Monahan, Kaspar. "Show Stops." *Pittsburgh Press*. September 14, 1948.

Mount Washington (PA) News. "Long Back in Old Haunt—Before the Bar of Justice." April 24, 1959.

New York Times. "M'Nair Goes to Jail for 'Numbers.'" April 19, 1936.

————. "Pittsburg's Amazing Story of Graft; Smiling Johnnie's." March 27, 1910.

O'Neill, Brian. "Corrupt Pittsburgh Politics: Those Were the Good Owl' Days." *Pittsburgh Press*, March 28, 2010.

O'Neill, Pat. "It's the Muse, Not the Booze They Seek." *Pittsburgh Post-Gazette*, May 2, 1950.

Ove, Torsten. "Gino Chiarelli/Powerful Figure in Pittsburgh Mafia." *Pittsburgh Post-Gazette*, June 14, 2012.

————. "Sexually Ambivalent Rub Parlor Owner." *Pittsburgh Post-Gazette*, January 9, 2003.

Pittsburgh Commercial Gazette. "Evidence for Flinn," November 29, 1899.

————. "The Flinn Case Begun." November 28, 1899.

————. "Gamblers Must Go." April 10, 1894.

————. "Massage Parlors Must Close." April 28, 1899.

Pittsburgh Post. "Cleaning Up of Allegheny." January 17, 1905.

————. "Crooks Are Fleeing City; Police Dragnet Traps Scores." January 23, 1920.

————. "Depends on Jury Now." February 11, 1892.

————. "A Famous Place Pulled." January 8, 1894.

———. "Little Canada, Long in Oblivion, Again in Limelight, but Old-Time Crooks Gone—or Reformed." January 26, 1920.

———. "Murdered at Early Morn." August 23, 1887.

———. "Northside Vice Ring in Faulkner's District." July 26, 1926.

———. "Oyster Paddy Acquitted." February 22, 1889.

———. "Walsh Takes Blame for Raging Vice Here." July 28, 1926.

Pittsburgh Post-Gazette. "Bachelor's Club Head Faces Squire." April 28, 1941.

———. "Board Condemns Park Settlement with Booth & Flinn." December 27, 1925.

———. "Court to Rule on Silence of Valenti." May 8, 1951.

———. "Defense Hurls Fiery Charges at Roxie Long." December 9, 1932.

———. "Democrats Feast, Dance over Victory." May 13, 1934.

———. "Eddie Guerin Dies at 80; First to Flee Devil's Island." December 6, 1940.

———. "Final Tribute Paid Former Mayor McNair." September 14, 1948.

———. "Florig Hits Unsolved Racket Deaths in Outlining Policy." May 16, 1948.

———. "Former Mayor McNair Dead at 67." September 10, 1948.

———. "From Madams to Magnates, Tour Features People Who Made Northside Historic." September 10, 2015.

———. "Jurors Again Turn Inquiry to Northside." October 8, 1928.

———. "Liquor Raid Puts Roxie Long Back into County Jail Again." December 21, 1938.

———. "Margiotti Hurls Charge of Graft and Bribery." August 5, 1950.

———. "Mayor's Phone Talk Just 'A Bit Thick' Mrs. Pinchot Hints." April 23, 1934.

———. "McNair Rule Last Nearly Three Years." September 10, 1948.

———. "M'Nair Fails Coyne Rally." *Pittsburgh Post-Gazette*, September 11, 1935.

———. "Mob Murder Suspect Takes a Fall." May 14, 1946.

———. "Murder Rap Beaten by Valenti." November 14, 1947.

———. "Northside Vice Aired before Graft Probers." November 20, 1928.

———. "Numbers Big Shots Unmolested as Police Round Up Small Fry." May 23, 1946.

———. "Numbers Slips Surprise Roxie." August 2, 1945.

———. "Pepper, Fisher Assured Backing of City Administration." April 4, 1926.

———. "Roxie Bagged in Traffic Jam." July 3, 1946.

———. "Roxie Long Disappears." December 5, 1932.

———. "Roxie Long Faces Burglary Charges." June 23, 1934.

———. "Roxie Long Held in Thefts." September 27, 1957.

———. "Roxie Long Takes Bride as Her Father Calls Police." May 5, 1943.

———. "Roxie, 'Missing Girl' Wed Again." May 7, 1943.

———. "Roxie's Latest Conflict with Law Loses Wife." March 14, 1958.

———. "Roxie's Number up again as He Tries to Beat the Rap." August 1, 1945.

———. "Roxie Wins, Cash, Freedom." July 9, 1946.

———. "State Men Nab 100 in Raid on 100 Clubs." March 7, 1938.

———. "Summary of the Grand Jury's Presentment." April 9, 1910.

———. "300 Subpoenas Going Out in Racket Probe." July 10, 1950

———. "Valenti Cracks Up under Quiz." June 28, 1946.

Pittsburgh Press. "Admitted It Was City Money." November 28, 1899.

———. "After-Hours Club Shuttered by State." January 10, 1963.

———. "After-Hours Clubs on Spot after Shooting." February 28, 1957.

———. "An Old Dive Yields Big Murder Mystery." June 23, 1906.

———. "A. Rex Flinn, Civic Leader Dies." May 29, 1950.

———. "Big Bootleg Profit Told by Roxie Long." December 1, 1932.

———. "Board Condemns Park Settlement with Booth & Flinn." December 27, 1925.

———. "Booth & Flinn." January 15, 1905.

———. "Bottle Lures Playboy from Home and All He Gets Done Is a Plastering Job." January 10, 1934.

———. "Clean Up Starts." April 18, 1933.

———. "Close the Tubes, Fill Them with Garbage, Says McNair." June 28, 1934.

———. "Clubs with Liquor." October 23, 1972.

———. "Colorful Spots of McNair's Career." September 10, 1948.

———. "Copy of Press Introduced as Evidence." June 17, 1926.

———. "Crime Quiz Brings Raid." March 25, 1951.

———. "Dance-Raiding Police Face Trial on Orders from McNair." February 6, 1934.

———. "Dean Produces Racket Probe Numbers Slips." November 20, 1946.

———. "Death of William Flinn." February 20, 1924.

———. "Decision Against the City." December 23, 1899.

———. "Dirge of Curiosity Makes Funeral of Nettie Gordon." March 8, 1934.

———. "Dizzy, Daffy Stunts Made Mayor No. 1 Headline Getting." October 6, 1936.

———. "Do Not Deny Their Guilt." March 2, 1910.

———. "Duggan Indictment Looked Like Just the Beginning." March 6, 1974.

———. "East Liberty Numbers Suspects Questioned in Double Gang Killing." May 18, 1946.

———. "Escape Plot Charge Against Roxie Long Not Substantiated." December 8, 1924.

———. "Fate Kind to Nettie Gordon: Case in Court 8 Years." July 9, 1926.

———. "Gambling Raiders Hit Two Clubs." August 25, 1947.

———. "Gang Victim's Body Taken to Uniontown for Burial." May 18, 1946.

———. "Herron Starts Work by Closing Swanky Club." April 2, 1933.

———. "Honest Brakeman, Says Roxie Long." May 16, 1946.

———. "Inspector Calls Police Head Tool of Numbers Racketeers." March 2, 1936.

———. "Iron-Clad Doors Guard Secrets of Gambling Joints, 1-Man Clubs." August 8, 1948.

———. "It Is Up to Council." February 25, 1931.

———. "Killing Net Out for Roxie Long." October 29, 1931.

———. "Kline Has Lapse of Memory." January 17, 1926.

———. "Klein Now a Prisoner in Cell at Riverview." March 30, 1910.

———. "Many Raids in Allegheny." July 20, 1903.

———. "Mayor Kline Offers No Hope." December 16, 1928.

———. "Mayor McNair Quits." October 6, 1936.

———. "Mayor's Carrie A. Nation Joke Backfires on Him." April 27, 1934.

———. "Mayor Stalks from Tax Hearing after Threat to 'Throw Him Out.'" March 31, 1936.

———. "Mayor Trades with Coyne in Ripper Battle." February 19, 1935.

———. "Mayor William to Face Trial." February 19, 1935.

———. "M'Nair Back, 'Wisecracks' Fill City Hall." September 28, 1934.

———. "M'Nair Whets Ax for Public Health Aides." February 24, 1935.

———. "New Gambling House Exposed by Patterson." September 5, 1932.

———. "New Warrant Out for Roxie." January 11, 1932.

———. "9 Raided Clubs Charter Goals Listed." October 12, 1972.

———. "Numbers Clue Get Hotter in Gang Killings." May 19, 1946.

———. "Numbers Gang Clash Near." May 28, 1947.

———. "1-Man Clubs Hit as Cause of Disease." January 17, 1947.

———. "The People Win." November 8, 1933.

———. "Police Open Gang Roundup." May 20, 1946.

———. "Preposterous Alibis." April 4, 1937.

———. "Racketeers Get Phones Using Phony Means." August 1, 1948.

———. "Racket Evidence Often Lost During Ferraro's Reign." August 26, 1973.

———. "Removal of Hump Triggered a Building Boom." November 12, 1915.

———. "Revelations by the Queen of the Underworld." July 23, 1922.

———. "'Robin Hood' Roxie Long Draws 9-Year Federal Term." July 2, 1951.

———. "Roxie Legal Career Climaxed by 10-Day Term for Contempt." May 27, 1959.

———. "Roxie Long Clears Reichman." July 25, 1922.

———. "Roxie Long Eludes Pursuers." May 6, 1922.

———. "Roxie Long Flees Country for Rome on Eve of Trial." March 2, 1922.

———. "Roxie Long, Fool." January 26, 1933.

———. "Roxie Long 'Seen' in Many Places but He Still Is Free." May 8, 1922.

———. "Roxie Long Slapped in Jug in Lieu of $100,000 Bond." January 11, 1951.

———. "Roxie Must 'Surrender' Today or the Sleuths Will 'Go Get Him,' Is Dire Threat." July 25, 1922.

———. "Support Pepper or Lose Jobs, Says Kline." April 29, 1926.

———. "Two Avoid Contempt in Racket Case." May 3, 1951.

———. "Two Slain in Numbers War." May 17, 1946.

———. "Underworld Fears More Gangland Killings." August 12, 1932.

———. "Volpe Aide Murdered." August 11, 1932.

———. "What the Hump Cut Means to Pittsburg." April 5, 1912.

Pittsburgh Sunday Post. "Back to Pestilential Devil's Island." May 27, 1906.

Pitz, Marylynne. "From Speakeasy to Harlem Nights." Pittsburgh Post-Gazette, April 18, 2004.

Rieland, Randy. "City Checking for Mob Links in 'Playboy Club' Downtown." Pittsburgh Press, February 1, 1976.

Rimmel, William. "Fainting Bertha." Pittsburgh Post-Gazette, November 13, 1954.

———. "Old Allegheny." Pittsburgh Post-Gazette, August 21, 1949.

———. "Out of the Past." Pittsburgh Post-Gazette, December 5, 1970.

Rouvalis, Cristina. "Rubbed Out: Massage Parlors Vanishing from City." Pittsburgh Post-Gazette, October 12, 1984.

Sabatini, Patricia. "Pittsburgh Athletic Association, the 108-year-old Private Club in Oakland, Struggles to Regain Footing." *Pittsburgh Post-Gazette*, March 27, 2016.

Sanina, Mila. "The Last Republican Mayor of Pittsburgh." *Pittsburgh Post-Gazette*, November 6, 2013.

Schmitz, Jon. "City Winning War with Liberty Ave." *Pittsburgh Press*, May 16, 1982.

Snyder, Thomas. "5 Clubs Facing Grand Jury." *Pittsburgh Post-Gazette*, July 25, 1961.

Sprigle, Ray. "Bungle and Sloth Put Frank Valenti Back in Operation." *Pittsburgh Post-Gazette*, March 29, 1951.

———. "Cangelliere Mob Rules Northside for 2 Decades." July 12, 1950.

———. "Hill Numbers Gang Writer Landed in Court." November 13, 1930.

———. "Jimmie McKay, Colorful Story Teller of Old Allegheny, Dies Almost Alone at 81." *Pittsburgh Post-Gazette*, January 4, 1944.

———. "Lombardo Puts Finger on Valenti in Evans Murder." *Pittsburgh Post-Gazette*, April 5, 1951.

———. "Lord Guffey of Pennsylvania." *American Mercury*, November 1936.

———. "Murder." *Pittsburgh-Post Gazette*, March 28, 1951.

———. "Murder." *Pittsburgh Post-Gazette*, March 31, 1951.

———. "Numbers Take $50,000,000 Yearly in City." *Pittsburgh Post-Gazette*, July 10, 1950.

———. "Racket Fund Raised for O'Connor." *Pittsburgh Post-Gazette*, July 19, 1951.

———. "Saloon Singer's 'Pigeon Song' Led Police to Valenti." *Pittsburgh Post-Gazette*, April 6, 1951.

———. "Two Said Valenti Offered to Hire Them as Killers." *Pittsburgh Post-Gazette*, April 9, 1951.

———. "Valenti Identified as Bullets Buyer by Gun Dealer." *Pittsburgh Post-Gazette,* April 4, 1951.

Steffens, Lincoln. "Pittsburg: A City Shamed," *McClure's* (1903).

Sterrett, Charles. "District Attorney Calls on Fairley to Aid Cleanup." *Pittsburgh Post-Gazette*, November 24, 1952.

Stuart, Roger, and Jack Grochot. "Crime Panel Ties Duggan to Campaign Fund Coverup." *Pittsburgh Press*, January 30, 1974.

Swetnam, George. "Paving Stones in Western Pennsylvania History." *Pittsburgh Press*, July 11, 1965.

Taylor, Robert. "Mayor McNair's 'Brain Trust' Made City Hall a Circus Spot." *Pittsburgh Press*, September 10, 1948.

————. "McNair Enters Hotel Strike." *Pittsburgh Press*, February 9, 1934.

Tomb, Geoffrey. "Attorney: Rub Parlors Prostitution Houses." *Pittsburgh Post-Gazette*, January 7, 1978.

Uhl, Sherley. "Gun Wound Kills Duggan." *Pittsburgh Press*, March 5, 1974.

Woltman, Fred. "Mrs. McNair Gags Mayor but Moritz Bubbles Over." *Pittsburgh Press*, September 28, 1934.

Wright, Guy. "Rookie Cop Comes to Dinner, Stays." *Pittsburgh Press*, June 7, 1953.

INDEX

A

Albany Kid 33
Allegheny Hunting and Fishing Club
 126
Allen's Café 130
Aloysius Club 127
Ambrose Club 127
American Hunting and Fishing Club
 127
American Musical Society 127
Amerita Club 127

B

Bachelor's Club 127
Beacon Club 133
Beau Brummel, the 127
Bigelow, Tom 52
Bloomfield Athletic Association 127
"bootleggers' union" 13
"boozocracy" 13
Boss Tweed 20
Brahm, Albert 28
Brand, William 27
"Broadway of the Hill District" 58

C

Cangelliere mob 106
Caputo, Charles 133
Carnegie, Andrew 19
Charleston, Oscar 60
Chelsea 127, 129
Chiarelli, Gino 133
Chicago May 33
Coltrane, John 58
Conn, Billy 133
Conn, Jackie 133
Cox, George 20
Coyne, Tom 128
Crawford Grill 58, 59
Crystal Barber Shop 58

D

DelMoro Canoe Club 127
Devil's Island 36
Dice Box Miller 33
Dick the Waltzer 33
Dihigo, Martin 60
DiPippa, Rocco. *See* Long, Roxie
Dolin, Tom 128

Dreyfus, Alfred 37
Duggan, Cordelia Scaife May 138, 139
Duggan, Robert W. 135, 136
Duquesne Hotel 26
Durham, Israel 20
Dutch Alonzo 33

E

Eldridge, Eldridge 58
Eldridge, Roy 58
Encardona gang 106
English Bill 33

F

Fainting Bertha 33
Farmer John 35
Ferguson, Hugh 27
Ferraro, Samuel 136
First National Ukrainian Societ 127
Fitzhugh, C.L. 26
Flinn, William 20
Foxy Lady, the 127
Frey, Ernest Lee 23
Frick, H.C. 18

G

Garner, Erroll 58
Gianni, Gus 132
Gibson, Josh 60
Gill, Dante "Tex" 123, 124, 125
Gordon, Nettie 80, 118
Goslin, Tom "Goose" 128
Grant's Hill 50, 51
Great Depression 55
Greb, Harry 128
Greenlee, Gus 53, 54
Grenet, Samuel J. 24
Grill, Saul 13
Grosso, Sam 106
Grosso, Tony 61, 106
Guerin, Eddie 36, 37
Guthrie, George 19

H

Harris, William "Woogie" 53, 54, 59
Hazelwood Literary Society 127
Hill District 56
Hines, Earl "Fatha" 58
Hobnail Riley 33

I

Iroquois Club 127

J

Johnson, Judy 60

K

Kennedy, William 38
Kid Taylor 35
Klein, "Smiling Johnny" 23
Kline, Charles 17, 71, 72, 73, 74, 75,
 76, 77, 78, 79, 80, 81
Knickerbocker Social Club 127

L

Lagatutta, Anthony "Ninny" 133
Lawrence, David 17, 71, 82, 85, 98,
 100, 101, 102, 105, 106, 107
Lepus Literary Association 126
Leslie, Artemus 131
Liggett, Walter 11, 12
Ligonier Valley 136
Little Canada 33
Llewellyn, David W. 26
Lomasney, Martin 20
Lombardo, Pete 132
Long, Roxie 108, 109, 110, 111, 112,
 113, 114

M

Magee, Christopher 19
Magee, William 19
Manley, Effa 56

Margiotti, Charles 106
Martin, "Pittsburgh Hymie" 88, 128
McKay, Jimmy 36, 38
McNair, William 71, 72, 90, 91, 92,
 93, 94, 95, 96, 97, 98, 99
Melany, W.H. 27
Mellon, William Larimer 138
Monaca, the 128

N

Nosey Steel 35

O

O'Donnell, Hugh 16
Olmsted, Frederick Law 50
Oyster Paddy's 16

P

Paige, Satchel 60
Perry Social Club 127
Piano Movers Association 37
Pinchot, Gifford 128
Pittsburgh Crawfords 56
Powell, William 34
Praying Mary 33

Q

Quay, Matthew 52
Quinn, Mary Ann 42

R

Rickey, Branch 60
Rief, Abraham 20
Rimmel, William 35
Rinehart, Mary Roberts 34
Ripepi, Antonio 133
Roberts, Frank 132
Rolling Rock Club 137
Rooney, Art Sr. 63, 64
Roosevelt, Theodore 23

S

Sarkis, Billy 106
Scaife, Richard Mellon 137, 138
Scott, Hugh 141
Sheeny Mike 33
Shoebox Miller 33
Showboat 127
"Skinny Ellsworth" 35
Soffel, Jacob Jr 27
Sprigle, Ray 66
Steffens, Lincoln 14, 15
Stein, Gertrude 34
Swifty Howard 56

T

Thornburgh, Richard 135
Three Toms Club 128
Tito, Joe 55

V

Valenti, Frank 129
Vilsack, August 28
Voters Civic League 18

W

Walsh, Peter 14, 73, 74
Weil, A. Leo 23
Willard, Josiah Flynt 35
Williams, Mary Lou 58
Wilson, Robert 25
Wylie Avenue 58

ABOUT THE AUTHOR

\mathcal{R}ichard Gazarik spent more than four decades as a journalist in western Pennsylvania. He has won awards for his writing and investigating reporting into public and corporate corruption in Pennsylvania and has written extensively about the bombing of Pam Am Flight 103 over Lockerbie, Scotland, the terrorist attack on United Flight 93 in Shanksville, Pennsylvania, on September 11, 2001 and the rescue of the Quecreek miners in 2002. He is the author of *Black Valley: The Life and Death of Fannie Sellins*, published in 2011, and *Prohibition Pittsburgh*, published by The History Press in 2017. He is a graduate of West Virginia University.